SELLING GRAPHIC & WEB DESIGN

DON SPARKMAN

Allworth Press, New York

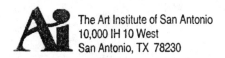

The Art Institute of San Antonio
10,000 IH 10 West
San Antonio, TX 78230

10 09 08 07 06 5 4 3 2 1

Published by Allworth Press, an imprint of Allworth Communications, Inc.
10 East 23rd Street, New York, NY 10010

Cover and text design: Don Sparkman

ISBN-13: 978-1-58115-459-7
ISBN-10: 1-158115-459-3

Library of Congress Cataloging-in-Publication Data

Sparkman, Don.
 Selling graphic and Web design / Donald Sparkman. -- 3rd ed.
 p. cm.
 Includes bibliographical references and index.
 Rev. ed. of: Selling graphic design. 2nd ed. 1999.
 1. Graphic design (Typography)--United States--Marketing--Handbooks,
manuals, etc. 2. Web sites--Design--Marketing. 3. Design services
--Marketing. I. Sparkman, Don Selling graphic design. II. Title.
Z246.S658 2006
381'.456862252--dc22
 2006013943

Printed in Canada

To those who know the difference between
function and form.

To Those Who Chose to Help

Mary Edens, Brian Choate,
Tad Crawford, David Cundy, Chris Foss,
Ed Gold, Ed Gracholski, Glen Kowalski,
Monica Lugo, Barry Miller, Esq.,
Kathy Renton, and John Waters

INSIDE

MULTI-TASKING DESIGN

Communication Seamlessly Integrates
Words and Images

A few years ago I began to notice an amazing change taking place in the design community. Design firms were no longer being asked to create design.

In 1990 I began a second career as a design instructor at the University of Baltimore, having been fascinated by the unusual approach to design I saw there. Led by a few very far-seeing and brave English instructors, the university had created a design program based on the at-the-time revolutionary idea that the best kind of communication is that which seamlessly integrates words and images.

In order to accomplish this, they created a graduate program that requires students to study and master both design and writing. In the almost thirty years that the program has been taught, it has turned out to be one of the most successful programs at the university. Graduates of the program are now spread out over the entire country championing the message to all designers "integrate or perish"!

Educational Overload

The problem with that message is that there is just too much for a designer to learn in order to integrate everything that needs to be integrated.

Designers are now being asked to create "brands." A "brand identity" is something that exists in the minds of clients and consumers based on every experience they have with a company. If

designers wanted to stay in business, much less grow, they were being asked to understand and manage a whole range of disciplines they had had no experience with, including public relations, advertising, packaging, crisis management, employee relations, interior design, marketing, and media selection, just to name a few. This means that designers were being asked not only to create effective design elements, but also to advise their clients on how they could successfully convey their message across the board, in every possible way.

Clients were no longer interested in "design" as most designers understood the term. They were certainly still interested in "problem solving," but the problems they were posing to design firms were no longer the same, simple ones they used to ask their designers to solve. They finally understood what designers have known for years: Design is not merely about what something looks like, it is about the blow to the psyche a person feels when he or she is confronted with a powerfully constructed message that comes through in everything they see, hear, feel, touch, or smell.

A Brave New World

The newly sophisticated demands of clients caught many designers unprepared. Most of them had spent years mastering the medium of print and perhaps television, but they found themselves at a loss when asked to develop branding strategies that communicated an integrated message across every possible communications medium, including ones that they themselves had no clue at all how to construct.

Recognizing this, the University of Baltimore approved the School of Communications Design's request to create a new terminal degree, the MFA in Integrated Design. The objective of the degree is to prepare designers to not only master all the various media clients are now asking designers to work within, but also to manage all the parts and pieces of an integrated branding campaign.

More and more, all businesses recognize that design can make the difference between products and services that succeed and those that fail. More and more, businesses are seeking graduates with MFA degrees rather than MBA degrees. Those who can innovate and create are being actively recruited by businesses that wish to grow.

Opportunity Is Knocking

Don Sparkman's book is the first one I've read that addresses this incredible opportunity being presented to designers. In this book, Don is asking designers to raise their heads from their computers and recognize that they have the power to change the world, and, at the same time, change the design business from the equivalent of a mom-and-pop store to a megaplex.

It won't be easy to do this, and, for certain, there will be many designers who will hate the very idea of abandoning the "arts and crafts" approach to design that the profession has followed for years.

But, as always, change is inevitable, and, as Don writes, this particular inevitability is already here.

ED GOLD

Ed Gold is a professor in the School of Communications Design, which is part of the Yale Gordon College of Liberal Arts, University of Baltimore. He is the author of The Business of Graphic Design *(Watson-Guptill).*

A BLURRING OF LINES IN DESIGN

It's All about the Design, Not Just Production

Graphic design today covers print, animation, and the creation of Web sites. Some people argue about which method of communication is the most effective. If you are a designer, you must be grounded in all forms. If you want to sell only Web design or only print, I'm sure you can find a firm that shares that "tunnel vision," and you'll be happy in the short term. But design, like water, will seek its highest level. If a message is better communicated through print versus the Web, it should be produced for print. If interaction is important, the Internet is probably best. The Internet can stand alone as a medium, but with no support from print, Web sites are easily forgotten or never found in the first place. While the Internet has the flash and sparkle that much print lacks, people need a break from constant motion, hype, and glowing color (even with millions of television sets and computers in homes all over the world, there are more magazines published today than ever before). Often, both print and Web design are needed in concert; they can complement each other. The one-two punch of a good print ad that features a Web address is ideal.

Embrace Technology

The Internet is not the first, and certainly not the last, revolution in the field of design. Letterpress printing was replaced by offset. Hot type was replaced by cold type. Paste-up was replaced by computer-generated, page-making programs. The printing "standard" went from two-color offset, to four-color printing, then five color, then

six, etc. The point is that you should never feel like you're on the leading edge. Design is just a train moving ahead, and you are on one of the cars. It's amazing to me how many people have retired because they didn't want to cope with the new technology. They couldn't embrace what they couldn't understand. Whenever we feel too superior, we should remember the "arm in the bucket" theory. What you do is fill a bucket with water and then put your arm down in the water. Now pull your arm out and see how much you've affected the level of the water. This is an old trick, but it certainly says a lot about our true importance.

Design is just a train moving ahead, and you are on one of the cars.

My first book, *Selling Graphic Design,* has been criticized as being pertinent only to account executives involved with client acquisition and maintenance, not designers. Anyone working with a client is my audience. This book is written for those who must market: be it themselves, their fellow designers, their company's production or programming staff, and everyone in between. So unless you are at the bottom of the design food chain at a very large firm, this book is written for you. If you are an account executive, graphic or Web designer, or an entrepreneur, this book will give you a sense of where the business of design is headed. It was written to help you avoid mistakes, seize opportunities, and close sales. You'll learn how to target the right clients, network, and write effective proposals. Best of all, you'll see graphic and Web design as a lucrative business opportunity. There may be things in this book that you already know, but that will only reaffirm what you originally thought.

The Art of Selling

This is a book on selling design. Design is different from other services or products. There is art in design, whether it's Web or graphic design. You can sell design even if you're not a designer, but you must understand design to sell it well. Most of the movers and shak-

ers in the industry are designer/presidents who came up through the ranks and in many cases are still designing. They have vision, and they can inspire those who are working for them, and just as important, they can inspire their company's clients. I've also known presidents of Web and graphic design studios who could talk a good story but their company's design was not stellar. In some cases it was lack of imagination, in others they were only concerned with the almighty buck. And in many instances, they couldn't win the big accounts. Anyone selling design must know design and embrace change. To quote Ed Gold, who wrote *The Business of Graphic Design*, "To sell graphic design, [one] must be knowledgeable about every aspect of design, design history, and the technology of design, which changes almost every day."

I didn't write this book in two distinct parts, one for selling graphic design and one for selling Web design. This book is for anyone in the business of design who wants to acquire and retain clients. It's as simple as that. If you feel that this cheapens your design practice, you should probably stop reading this book now.

THE HARD SELL

*Who Says Selling
Isn't Hard*

’m sure you've heard of the school of hard knocks. This is about
the school of hard sell, because selling is hard. All of us are in
sales. Selling, as we've all been told, begins with selling ourselves
to others. Whether it's to our employer (perhaps for a raise or pro-
motion) or to the public (the potential client or customer), we are
selling. Now, here's the hard part. You are only paid for what you
sell. No sales, no clients, no pay. Today, the media your company
works in isn't as important as the results of your sales efforts. Your
company can be the world's answer to high-tech graphic design and
super-savvy in cyberspace, but with no clients, there's no business,
no compensation, no reason to come to work.

*With no clients, there's no business, no compensation
and no reason to come to work.*

If you are selling a product—yourself or something else—it only
makes sense to want to sell the best product available. But always
remember that if you are selling graphic or Web site design, you
should be selling the best design, and anything else your company
does should only support this function. Selling anything else in addi-
tion to design will only result in a second-rate design. Several years
ago, I met with the principals of two other design firms in my office

building's conference room. We were working as an advisory committee to the local art directors' club. Both of the other companies were ahead of mine in technology. They had more sophisticated software and expensive hardware. There's a large bookcase on the far wall of my conference room where I display our work. The majority of the pieces are high end and full color. I commented that I believed that design was the most important thing my company did and that, while also important, technology didn't seem to impress my clients. One of my guests shook his head, motioned toward the bookcase, and said, "That's easy for you to say. We don't have Fortune 500 clients like you do!" I nodded politely, wondering if he would later reconsider what he had said and realize that he made my point for me. We have such great clients because better design, not newer technology, brings in better clients.

It's true that you have a lot more to learn than your predecessors ever did. But every negative has an equal if not stronger positive; you have a tremendous opportunity to become a valuable asset to your prospective clients. In many cases, they have little to no knowledge of the latest technology—for design or in general—and they are afraid to let anyone know how

You can be their greatest ally. Be thoughtful, cheery, and best of all, approachable. I remember a very successful printing saleswoman who made it a point to bring donuts to her first appointment. She was always welcome because management felt she helped morale and the staff thought the donuts were great. It was a win-win situation.

Keep in mind that selling isn't always just about being friendly and accessible. It's also about thinking on your feet, no matter what discipline you're working in. For example, we have designed award-winning Web sites for clients. After establishing sites and turning them over to clients, sometimes their IT personnel make changes. The changes can be small—or major and disastrous. Once I was invited to make a presentation to a prospective client showing specific types of pages we had designed. Unfortunately, the sites had been butchered, and our designs were barely visible. I decided to turn the presentation into a PowerPoint show using the original layouts we had presented our clients with before they changed them. At the end of my presentation, I was asked why I didn't show the sites as they are on

2

the Internet. Fortunately I had brought a couple of screen shots of the sites on my laptop and was able to show them the cyber-carnage. If I hadn't had the screen shots, I don't know if they would have believed my explanation of good work gone bad.

Inside This Book

In the first half of this book, you'll learn how to research prospects before you make a cold call. In fact you'll learn how to prepare for a call so it won't feel cold. You'll also learn how you can tap into resources that will bring results rather than "maybes." Once you're in the marketing mode, you'll be asked to prepare proposals. We'll walk through the process of preparing winning proposals. There are tricks of the trade that you'll never be taught by your prospects or your peers.

The second half of the book addresses what to do once you've got an account on board. The Graphic and Web Trade Customs are the terms that you use in doing business, and they have teeth. When used correctly, they can save your company time, money, and heartache. We'll explore each of the customs and learn what they mean. With business comes the question of ethics. David Cundy explains the ins and outs of ethics in this high-tech world of design. There's good, bad, and definitely ugly; David has seen it all and will share his experiences with us. His observations offer us a savvy view of today's ethics in high technology.

It All Starts with the Brand

Next, we will examine branding. You'll learn how to audit your client's brand. Whether or not it needs to be updated or totally redesigned will become apparent with this short but effective audit. Once you've addressed branding issues, you'll need to know about trademark law. Barry Miller, a prominent intellectual property lawyer, shares his knowledge of trademark law. While the World Wide Web can give even a small company high visibility, it also makes them highly vulnerable. By knowing the legal perils a brand can encounter, you may be able to save your client from a lawsuit and be their hero.

We then delve into specific concerns for Web and print. First up is

John Waters, a veteran of the Internet revolution, whose new company has blurred the boundaries between methods of design communications, mixing conventional printing and the Internet. His unique perspective comes from true on-the-job training in the school of hard knocks. Content management is important for organizations that want their Web sites to automatically inform and serve visitors. Amazon.com is a prime example of exceptional content management. Bran Choate, president of Timberlake Publishing, shares his company's methods and goals, giving us an understanding of this type of Web site design. Chris Foss of AmericanEagle.com will explain how his company markets the design and production of complex Web sites. You'll also learn how to manage commercial printing jobs and the intricacies of choosing paper and envelopes for yourself and your clients. With this information, you'll not only impress your client, but also perform a service that is worth compensation.

OPENING THE DOOR

*It's Not Just Where We're Going, But It's
Getting There in Style.*

ON-THE-JOB MARKETING RESEARCH

An Interview with Yourself

We all feel that there is someone out there who will click with our personality. It's the law of probabilities. But, let's face it, effective sales are planned. "Marketing research" is a daunting term if you are not familiar with it nor experienced in the field.

The first step is to analyze the company or studio you're working for. You need to sell what your company is capable of producing. If you are the company, then do some of the same soul-searching. Determine what type of work you do best and the type that is the most lucrative for you.

If you work for a firm with two or more designers, you need to know the capabilities of the group as well as the type of clients that fit their niche. Many studios exhibit work that previous employees have produced. However, the current design team may have different strengths and weaknesses. I suggest that you also review the type of work the present staff of designers has produced. Next, meet with the creative director, art director, and/or Web manager to learn their perceptions of where the company is going and to review their individual strengths. When you ask them to show you their portfolio, let them know you're interested in their work. After that, meet with the principal or principals of your company and bring a list of important questions.

For selling Web design, you need to determine whether your company is strong on the "front end" (mainly design) or "back end" (programming/production). For strong "front end" design,

your prime clients will probably be smaller companies with an emphasis on their brand and company information. If your company is into complex "back end," creating sophisticated databases, then you should look at organizations that want a Web site like Amazon.com. I'm not going to try and educate you on how to create Web pages or work with the programs. You need to learn to "talk the talk and walk the walk" to sell your firm's work. You need to know the difference between the Internet and Intranet and much more if your company sells technology over (or with) design.

I know it's hard to turn down business, and it's human nature to want to be all things to all clients. But there is nothing worse than when graphic design firms that are strong in print but have little knowledge of Web design offer themselves to clients as "full service" firms. The same is true of many Web design companies that claim they can do print design. They'll take on a client and have to farm out the design or try to wing it themselves. The successful one-stop shops sell to their level of expertise and realize they can't be all things to all accounts.

Down to Basics

Here are thirteen questions to ask yourself or the other members of your company. These questions could also generate new ideas, and this could help develop new goals:

1. What are your company's sales goals? In order to know what's reasonable, determine what sales were like last year.

For Start-ups: See if you can find sales figures for other companies doing the same type of work you want to do.

2. Who are your company's past and current clients? You need to know current clients as well as ones the company doesn't work with anymore. Are there clients on the "inactive" list, such as slow-payers and no-payers, whom you should avoid? Also consider what current accounts may be capable of giving out more work.

For Start-ups: Move on to question 3.

3. What types of new accounts does your company want? If the answer is unclear, it will be up to you to set up a strategy (especially

if you are an account executive or a freelancer). Focus on very strong, emerging growth industries. Stay away from industries that appear to be flat or stagnant.

For Start-ups: Having a clear idea of the kinds of clients you want is important for the success of your business venture.

4. What is the company's promotional plan? Are promotional materials available to you? Is there an advertising budget? What is company policy on client lunches and other promotional expenses?

For Start-ups: While you may not have a lot of funds to devote to promotion, it's critical that you keep promotions in mind and establish a plan.

5. Are designers available for out-of-office meetings? If you are an account executive, you might not ask all of the right questions. If the project is complex, you should have a designer present. If the designers are not available, try to have the clients meet in your offices.

6. Are the company's latest proposals professional and impressive? A good proposal isn't the only factor in getting a project, but it can be very important. You need all the help you can get. It may be the first thing a potential client sees from your company. Many companies rely on proposals that may be good in their content, but don't look as good as they could. If you are not the designer, make sure a designer has designed your proposal. Knowing the success ratio of the company's proposals is a way to gauge their effectiveness.

For Start-ups: Since you don't have work from previous clients, it's all the more important that your proposals be well designed, professional, and inspiring. They can act as showcases of your abilities and style.

7. How many concepts are produced for one project? Some companies only show one concept. Others show several. You need to know what you can promise a client.

For Start-ups: If you are a solo freelancer, you already know the answer. Lucky you! If you are going into business with a couple of fellow designers, the answer is not so simple. At the very least, you should know and understand the work process of your business partners. They may be

more comfortable with many concepts, while you want to keep it down to just one. Decide early on how your company will handle concepts, so there is no confusion later.

8. What are normal schedules for various projects? You need to give a prospective client a realistic schedule. Make a list of job types, from simple to complex, and assign a reasonable working schedule to each of them.

9. Does your company charge for overtime? Some companies do and some don't. If your company does, how is the rate determined? Is it time-and-a-half or double time? If there is no charge for overtime, you can use this as a sales tool.

For Start-ups: Like the issue of concepts, you should decide on your overtime policy immediately.

10. Does your company have regular staff meetings? If you are the account executive at a big firm that doesn't have regular meetings, you should at least set up a sales meeting schedule. The last thing you need is to work in a vacuum. You have to keep the lines of communication open, and it's work. The company has to be a team, or you are going to be the loser. If you're a designer, you need to have a firm grasp on all of the projects in the studio and in progress.

I once worked in sales for a company that had their entire design staff threatening to quit because I was such a free-spirited salesperson. They saw me come and go with client visits and meetings, but they didn't see the extreme overtime I put in to reach clients' deadlines. I was very young then, and I didn't realize that I needed these designers more than they thought they needed me.

For Start-ups: If your new business venture is not a solo one, it would be constructive and worthwhile to establish steady lines of communication early on. Decide when and with what frequency you will hold meetings.

11. What does the average project cost? It is important that you have a grasp of the usual estimating process and average costs, so you can talk intelligently with prospective clients. That's not to say you're going to give verbal prices. It simply gives you a chance to

know if a project is out of the question.

12. Are the work samples in a central location? All samples from different types of jobs should be filed in a central location. You want to tailor your portfolio to the type of account you're soliciting. If it's not being done, require a minimum of twenty-five samples of each finished piece. If your company manages printing or buys it, this is fairly easy. For Web design, you can offer URLs or hardcopy color prints of several Web pages.

I've found that developing a PowerPoint show is very effective, like a virtual walk-through of a Web site. It can be e-mailed or burned on a CD-ROM and shown to a prospective client on a laptop. Another way to show a site is to use the files to recreate the site and link it to your company's Web site. It is important for Web designers to have the site's original content archived, since the client could alter it later.

13. What happens if you work on commission, but the company is too busy to accept more work? If you are an account executive, there's the issue of commissions. It's your job to keep the company in the black with good billings. It's also up to the company to keep you in the black.

I personally don't believe in sales commissions for design account executives. They either sell or they don't. Plus, when the designers are too busy to take more work, they shouldn't have to worry about executives taking on more clients for the commission. If you're an account executive on commission and the designers are often too busy to take on new work, you need to talk with management about putting you on straight salary or more base and less commission.

For Start-ups: Focus on the types of accounts you would like to work with, but make sure you only take on work you can finish. You could also set up a backup procedure with another designer. When you are too busy to take on a project, you could recommend his or her services, and vice versa.

How Do You Position Your Company?

You and your company are in the consulting business. A lot of Web and graphic design companies are trying to be something they're

not. They also want to be marketing firms, ad agencies, or some confused combination of all three. This is the age of the specialist, and it applies to every industry. There's just too much for all of us to learn. Know your company's strengths and market them. Not what you wish your strong points to be, but what's real.

I attended an Art Directors Club meeting some years ago. There were several firms there that did government work that consisted of down-and-dirty charts and graphs. They did not produce intricate Web sites or graphic design projects, and since it was government work, they did not have to worry about the complexities of branding. The government was talking about giving all of their design work to one or two large companies on a yearly contract. These companies would have to be very large because they were expected to handle other services such as janitorial and furniture procurement. Needless to say, this would kill the small design firms that lived off of piecework from the government.

The majority of the designers at this meeting sympathized with the seriousness of their plight but didn't feel it was worth their time and energy to help these threatened firms. This turned into a nasty exchange. The smaller, government-oriented design firms threatened to go after private-sector clients if the other designers didn't help them fight for their business. They said they'd "eat their lunch." This, however, was an idle threat because their companies operated in a different stratum.

The small, government-oriented firms thought they could instantly challenge firms in the private sector that specialize in Web and graphic design, even though they were without any such experience. That's not saying these companies aren't capable of other types of design. But it's hard enough to sell what your company does well, let alone what it would like to do. The moral of this story? Know your company's real strengths and concentrate on them.

So what are your strengths and weaknesses? Let's start with one-person shops or freelancers. With computers, there is a large cottage industry of these designers. A huge asset they have going for them is that they are generally cheaper than design companies because they have less overhead. They often work out of their homes, where the

rent for their business is nonexistent. Their equipment usually consists of a computer and some software programs.

One of the downsides to this situation can be precisely that there is only one designer on board. The client generally has a lag-time between approving a concept and committing it to the production or programming stage. Often, if the freelancer is good, he or she will have another client's work on their plate in case the other client doesn't pan out. Unfortunately, when the other client commits to the project, the freelancer cannot immediately resume work on the next phase.

For some clients, this is unacceptable. One solution to remedy this is to try to have a back-up plan with another designer. If he or she is available to help you with the workload, you can work together on the project and split the fee accordingly. If you can't put together an arrangement like that, always remember that your one-man-band structure and low overhead are your big strengths—play on them! If you find that a client is reluctant to wait the extra time, there is no harm in reminding the client of the lower price you offer them in return. And remember to go after accounts that fit your profile. Avoid clients who will never have the flexibility to work with your kind of schedule. As a freelancer, you have an opportunity to forge a friendship with a client, and that is invaluable in building a great (possibly long-term) working relationship.

Large Versus Small
If your company is large, you have distinct advantages, too. For example, with your larger company, there is no waiting. Work can begin as soon as a client commits because there is more than one designer on staff. Other advantages to being larger include:

- Larger firms can offer different types of talent to suit your client's projects.

- Larger firms tend to attract talented designers because of their stability.

- There is consistent quality when a staff produces the work.

- Larger firms will never be too busy or understaffed to take on more work.
- The principals of large firms are usually very savvy about print or Web technology. And their reputations, if they are good, attract the best print or Web salespeople.
- Larger firms are usually able to purchase the latest hardware and software.
- Larger firms can usually survive past thirty days if a client's policy is to pay in sixty.

Whether you are selling Web design or graphic design, the key word is "design." If you forget this, you'll blur the distinction between design and production. The worst thing is that in many cases, the clients do their own production and only need a layout to follow from you. This applies to brochures, newsletters, books, and even magazines. And if so, who needs you?

You Can Become Your Client's Best Ally

There are some people who will never ask for directions when lost in a new city. If their time were worth money, just think how stupid this would be! And your client's time is worth money. Your clients should use you as consultant and call you if there is a procedure they're not sure of. They know you won't laugh at a question, and they know you're not in a position to use their lack of knowledge to make them look bad.

Take the time to learn the new design technology, or you will probably be left behind by those who have. Learn as much as possible so you can help your clients understand what they are buying. Lunches are a great place to cultivate a trusting relationship. Your clients can ask questions without their peers being present. Don't take this lightly. A lot of people in sales think that misery loves company. With technology, this isn't true.

The best thing you can do is listen. If you understand your client's needs, you should be able to give them answers they need to impress their boss or the public. When you become part of your client's arsenal of protection, you'll be an asset they won't want to

lose. I have watched savvy clients guess about the answers to questions a designer could have answered instantly. This may be human nature, but it doesn't have to be theirs. They'll look good when they seem to have solved a technical problem all by themselves. You want your clients to remember you for what you did say, not what you didn't. No one likes surprises in business, because they are rarely good ones.

The Art of Anti-Brokering

As our evaluation of your company and its place in the market comes to an end, I'd like to offer a business procedure you might want to consider adding to your arsenal. Many in the graphic design business may consider me a heretic when I explain my philosophy of "handling" outside services.

The usual process for acquiring the services of outside vendors—like illustrators, photographers, or printers—usually goes something like this: Design firms pay for all the expenses related to using the vendor on a particular project. For example, the design firm would negotiate with an illustrator and pay him or her the agreed-upon fee. The design firm then charges the client the illustrator's fee plus a 15 or 20 percent markup fee for performing this service. If your company doesn't work with outside vendors at all, or wants to continue paying for those services and marking them up, then stop reading here.

Here's what I do: I have the services billed directly to my client, and I bill them a management fee that is usually much less than the standard markup fee. I am not a broker, nor do I want to be. My rationale for not buying services (especially print) began several years ago. A friendly competitor designed marketing materials for a client. The job became rush, as they often do, and the job was given to the printer late on a Friday night. At the client's request, the designer paid for the job and for extra expenses so it could be printed over the weekend. The good news was that the printer was able to complete the job by Monday morning. The bad news was the client's firm made the front page of the newspaper for cooking their books. By noon they were out of business, and my friend was out $45,000.

Here's how you explain your company's philosophy to your

client: First, outline the standard markup fee if they are unfamiliar with it. Next, use a big-ticket item, like printing, to explain that you will manage the printing process on an hourly basis, which is billed at the designer's hourly rate, and this includes writing the specifications to get competitive bids, selecting three printers with equal strengths best suited for the job, checking all proofs, and preparing the final files for output. You can also offer to inspect the printer's final files, to be billed on an hourly basis. They are going to have to pay for the vendor services no matter what, but this way they'll save money. And, since you are familiar with the processes and the vendor, the project will run like a well-oiled machine. Clients want to save time and money, and they'll appreciate you helping them to do just that. For a more in-depth discussion of billing for your time, flip ahead to chapter 17.

What Is the Right Account?

With this thorough analysis behind us, we can zero in on the right accounts for your company. So, what is the right account? It's an account your company wants and is suited to. Your company could unwittingly cause itself to look for the wrong accounts. When you are able to get a "sit down" with a prospective client, you need to interview them on *your* behalf as well as what you can offer them. The companies or organizations that you pursue should be successful in the following ways:

- It's in a growing industry with a future.

- It has a good credit rating.

- It has a steady stream of work, and it's the kind that suits your Web or graphic design staff.

- It understands or appreciates the need for good graphic or Web design and its impact on their company's profitability.

The last point is the most important. If a company is looking for branding to give it a nice look, but doesn't want you to offer anything beyond that, put it on your C-list. If it wants a corporate brochure as a vanity piece and has no interest in updating its ugly

logo and weak Web site, don't pursue the account.

I've watched many design companies take on clients with no vision or taste in the hopes of changing them and making a quick buck. This is a little like marrying an ax murderer and thinking he or she might come around. I've discriminated against clients who don't understand design and don't want to, either. It's proved to be a smart move. That's because they didn't establish goals in the beginning. It's easier to get what you want if you've established what it is that you need. Many clients are savvy about what Web or graphic design can do to enhance their marketing efforts.

Also, you don't need to court accounts that only have one or two or three small jobs a year. Unless it's an annual report, corporate identity program, or a complex Web site to attract new accounts, you don't need them. I personally have never pursued accounts that were smaller companies than mine. Ninety-nine percent of the time, they've given me more grief and aggravation because they either didn't understand the importance of good design, or they were undercapitalized. Remember it takes just as much time and energy to reel in a low roller as it does a high one. Make your moves count.

It's easier to get what you want if you've established what it is that you need.

If you're with a small firm, you need to be aware of who you're up against. Many design companies in competition with yours have sales representatives who are savvy in the client/designer relationship. There are also firms that do not have sales representatives. They depend on the principal or principals to perform this function. That can be formidable competition if your firm doesn't have someone in the position.

SELF-PROMOTION BEGINS
WITH SELF

And It Involves
Others

Promotion is an art form, and many fine books have been written on the subject. Whether you work for a large company or a small firm, promotion can help it survive. Here I'll use my own experience to highlight some of the basic ideas about marketing and self-promotion that will work for any Web or graphic design company.

My lawyer once invited me to a partners' dinner meeting to discuss his firm's new marketing approach. He explained that the partners meet once a month to plan strategies. I thought that I would be part of a discussion on how to market the law firm to the public. Wrong! After dinner I was introduced as the person who would now give the partners a seminar on the new marketing plan for their firm. This caught me by surprise, to say the least.

Not wanting to embarrass my host, I decided to wing it. Fortunately I knew the basics: First I told the partners that it was their individual responsibility to sell for the firm, not by cold calling, but by joining the Rotary Club, the Chamber of Commerce, or other community organizations. Next they needed a public-relations plan. This meant that someone had to be in charge of sending out press releases when something newsworthy happened in the firm.

I told them that they also needed a simple brochure that was nothing more than an extension of their business card. This brochure would fit in a standard business envelope, and each partner's bio would be on a single sheet in a pocket in the back of the

brochure. I then talked about a simple but catchy series of ads. These ads would be very general, simply portraying the law firm as a reputable and multitalented group of partners, not a group of ambulance chasers.

Everything I said was based on common sense. These ideas weren't new, except for the ad concepts. They needed to update their Web site and make it an anchor for all of their promotions. They needed something to entice clients to visit the site more than once. A weekly legal puzzle concerning bizarre cases could give the Web site the ability to develop followers. The answers to the puzzles could be posted the following week. This would give the firm the chance to announce promotions or post other news to the returning puzzle fans.

Last but not least, I remembered a large clock on their reception area wall. I couldn't resist an experiment. I told the lawyers that any of them could run a little late for a client's appointment, some more than others. The clock was an unnecessary reminder to those waiting in the reception area of just how late they were running. After all, it takes more effort to look at a watch or a cellphone than to look up from a magazine at a wall clock.

I was given a hearty round of applause for my little common-sense approach to marketing. Two weeks later, I was in my lawyer's office reception area. There was a big pale spot on the wall above the receptionist. I asked, "What happened to the clock?" She replied, "I'm not really sure. About two weeks ago, the partners came in one morning, and the next thing I knew, the clock was gone." I smiled to myself. The clock was a shot in the dark, but it was a marketing truth. Thinking on your feet is part of marketing, and practice makes you closer to perfect.

Marketing Is a Necessity

Marketing is a series of necessary efforts to promote your company. The only difference between your company and a law firm is your imagination or knowledge. Don't bite off more than you can chew, but don't be so sure you can't bite off quite a bit. Be aware that you are marketing your company in any business situation. Remember

the lawyers? Hoping for another solution, I asked people in my firm what they would've done if asked to come up with an instant marketing seminar. I got a blunt answer: "I would've thrown up!"

Marketing is only effective when it's used. I've been to many good seminars on the "how to" of marketing and have seen people forget everything they paid money to learn as soon as they got back to their office. No game plan will guarantee no results. Marketing is work, but you can see results. I also like to remind the principals of Web or graphic design firms and other businesses that when times are tough, they should not forget that they were the reason for the company's original success. They should remain active in the day-to-day sales effort of the business.

Some Web or graphic design companies already have a marketing and/or a public-relations program in place. Look at yours. Don't be too quick to offer suggestions until you thoroughly understand what has been done in the past and have decided what you want to do now. I have seen many a shot from the hip come back as a ricochet to the heart, and this can be a killer for future projects.

Usually a public-relations program had an author. Find out if that author is still around. You don't need surprises if that person is now above you. That person may also be able tell you if their campaign was effective and why. Web design firms seem to have more luck with radio ads using testimonials. With graphic design, the visuals they produce are great for print ads; Web design is tough to show in print.

If your company doesn't have a PR plan, or you are just starting out and need to make one, keep reading; I'll walk you through it.

First, Clean House

The best way to get your company's public-relations juices flowing is to hold an open house. This is a great way to promote your company and to get the facilities cleaned up. I've used the open house as a deadline for having the corporate brochure printed or the Web site go live. This is a method used in business every day. If there is no tangible deadline, then usually there is no tangible product. It's also imperative for top management to understand and back this concept.

Don't take the open house lightly. There should be a theme. I know of one firm that holds a Valentine's Day party for their clients. After all, February is a partyless month. You can usually negotiate a good deal with a caterer. You can use the open house to announce a new product or service, a company anniversary, or any other excuse to invite clients to your offices.

Corporate Web Site and Brochure

Every design company needs a Web site. If a company is involved in print, exhibit design, or branding, it needs a brochure as well. Business people used to exchange business cards whenever they would meet. Now a company brochure is considered the best way to introduce yourself to the world. Your company brochure doesn't have to be fancy or expensive. But it had better be good. In this age of information, people are inundated with good graphics and good brochures. The difference between conservative and mundane is a fine line. Often good design is the best differential for making your message stand out in the crowd.

Obviously, if you are seeking high-level clients, you will need a brochure that addresses a much higher level of design. I once heard a designer say that the samples of his past work were his brochure. If that's the case, make sure you have a lot of samples to leave behind. Pure Web design companies feel they don't need a brochure. They think their Web site will sell their work. This is true to a certain extent, but a brochure doesn't have to feature Web sites they've developed. It can feature the company's staff, testimonials, and the philosophy of the principal or principals. There is one basic problem. For the most part, Web designers refuse to see print as a viable option. They won't let a print designer help them with their promotion needs. They feel it's the Internet or nothing, while graphic designers are open to using different mediums.

Designers' Profiles

Rather than "biographies"—a boring, unapproachable term—I use the word "profiles." You can really spice them up—make them more exciting. Plus, a profile is written about someone, not by them. Most people have a hard time writing their own bios because they

are naturally embarrassed to toot their own horn. It is hard for people to step back and give themselves a glowing review. Their professional credentials take on a very matter-of-fact tone. But there is no reason why someone's obituary should be more exciting than his or her biography.

Profiles are much simpler than biographies or résumés, which are usually dry and very boring. The profiles should be relatively short, but they should be just as meaty as the best résumé. If you are going to write the profiles, ask each designer for a current copy of their résumé. If it's really current, you may want to think about their relationship with new accounts.

There is no reason why someone's obituary should be more exciting than his or her biography.

There's an art to writing a good profile. For example, one of my employees had only a little professional experience prior to working for me. Her résumé was sparse. She was very talented, despite her lack of experience. (It's a fact that a bad résumé may keep a wonderful prospective employee from ever being considered for a job.) She was very timid when talking about herself, but was quite the opposite when verbalizing her work. I had to really work on her profile to give her credibility. And I couldn't lie. She was born in Europe, and I decided to make this a big plus. I played on her strengths and the recent successes she had had while working on projects in my studio.

Once you've learned to write an effective profile, you will be able to offer this service to your clients. Many companies include biographies in their corporate brochures. They also use them in proposals. The profile is also an awesome résumé.

See the example on the next page.

Pandora, Inc. New Media Design

Profile: Jane Smith
Senior Web Designer

Ms. Smith is a senior Web designer with Pandora Design. Whether she is directing a special project or participating as a key member of a Web design team, Ms. Smith offers an array of special talents. She is highly skilled in Illustrator and Photoshop and has a thorough knowledge of the complex animation programs that Pandora utilizes.

Ms. Smith has worked with national accounts, bringing a unique European flair to Web design projects. She has worked on Web sites for Titan Electronics, CNB Industries, Ozark Technologies, GateTrade Bankshares, and Windward Papers. Prior to joining Design+Associates, Ms. Smith was a designer at Electric Images in New York. Before that, she freelanced for Studio XL in New Jersey and also freelanced for Jones, Hunt & Simms, an advertising agency in Connecticut.

Ms. Smith graduated with honors and a BFA from the University of Buffalo, College of Art and Design. She also studied at the Swiss School of Design in Basel, Switzerland, as well as the University of Rome in Italy.

Ms. Smith is fluent in both French and Italian.

The All-Important Press Release

The press release is an excellent way to blow your company's horn. First, collect the addresses of people and/or publications you want to send your releases to. Always remember that a press release has to feature newsworthy information. It can announce a person's promotion or some new product breakthrough, but it can't sell. I can't emphasize this strongly enough.

The structure of a typical press release is an inverted triangle, with the most important information at the top and the least important at the bottom. This way, if the editor doesn't have room for everything, he or she can simply edit the text from the bottom up.

Press releases should be categorized by subject, and you can make up a file of specific publications and editors for each type of subject. For instance, trade journals will often publish employee promotions and new arrivals. Other publications will print stories on new accounts that you have landed. Look through magazines and trade tabloids to see which ones print what.

Editors are often looking for news. If you can get to know some of the key editors, it's not inappropriate to call them and sound them out on a potential release. If you're good at writing, you may be able to turn a press release into an article. A sample press release is shown on the next page.

A press release has to give the following information:

1. Who or what is the subject?
2. What has happened?
3. When did the event occur?
4. Where did the event occur?
5. Why is it newsworthy?
6. Last but not least, you should give your name and phone number for more information.

Pandora, Inc. New Media Design

June 8, 2007

For Immediate Release:

Washington, D.C.–based Pandora New Media Design announces a strategic partnership with CyberCom and SAI PR Associates. The new organization, Pandora Group, LLC, represents a consortium of companies with a unique combination of Web design, Web branding strategies, and marketing/PR.

Pandora's spokesman, John Ambrose, says," The group will offer prospective clients a combination of skills rarely found under one roof." Catering to emerging technology companies rather than Fortune 500s will give smaller clients the capability of competing with the large software developers.

The Pandora Group has won three Addys for the branding campaign for LexiComm International. LexiComm CEO Charles Barnes says, "We would still be looking at logo designs if it hadn't been for Pandora. Now we have a brand personality and we're using it to win customers."

The Pandora Group is based in Alexandria, Virginia, with offices on King Street convenient to Metro, restaurants, and Reagan National Airport. The staff is made up of senior Web designers, graphic designers, and marketing consultants specializing in technology.

For more information, contact Janet Doe at (202) 555-5555.

• • •

Please note that the press release comes dangerously close to selling and probably would only be picked up by trade publications.

I've found it very helpful to file lists of publications, the names of their editors, and addresses under specific areas of interest. List A contains all of the publications; list B contains high tech publications for product announcements; and list C is general interest publications for personnel announcements and other general company news. You can arrange your lists to suit your needs.

The Map

If your company is in a remote area, such as an industrial park, develop a postcard-sized map for prospective visitors. The map can be very simple, but clear. Everyone in the company should be encouraged to use it.

The Clock

Don't forget the clock in your company's reception area. Get rid of it now. This may have been a second thought in my marketing seminar, but it could make your visitors a lot happier and enhance your total promotional effort.

What If There Is No Budget for Marketing?

If there is no budget for marketing in your company, you'll have to get creative. Read as many books on marketing as you can find (the public library is a good source). There are things that don't require much money. The press releases and the designers' biographies require next to nothing. You may want to hire a professional writer, but in the case of the bios, it will be a one-time expense. The map can be one-color, which is inexpensive to print. If you are not the designer, ask one of your company's graphic designers to make it.

If you need to wrestle some funds from higher-ups, try this: Clip competitor's advertisements or record their radio spots. Go to design trade shows and pick up competitors' brochures and other handouts. If your company's materials need to be re-designed, collect good examples of competitors' promos, stationery, and logos. Sit down with management. Show them what the competition is doing (I suggest mounting the examples on presentation boards)

and discuss ways of moving funds from another budget to the marketing budget.

The Marketing Consultant

Marketing is a company effort. Everyone counts. If your ideas are falling on management's deaf ears, hire a marketing consultant. This is not because they know more than you do, but because someone outside the company usually lacks hidden agendas. And it's true that management will often assign more worth to something they pay for.

An outside voice is often listened to because an insider must be part of the problem.

I have an example of this that hits close to home. I asked an editor friend of mine, as a consultant, to read this book and to feel free to use her infamous red pen. She did, and my manuscript was a sea of red marks. I decided to make only limited changes. She had added numerous commas, and I questioned almost all of them. We had agreed, up front, that I would receive a bill for her services. When I got her bill a few days later, I looked at her work quite differently. I made every single correction that she had marked. After all, I paid for all of those commas.

It has often been said that management listens to an outside voice because an insider must be part of the problem. Whether it's true or not, it is a fact that can't be ignored. So go with the flow. Hire a consultant who shares your views.

Advertising

If your company is large, it may place advertising for its clients. (This is an area that's often overlooked by small companies.) Since advertising doesn't always have a defined result, it is usually the last area to receive a defined budget. But advertising can work for your company just as it does for its clients. Many professionals feel ad

campaigns are demeaning. Too often design firms refuse to advertise in the yellow pages, newspapers, or other local publications. They, like doctors and lawyers, feel this is beneath them. Well, we have to face it. We're not doctors or lawyers, and there is a glut of designers in the marketplace. We need an edge, and advertising reaches businesses, as well as influential individuals.

If your company doesn't buy advertising, but it does have a budget, work up a game plan. Many small companies find it profitable to advertise in the yellow pages. Some companies also spend time and money advertising in trade publications. But since only their competitors read these, this has never made much sense to me.

You can create simple ads. You can be the writer and place the ads yourself, remembering that the secret to successful advertising is frequency. It does no good to run an ad once and then pull it. The public is very busy, so you have to hit them over the head, so to speak. Run your ad numerous times to get their attention. I've seen ads generate new business three months after the last one appeared in a publication. It's a lot like fishing. You have to be patient and hang in there. The more patience, the bigger the fish.

NETWORKING FOR EFFECT

You Must First Go to the
Mountain

Networking is very important in any sales position. But a lot of people make the mistake of thinking they should network with their peers. Wrong! Your peers are essentially your competitors; they are not going to give you any business, and they certainly won't refer you to clients. Of course there is an exception to that rule. If your company is outrageously expensive, they will offer up your name when a new client asks for other names for a bid.

If you are an account executive representing designers, you will need to learn everything you can about the field. That doesn't mean you have to be a designer or a programmer. Staying on top of what is going on is a form of networking.

Where the Clients Are

Most design firms work with local accounts because it's easier to call on them, as well as serve them. The exception to this rule is when the design company has outgrown its locale or there isn't enough business there to support it. A few just feel they are national in nature and want nothing but national accounts.

The phone book is often overlooked as a source of companies who are potential design buyers. If a company has a sophisticated ad in the phone book, it's already using a designer. There are also local business directories available in most cities.

Most cities have a local newspaper with a business section that appears weekly or daily. This is a great way to find out what area

companies are doing. Their press releases will give you important information to be used in your conversation with their design buyer. In some cities, there are publications that offer lists of companies that are starting up. This may be a gold mine for corporate identity work.

Research Your Potential Clients' Clubs or Groups

There are many different types of groups that can generate business. As I mentioned in the previous chapter concerning the lawyers, you can join community organizations like the Jaycees, Rotary Club, Kiwanis Club, Board of Trade, or even a religious community. These groups perform community services, and they can always use the talent of a design company. This is not to say your company will be doing a ton of free work. The members of these groups are professionals and realize the time you use is valuable.

These organizations will not only expose you to potential clients, but also expand your knowledge and give you leadership skills. Remember, you only get out of an organization what you put into it. I joined the Jaycees twenty years ago. My old friends are now the presidents of companies. This has helped me throughout my career, and it really helps now. Even if you're in a rural area, there will be some sort of group that you can join. Most small towns have a Lions' Club.

The key is exposure and becoming one of the group. Networking is an art, and it should be done naturally. Joining in is better than selling from the outside. In my experience, Web designers aren't as outgoing as graphic designers, and this is probably due to the intensity of their work. If you're selling Web design, you need to be an extrovert. If you join a group, plan to get involved. You will be visible if you get on some key committees. There are people who join a group and expect to network without any personal investment. They'll meet a few people, but they'll never be as effective as you. The people who are visible are the doers, not the silent observers.

Selling is best done when you are not aware that you are selling. Interpersonal relationships need to develop to form lasting bonds that will keep clients from jumping ship. You need to be a problem-solver as well as a mentor. Remember what we learned earlier: The

client is a person, not the company he or she works for. Just as with any successful relationship, you must work at nurturing your business friendships. A part-time effort will yield nothing. Your client has a full-time job, and he or she expects the same from you.

Since most clients come through referrals, you need exposure. You also need to do some research on what organizations your potential clients will join. For instance, if you want to do annual reports, there are groups of financial analysts who meet and would welcome a presentation on the design process for producing an annual report.

Below I have listed the national offices of organizations worth investigating. To find out if they have a local group in your area, write, call, or visit the Web site; many local chapters have their own Web sites, as well.

IDEAlliance
1421 Prince Street, Suite 230
Alexandria, VA 22314-2805
Tel: (703) 837-1070
Web site: *www.idealliance.org*

IDEAlliance used to be the Graphic Communications Association (GCA), and before that, it was known as the Printing Industries of America. There are chapters in cities all over the country.

**International Association of Business
Communicators (IABC)**
One Hallidie Plaza, Suite 600
San Francisco, CA 94102
Tel: (415) 433-3400
Web site: *www.iabc.com*

IABC is involved with the issues of business communications. They hold local and national conferences and seminars.

The United States Junior Chamber (Jaycees)
7447 South Lewis Avenue
Tulsa, OK 74136
Tel: (918) 584-2481
Web site: *www.usjaycees.org*

If you're under thirty, this is a great place to build lasting professional and personal relationships.

Rotary International
One Rotary Center
1560 Sherman Avenue
Evanston, IL 60201
Tel: (847) 866-3000
Web site: *www.rotary.org*

Rotary clubs are community-oriented and will give you access to many business and civic leaders.

The U.S. Chamber of Commerce
1615 H Street, NW
Washington, DC 20062-2000
Tel: (202) 659-6000
Web site: *www.uschamber.com*

Each city usually has a Chamber of Commerce. This is an excellent area for meeting the community's movers and shakers.

Professional Organizations Are Important

I'm not saying you shouldn't belong to organizations relating to the field of graphic design. Design organizations often offer technical forums, lectures, and meetings, as well as social events. And let's face it, you might meet your next employer at one of these meetings. There are many professional organizations that can help you achieve

many things. Some of the benefits are education, technical support, networking, new product and service information, conferences or seminars, or just social contacts.

If you are a designer, joining a design group is even more important because you can't afford to become insulated from the latest trends. If you buy illustration or photography, you'll be kept up to date through club meetings. If you're selling design now, you could be buying it later.

*You moght meet your next employer
at one of these meeetings.*

You may also wish to join the local art directors club in your area, which can give you an inside track on what's happening in your field. Most people don't realize that you don't have to be a member of an organization to get on its mailing list. Also, many of these groups welcome guests to their meetings; in fact, they openly promote it.

The following is a list of numerous design organizations and art director clubs across the country. You can also search for a local group in your area online.

The American Institute of Graphic Arts (AIGA)
164 Fifth Avenue
New York, NY 10010
Tel: (212) 807-1990
Web site: *www.aiga.org*

Founded in 1914, the AIGA is the national, nonprofit organization of graphic design and graphic arts professionals with forty-eight chapters nationwide. Members of the AIGA are involved in the design and production of books, magazines, periodicals, film and video graphics, and interactive multimedia, as well as corporate, environmental, and promotional graphics.

The AIGA national and local chapters conduct an interrelated program of competitions, exhibitions, publications, and educational activities and projects in the public interest to promote excellence in, and the advancement of, the graphic design profession. The Institute sponsors both design and business conferences. AIGA is expensive to join, but worth the dues. Their publications, shows, and conferences are first-rate. If you are from a graphic design background, you already know this.

Art Directors Club, Inc. (ADC)
104 West Twenty-ninth Street
New York, NY 10001
Tel: (212) 643-1440
Web site: *www.adcglobal.org*

Established in 1920, the Art Directors Club is an international non-profit organization for creative professionals in advertising, graphic design, new media, photography, illustration, typography, broadcast design, publication design, and packaging.

Programs include publication of the Art Director's Annual, a hardcover compendium of the year's best work compiled from winning entries in the Art Directors' Annual Awards. The ADC also maintains a Hall of Fame, ongoing gallery exhibitions, speaker events, portfolio reviews, scholarships, and high school career workshops.

Design Management Institute (DMI)
29 Temple Place, Second Floor
Boston, MA 02111-1350
Tel: (617) 338-6380
Web site: *www.dmi.org*

Founded in 1975, the Design Management Institute has become the leading resource and international authority on design management. DMI has earned a reputation worldwide as a multifaceted

resource, providing invaluable know-how, tools, and training through its conferences, seminars, membership program, and publications. DMI is a nonprofit organization that seeks to heighten awareness of design as an essential part of business strategy.

Design Studies Forum (DSF)
Web site: *www.designstudiesforum.org*

Design Studies Forum (DSF) is a College Art Association Affiliated Society. Founded as Design Forum in 1983 and renamed in 2004, Design Studies Forum seeks to nurture and encourage the study of design history, criticism, and theory and to foster better communication among the academic and design communities. DSF's four hundred members include practicing designers, design historians/ critics, and museum professionals. For information about membership and DSF's electronic announcement list, visit the Web site.

Graphic Artists Guild (GAG)
90 John Street, Suite 403
New York, NY 10038
Tel: (212) 791-3400
Web site: *www.gag.org*

This national organization represents professional artists active in illustration, graphic design, textile and needle art design, computer graphics, and cartooning. Its purposes are to establish and promote ethical and financial standards, to gain recognition for the graphic arts as a profession, to educate members in business skills, and to lobby for artists' rights legislation. Programs include group health insurance, bimonthly newsletters, publication of the handbook Pricing and Ethical Guidelines, legal and accounting referrals, artist-to-artist networking, and information sharing.

The Grolier Club

147 East Sixtieth Street
New York, NY 10022
Tel: (212) 838-6690
Web site: *www.grolierclub.org*

Founded in 1884, the Grolier Club of New York is America's oldest
and largest society for bibliophiles and enthusiasts in the graphic
arts. Named for Jean Grolier, the Renaissance collector renowned
for sharing his library with friends, the Club's objective is to foster
"the literary study and promotion of the arts pertaining to the pro-
duction of books." The Club maintains a research library on print-
ing and related book arts, and its programs include public exhibi-
tions, as well as a long and distinguished series of publications.

International Council of Graphic Design Associations (Icograda)

Icograda Secretariat
455 Saint Antoine Ouest, Suite SS 10
Montréal, Québec
Canada H2Z 1J1
Tel: +1 514 448 4949
Web site: *www.icograda.org*

Icograda is the professional world body for graphic design and visual
communication. Founded in London in 1963, it is a voluntary com-
ing together of associations concerned with graphic design, design
management, design promotion, and design education. Icograda
promotes graphic designers' vital role in society and commerce and
unifies the voice of graphic designers and visual communication
designers worldwide.

Society of Publication Designers (SPD)

17 East Forty-seventh Street, Sixth Floor
New York, NY 10017
Tel: (212) 223-3332
Web site: *www.spd.org*

SPD was formed in 1964 to acknowledge the role of the art direc-
tor/designer in the creation and development of the printed page.
The art director as journalist brings a visual intelligence to the edito-
rial mission to clarify and enhance the written word. Activities
include an annual exhibition and competition, a monthly newsletter,
special programs, lectures, and the publication of an annual book of
the best publication design.

ATypI (Association Typographique Internationale)

ATypI Secretariat and Conference Office
Maxstoke House
104 Parkside Drive, Watford,
Hertfordshire, WD17 3BB, UK
Tel: +44 01923 800425
E-mail: secretariat@atypi.org
Web site: *www.AtypI.org*

This is the premier worldwide organization dedicated to type and
typography. Founded in 1957, ATypI provides the structure for
communication, information, and action among the international
type community.

Type Directors Club (TDC)

127 West Twenty-fifth Street
New York, NY 10001
Tel: (212) 633-8943
Web site: *www.tdc.org*

TDC is an international organization for all people who are devoted to excellence in typography, both in print and on screen. Founded in 1946, today's TDC is involved in all contemporary areas of typography and design, and welcomes graphic designers, art directors, editors, multimedia professionals, students, entrepreneurs, and all who have an interest in type: in advertising, communications, education, marketing, and publishing.

Organization of Black Designers (OBD)
300 M Street, SW, Suite N110
Washington, DC 20024-4019
Tel: (202) 659-3918
Web site: *www.core77.com/OBD/welcome.html*

The Organization of Black Designers is a nonprofit national professional association dedicated to promoting the visibility, education, empowerment, and interaction of its membership and the understanding and value that diverse design perspectives contribute to world culture and commerce. OBD is the first national organization dedicated to addressing the unique needs of African-American design professionals. The OBD membership includes over 3,500 design professionals practicing in the disciplines of graphics design/visual communications, interior design, fashion design, and industrial design.

The Society for Environmental Graphic Design (SEGD)
1000 Vermont Avenue, Suite 400
Washington, DC 20005
Tel: (202) 638-5555
Web site: *www.segd.org*

An international, nonprofit organization founded in 1973, SEGD promotes public awareness and professional development in the field of environmental graphic design—the planning, design, and execution of graphic elements and systems that identify, direct, inform,

interpret, and visually enhance the built environment. The network of over one thousand members includes graphic designers, exhibit designers, architects, interior designers, landscape architects, educators, researchers, artisans, and manufacturers. SEGD offers an information hotline, resource binder, quarterly newsletter, biannual journal, Process Guide, Technical Sourcebook, information clarifying the Americans with Disabilities Act as it pertains to signage, annual competition and conference, and regional groups that help connect people working in the field and offer a variety of tours, demonstrations, and meetings.

Society for News Design (SND)
(formerly known as the Society of Newspaper Design)
1130 Ten Rod Road, Suite F-104
North Kingston, RI 02852
Tel: (401) 294-5233
Web site: *www.snd.org*

SND is an international professional organization with more than 2,600 members in the United States, Canada, and more than fifty other countries. The membership is comprised of editors, designers, graphic artists, publishers, illustrators, art directors, photographers, advertising artists, Web site designers, students, and faculty. Membership is open to anyone with an interest in journalism and design. Activities include annual newspaper design workshop and exhibition, quick courses, the Best of Newspaper Design Competition, and publications, including the quarterly magazine Design and the monthly newsletter "SND Update."

Graphic Design Regional and National Markets
There is no way to list all of the local associations and publications in each area of the country. You'll need to do some homework of your own. Don't forget about the printing and paper salespeople in your local area. They can give you leads if they can trust you to protect them with their client, and if you can give them a lead, you'll have

more of a chance of them reciprocating.

If you are interested in markets outside your locale, there are many resources available. Preparation is everything. I once heard a housepainter say that 90 percent of his job was preparation and only 10 percent was painting. No matter how successful a design company becomes, attrition will come into play. Say a long-time client, who works at a large company, leaves or retires. The replacement may want to work with a different graphic or Web design company. If your company is not looking for more business, it should be looking for replacement business.

The books listed here are good sources for those wishing to expand their marketplace, and that's what selling is all about. Look for them in bookstores or online.

Artist's & Graphic Designer's Market
Published by: Writer's Digest Books
Web site: *www.writersdigest.com*

This book contains a basic listing of the markets for graphic designers, such as ad agencies; art publishers and distributors; greeting card, gift item, and paper product companies; magazine publishers; record companies; syndicates; and clip-art companies. It also offers marketing tips for negotiating the best deal, successful self-promotion, business nuts and bolts, and much more.

O'Dwyer's Directory of Corporate Communications
Published by: J. R. O'Dwyer Co., Inc.
271 Madison Avenue, #600
New York, NY 10016
Tel: (212) 679-2471
Web site: *www.odwyerpr.com*

This directory features a basic listing of public relations executives at over two thousand companies and three hundred trade associations. It contains a geographic breakdown showing the companies in your

area, as well as the key decision makers. There's a listing of investor-relations officers and employee-communications officers who are the key contacts for annual reports and house organs. There's also a breakdown of companies in industry groups such as pharmaceuticals, transportation, healthcare, and many more.

Advertising Agencies

Advertising agencies often buy outside design services. The smaller the agency, the greater the chances are that they outsource creative work. Ad agencies are brokers, and most of their money comes from buying ad space for their clients. Design is a necessary part of the process, but not the profit center.

As a rule, advertising agencies hate overhead. They aren't keen on committing to heavy capital investment on things like computer systems for design. They know how volatile their business is and that they can lose a major account at any time. They can always lay off people, but not computers. If your company is operating state-of-the-art equipment, this could be a big selling point.

When approaching an ad agency, don't load your portfolio with annual reports, unless that's something they offer their clients. It's very important to tailor your portfolio to your client's needs. Most agencies have an artist on board, but if they are small- to medium-sized, their design capabilities are probably limited to a jack-of-all-trades person. This means they will need a specialist from time to time.

An excellent guide to finding advertising agencies as potential clients is the Standard Directory of Advertising Agencies. This book contains over three thousand ad agencies with addresses and telephone numbers and one thousand foreign agencies. There is a geographic cross-reference by state and city, giving you regional information. The names of senior art directors are included when applicable. The names of art buyers aren't listed, but you will have to call the agency for an appointment, and you can get the correct name and title of that person then. The agencies' clients are listed. This is key to your selection of work to put in your portfolio. Gross billings are given. The size of the agency is indicated by its billings, and this indicates their stability.

Publications

If a publication has its own in-house design staff, they may need illustration or photography, but not design. And some publications are run on a shoestring budget with no money set aside for good design, so beware. However, publications do offer many opportunities for designers. Magazines are what I call "evergreen accounts." They are steady buyers of good design. Trade publications can be very sophisticated, as well as award-winners for design excellence. Quite often, the more technical the information is in one of these publications, the more fun the designer can have at distilling the dry topics. An example of this is *The Industrial Launderer*. This magazine is published for just what the title says, industrial launderers. It has also received more awards than any other publication of its type, and it's even been featured in *Graphis*. For more ideas, check out the following directories.

Bowker's News Media Directory
Publishers, Distributors & Wholesalers of the United States
Published by: R.R. Bowker
630 Central Avenue
New Providence, NJ 07974
Tel: (800) 526-9537
Web site: *www.bowker.com*

Bowker's News Media Directory features a three-volume set with 180,000 decision-makers at 32,000 media centers organized in easy-to-navigate sections. Detailed profiles include 8,000 daily, weekly, trade and specialized newspapers; 130 news services and feature syndicates; and over 7,400 magazines and newsletters. Volumes are separated by media type, and information is presented in a user-friendly format, making research quick and easy. Publishers, Distributors & Wholesalers of the United States contains publishers; museums, association imprints, and trade organizations that publish; software firms; and even a separate index of inactive and out-of-business publishers. You can track them by name, imprints, sub-

sidiaries, division, state, ISBN prefix, and by publisher's field of activity.

Gebbie Press All-In-One Directory
Published by: Gebbie Press
Box 1000
New Paltz, NY 12561
Tel: (845) 255-7560

This guide contains an alphabetical list of names and addresses of consumer and trade publications, but no phone numbers. The above are divided into two hundred well-defined categories. There is a separate list of newspaper-distributed magazines with addresses and circulation figures.

Public Relations Firms
There is a significant amount of work given to design firms by public-relations companies, including annual reports. Public relations companies often share the advertising agencies' fear of too much overhead. Some of the very large firms have a designer or designers on staff, but this is a rarity.

O'Dwyer's Directory of Public Relations Firms
Published by: J. R. O'Dwyer Co., Inc.
271 Madison Avenue, #600
New York, NY 10016
Tel: (212) 679-2471
Web site: *www.odwyerpr.com*

This book contains public relations firms throughout the United States. There is a geographic cross-reference by state and city, giving you regional information. The directory includes a list of over 2,900 firms in the United States and worldwide, and over 18,000 clients

are cross-indexed. This will help you to select a public relations company that will best utilize your firm's strengths. The size of each public-relations firm is listed, indicated by their number of employees.

Other Resources

Here is a listing of organizations for those interested or working with illustration, stock photography, and live photography.

Society of Illustrators (SI)
128 East Sixty-Third Street
New York, NY 10021
Tel: (212) 838-2560
Web site: *www.societyillustrators.org*

The SI was founded in 1901 and is dedicated to the promotion of the art of illustration, past, present, and future. Included in its programs are the Museum of American Illustration; annual juried exhibitions for professionals, college students, and children's books; publications; lectures; archives; and library. SI also sponsors member exhibits in one-person and group formats, as well as government and community service art programs. Membership benefits are social, honorary, and self-promotional, and include Artist, Associate, Friend, and Student.

Society of Photographer and Artist Representatives, Inc. (SPAR)
60 East Forty-Second Street, Suite 1166
New York, NY 10165
Web site: *www.spar.org*

SPAR was formed in 1965 for the purposes of establishing and maintaining high ethical standards in the business conduct of representatives and the creative talent they represent, as well as fostering productive cooperation between talent and client. This organization

runs speakers' panels and seminars with buyers of talent from all fields, works with new reps to orient them on business issues, offers model contracts, publishes a newsletter, and offers free legal advice. Categories for members are regular (agents), associates, and out-of-town.

Success Breeds Success

Failure breeds contempt. No matter how bad things get, you must draw on your past successes. Everyone has a little bad luck. If you hit a streak of lost sales or accounts that don't pan out, only your mind can make this a big or small setback.

Don't take business personally. People are attracted to different design firms for a myriad of reasons. Designers are very sensitive, or they wouldn't have the temperament necessary to be great. You have to be the proverbial cheerleader. If you're down, it will show to your co-workers. Since you're the point-person, this can have a devastating effect.

TURNING A COLD CALL INTO A WARM CALL

*All You Need Is
a Plan*

Cold-calling is the most hated, feared, and emotionally debilitating part of sales. But it's a necessary evil. Many great designers can't cold-call, and yet they'll force themselves to do it. They may overcome their fear or intensify it.

The first step to selling Web or graphic design is to realize that design is not fun and games. It's not the unnecessary embellishment of a printed piece, a homepage, or any other visual vehicle. Once you are convinced of this, you'll be more sure of yourself and what you are selling. Web and graphic design have both earned great respect from the corporate heavyweights. They know the power of effective graphic communications. Why else would they have comprehensive graphic standards manuals to strictly govern the correct use of their corporate graphics both in print and on their Web site? It's not ego. Companies do not throw money around without paybacks. This applies to their identities, as well.

The Preparation

Before your first verbal contact with a prospect, do some research and find out as much as possible about them. If they are a Fortune 500 company, you know they produce an annual report. Get a copy of it and read it. Find out who their competition is and the quality of their communication tools. The more you understand about your prospect, the faster you will become a member of their team. If your prospect is not a large company with an annual report, you can ask

for a brochure, newsletter, or press releases they furnish to the public. Also, try to pick up some samples of the current creative/design work being used.

Find out the name and title of the person you would be pitching to. If possible, try to talk his or her assistant so you can ask the following questions (they will usually open up to you because they are keeping you from bothering their boss):

* What is the correct spelling of the person's name and his or her title? One slip in spelling can mean disaster.

* Is he or she happy with the current designer/firm? They may say yes because the designer is a friend of theirs. But if they say no, you've pressed the right button.

* How are design decisions made? Is it usually through a committee? By now, you may have worn out your welcome. If so, quit here.

Analyze the information you've received. Make an outline of the answers to your questions. That becomes the company story from start to end.

After reviewing everything you can find on your prospect, write a good, coherent letter of introduction. If you were referred to this client, say by whom. But be sure that the person who gave you this lead is in good favor with your prospect. If no one referred you to this potential client, don't allude to a third party. You'll get caught. Just play it straight and use some of the information you've learned about this company as part of the letter. You can say that you feel your company is a perfect fit, but you should qualify that.

Keep the letter short. If this is your first letter to this client, one page should do it. In the first paragraph, give a quick overview of your company or self. In the second paragraph, express an interest in their type of business. In the third paragraph, outline your services that are tailored to your contact. In the last paragraph, let them know how you plan to contact them again. This can be when you will call them.

The Call

Before you make your formal call to the prospect, call the assistant to see if your letter arrived. This is a great place to get the assistant on your side. You can make small talk about family, friends, and even the weather. This will gain you miles not yards in the future. Remember the housepainter earlier? Preparation is 90 percent of the work. Selling is a lot like that.

The Interview

You've made the phone call, and if you're lucky, you've made an appointment with the key person. Make notes as to which pieces or Web sites relate to your prospect's needs and prepare this portfolio carefully. Include pieces that are as close to what your prospect does as possible. If you don't have pertinent samples, use your research to explain how your work parallels their work. Don't take a sample if it has no relationship to your prospect's work. The exception is something like a coffee table book or Web site so special that it is a feather in your cap to have designed it. But be discriminating when choosing whether or not to show this kind of work. Also, realize that you are selling potential design, not what your company has already done. If need be, take fewer but more tantalizing samples.

Your company's portfolio of work is your most current sales tool. Always arrange it for maximum effect. This means put the best work in the front. You should be able to tell when you've made your point and your prospect has seen enough. Don't overstay your welcome. I've seen salespeople ruin an interview by not knowing when it was over. Stop when you're ahead.

Your Office Can Be Your Credibility

If you have attractive offices, invite them over for the interview. This is a great way of reinforcing your credibility, but only if your company's offices are impressive. They can meet the other designers and see the facilities. If you are not the designer, tell them that they can meet with the art director and/or the designer(s) if the meeting is held at the office. A good-looking studio is a plus for a full-service company. Also, most Web studios don't need offices that are show-

places, and clients do not expect it. During the interview, it is help-
ful to ask procedural questions such as:

- **How do you like concepts presented?** How many concepts do
 you normally like to see? If it's for print, ask if they would like to
 see them as PDFs or color hardcopy. You can explain that PDF is
 a great way to view concepts and make minor changes before
 color copies are made. For Web site design, it's best to present the
 concepts and layouts online, in their office. If you are not a
 Webmaster, I'd take a programmer with you in case there's a
 problem. The programmer can contact someone back at your
 shop to possibly fix a problem on the fly.

- **What do you consider to be a normal turnaround?**
 Turnaround and scheduling are important. Most companies are
 used to quick turnarounds. Be prepared with rough schedules of
 work from your firm.

- **Would you consider meeting in our offices if it would save
 money?** If your offices are inviting and in a convenient location
 for your client, you might offer a cost-break for holding meetings
 in your office for initial project consultation and presentation.
 After all, time is money.

- **Do you have someone as a back up in case you get too busy?**
 This is important if it's a large project with a tight deadline.

- **How do you like to be invoiced?** Many companies will agree to
 phase-billing while others only want one invoice when the project
 is complete.

- **Do you have vendors you wish you to use, such as
 commercial printers, exhibit houses, or a Web hosting
 company?** This will give you the opportunity to refer your own
 contacts if they have none.

If your company does not charge a premium for overtime, men-
tion it; you can use this to your advantage. Overtime is a big consid-
eration. Many firms pay straight time for every hour of work. Others

pay comp-time, which is time off for overtime hours, and some companies expect salaried employees to work as long as it takes with no extra compensation.

Show and Tell

If your office presents weekly educational presentations for the staff, say, every Thursday from 10 A.M. to noon, invite a potential client to your offices to attend one. Suggest to your client that the seminar could help his or her staff understand the graphic design or Web site design processes. If your company doesn't offer such presentations, suggest that they develop one. You could even develop a presentation pertinent to the client's needs. It could be a seminar on the stages involved in the design and production of a print project. There are DVDs from manufacturers on the latest hardware and software. You can mix these into your presentation to give it some flash. Another angle is to bring in an expert to be part of the presentation. If it's for print, you could bring in someone who can talk about printing papers. With the Web, it could be an animator.

WINNING PROPOSALS START HERE

The Devil Is in the Details

In the past, buyers could sole-source their work. That meant they could use your company without getting three bids. That's not true any longer. Whether you work for a firm or for yourself, the rules are the same. Bids are the rule, no longer the exception. This chapter will show you how to prepare your ultimate proposal.

You will still need to do your homework, though. The more homework you do, the better your chances. Each proposal is a unique blend of your company's capabilities, your understanding of the project, and the quotation. The price alone does not guarantee a winning proposal. If three prices are close or equal, the proposal's structure and substance comes into play.

The Bid Process: Common Problems and Solutions

It's to your advantage to make the bid process as clear as possible, as it is the most important factor in the success of a Web or a print design project. Many companies simply send out a request for proposal (RFP). Another name for this is a request for quotation (RFQ). You need to read the RFP carefully and quickly so you can ask questions immediately.

First and foremost, the types of firms or individual designers involved in an RFP should be of equal talent and capability. Be it freelancers or large design firms, it is better that they are similar to each other. You wouldn't invite a large printer and a quick-print shop to do the same printing project. The same holds true with

design firms. The expression "apples and oranges" is quite appropriate.

There is another apples-and-oranges factor to be considered. I've found the greatest mistake most clients make when writing RFPs is that the specifications are not clear. They often use a businesslike tone but forget to include key information, or they leave it up to the individual designers to make up specifications on their own. If several design companies are bidding on a project, it is very important that each bids on the same requirements or specifications.

I received a RFP once for a complex project that involved the design and production of a brochure. The client was explicit about the quality expected, the deadline, the number of colors, and the dimensions. But the information on the number of pages was missing. The client was very busy and didn't want to get into a discussion about the project. When I asked about the page count, I was told there would be between twenty and thirty. This told me that I would have to fill in some holes.

Since the specifications told me the project was a saddle-stitched brochure, I knew the number of pages had to be divisible by four. (Four pages equal one sheet bound in a saddle-stitched brochure, as you can see if you pull the staples out of a *Time* magazine.) Also, the most economical way to run this job is in multiples of eight or sixteen. Neither was an option without a discussion with the client. So, to solve the dilemma and make sure I would be covered, I simply gave a per-page price. I don't know what my competition did. I do know the client was going to be even busier later trying to get comparative bids.

Web projects are not immune to such complications and misunderstandings. In one Web design RFP I received, the client referred to a "style guide" that would govern the design of the site. When we asked for a copy of the guide, we were told it was not available! In a world of information, common sense should prevail but often does not.

Forgive Ignorance

Another RFP I received once was for a project that required designing five forty-eight-page booklets with illustrations. The booklets

had to be converted to PDFs for the client's Web site. Five firms were invited to offer full-blown proposals consisting of a technical section with bios and a business section with costs. Three weeks after the proposals were submitted to the client, we received an e-mail that the project had been cancelled due to budget constraints. At first I was angry that the client could be so off-handed and simply kill the project. But I decided to be proactive. I wrote them a letter. First, I thanked them for inviting us to submit a proposal. Then I suggested that next time they want to obtain proposals, they should hire a firm to give them a rough idea of what the project would cost. That way, if there isn't enough money to fund the project, five firms wouldn't have to go through the ordeal of preparing complex proposals.

A week later all five firms received a new RFP for one large booklet, but each firm would have to offer the specifications as to the format, the number of pages, and the number of colors. We were invited to submit questions via e-mail. Every one of the firms asked the same questions: How many pages should we bid on? (The answer was, "Be creative.") What should be included? (The answer was, "It's on the company Web site.") What format should the printed piece be in? (The answer was, "A CD-ROM, a booklet, a magnet on a refrigerator, or something entirely different.") Well, the company's Web site was voluminous. There was no specific section dedicated to this project. I offered loose-leaf binders with sections, based on our first proposal's content. It wasn't hard to adjust the original proposal, reducing the number of pages in the binder and lowering the cost. To make a long story short, we took our best shot. We finally heard from the client after three weeks. It seems the project had been cancelled because the bids were so disparate that the firms weren't bidding on the same project.

A Better Way

The best way to avoid any problems in the bid process is to hold bid conferences. The U.S. government holds formal bid conferences, and they bid out everything. If your client is not holding bid conferences on complex projects, you should suggest that they consider doing so. Let them know that not only will they reap some benefits, but they're actually doing themselves a disservice by not holding

them. You can explain that when all of the design companies or representatives are present at once, they can ask questions and each of them will hear the same answers. If one design company receives an RFP in the mail or in an individual meeting, that design company may have a legitimate question or, even better, a more economical suggestion for producing the job. If the idea has genuine merit and changes the scope of work, the client should notify the other designers individually of the new specifications. The bid conference can be a hotbed of good ideas, if the client lets the participants feel they are shaping the project for the better. This is a fact. I've seen it happen over and over again.

Ideas on Spec

Some companies ask for designs or "ideas" on speculation (free designs with a proposal). In a typical scenario, a client will ask three design firms or individuals to submit a design with a proposal. Sometimes they will offer each firm a fee to come up with a design concept. If the fee is just a token amount, the company will probably get inferior designs. This is a waste of money anyway because if the client picks one of the firms, the client will usually make the firm start the design process all over again.

Ideas on spec are against the Codes of Ethics of the American Institute of Graphic Arts and the Graphic Artists Guild and it is also against the Graphic & Web Design Trade Customs (included in appendix A). This issue is currently under review by the FTC. It has been determined by the United States Justice Department that no one can stop a designer from doing spec work; they feel that this causes the restriction of competition. But I feel the majority of designers in the industry agree that it's unethical to ask for such services. Design firms, unlike advertising agencies, are not counting on millions of dollars in ad revenues to enable them to offer free or speculative work. They bill by the hour for services rendered. Spec work is free work, and it's usually worth what they pay for it.

Fortunately, the majority of clients will evaluate the design firms' portfolios and will be confident that the designers chosen will be able to give them a superior product without speculative designs. Most designers refuse to work on speculation.

The Winning Proposal

Now that you know what pitfalls to avoid, you can proceed to writing your proposal with confidence. The formal way to preface your bid on a project is with a letter introducing yourself and your company. The letter should give a very brief overview of the project from your standpoint. Be sure to describe the level of quality you intend to offer. The letter can be informal or formal, but don't make the mistake of putting some key observations in it and leaving them out of the proposal. Since the letter is usually to an individual, their peers may not see it. If the proposal has to go through a committee, it can become separated from the proposal and will not be a part of the decision process.

A Web or print design proposal can be as simple or as complex as you want it to be. Let's look at the most complex, because, after that, you can decide what you want to omit. There are usually four parts to a bid: Capabilities Statement, Project Overview, Technical Proposal, and Cost Proposal. Each of the four is often said to carry equal weight, but cost is a consideration when the other criteria have been met. Here is a breakdown of the elements of each part of a proposal:

1. Capabilities Statement: This is the area within the proposal to show why your company is the best suited for this project. It can contain a history of your firm, as well as past experience your company has had in managing similar projects. If you are just starting out, provide other relevant information such as your educational background, internships, etc. You could also expand on your understanding of the project.

2. Project Overview: This part explains to the client what you perceive the scope of work to be, as well as what the client will be responsible for providing. Don't just parrot back their specifications. Show some thinking on your part.

 a. Background: This overview is important in showing your understanding of how the company does business. It is your

 interpretation of the history of the project to be designed, if it

has one. The history of a project only applies to work that has been performed before, such as previous annual reports, magazines, newsletters, and Web sites. Also, you can show your understanding of the client's needs by discussing the goals or purpose of the project as you see them.

b. Work Requirement: This is the "meat and potatoes" of the project—a complete description of the project's specifications. Don't just repeat the client's explanation of the work to be done, but rephrase how you understand the requirements.

3. Technical Proposal: The technical proposal is a description of the scope of work from your point of view, as well as your insights as to how the project's production (or programming, for a Web design) process can be improved. You can give some broad-stroke ideas of how you can lend creativity. You can talk about using illustration versus photographs, animation versus flat art, or special printing techniques. This is not a request for verbal descriptions of design solutions or for a free design consultation. It is meant to show the client that the designer isn't going to approach the project with a cookie-cutter or standardized method. They are paying for a custom job, and they will accept no less.

4. Cost Proposal: The cost proposal should contain only the cost of work spelled out in the client's Statement of Work and Requirements in the RPF. You can assign hourly rates for services that may be needed, such as print management, photo art direction, illustration or photograph acquisition, preparation of charts and graphs, copywriting, transcribing text, and anything else that might be part of the scope of work but has not yet been defined. Other unknown out-of-pocket expenses must be excluded.

Author's alterations, unless you know exactly what they will be and can convey this to the client, should not be included in the proposal. Most companies use cost as a parameter, not as a specific criteria, in evaluating the proposal.

Other Elements

Each proposal will be judged in its entirety. The client may not have asked for the following, but you may wish to consider these four elements anyway:

1. Timeline Management. This is the specific timeline for completing the project.

2. Project Staff Profiles. These are the biographies of the staff members who will be assigned to this project.

3. Client List. A list of your clients similar to the company requesting the proposal.

4. Graphic & Web Design Trade Customs. These are the terms your company uses to conduct business. It is very important that they be shown to a prospective client prior to beginning any work. Your company can use any part or all of the customs.

Remember that your proposal must be professional and impressive in both content and design. You won't get a phone call from the client because of unclear prose or a disheveled, amateurish execution. You won't get the project, either. They may think you don't know your job, and this sign of weakness could come back to haunt you later.

It's also important to spell out in the proposal exactly what you would furnish. I once submitted a proposal to design a logo for a company. The project was awarded to us. We then submitted three rounds of concepts that seemed to be going nowhere. I called the president of the company and explained that I would need more money to continue. His statement to me was, "The quote was for the design of a logo, and you haven't designed one yet." You can bet that never happened to me again. I specify exactly how many concepts the client will get for the quote. This has worked for over twenty years.

This may seem like common sense, but very often we don't see the bad client coming. In sales, we usually take the approach that everyone is as honest as we are. And it's probably the only way to stay optimistic.

The Question Never Asked

Let's say the proposal you're working on is a yearly project. Most salespeople are timid when it comes to the crucial question that begs to be asked. The question is, "What did you pay for this job last year?" The client doesn't have to tell you, but very often they will. The meek may inherit the earth, but they probably won't get this project. Sometimes clients will think it's not kosher to give out that information. But there's a rationale that they can't argue with. If they tell what they spent before, there's a good chance the bid or bids will be lower than the previous year.

If the project is new, ask them if they have a budget in mind. They will often include printing with the total budget. If so, you can get a rough printing estimate and subtract that amount.

The Exit (Debriefing)

After a thorough portfolio review with each participating design firm and the submission of a detailed proposal, a client should have enough input to make an intelligent decision. If you don't get the project, don't stop there. Call the client and request a critique of your proposal. Also, don't burn a bridge. Write a letter telling the client that your company is available if things don't work out with your competitor. This will be appreciated, and you may get another chance. Jobs can make enemies out of clients and designers almost as easily as they can make friends.

CLOSING THE DOOR BEHIND YOU

To Walk the Walk and
Talk the Talk.

CHAPTER 6

HOW YOU DO BUSINESS
WITH OTHERS

Follow the Paper Trail

Ever watch *The People's Court* with Judge Wopner? It always
seems that the party with a piece of paper wins. When you
have established a solid paper trail, chances are you'll prevail
in a common-sense dispute. This is as true in business as it is in life.
A contract is always a good idea. It usually applies to one specific
project, and further defines the responsibilities of both parties,
including scope of work, schedule, costs, and terms of payment.
There are many contracts used by design firms. Your own company
may have a standard contract. The contract may be no more than a
letter of agreement between you and the client.

On the Same Page
Graphic design professional organizations have published contracts
and guidelines for writing contracts to protect design companies
from all of the pitfalls that a complicated project can produce. These
guidelines are very helpful and should not be dismissed. They lean
toward protecting you because the client has a distinct advantage
over the design company. It's the golden rule: "He who has the
gold makes the rules." The Graphic Artists Guild has developed its
Code of Ethics, which is meant to define the design company's
responsibilities, as well as the client's. AIGA has a standard contract,
but the problem with it is that it covers so much detail it can scare
off your potential client. I feel this contract is viable for very large
projects, but for the small-to medium-sized projects, the AIGA con-

tract may be overkill. There are many projects that will come in and go out so fast that there is only time for a memo. If you begin a relationship with a client by including the Trade Customs with your initial correspondence and you'll be covered for future projects.

Why Were the Trade Customs Developed?

When you agree on the production of a work with your client or a printer, you may not realize that the simple contract you sign carries a host of terms and conditions. In almost every state, there are laws grouped under a heading generically referred to as the Uniform Commercial Code (UCC). The code is a compilation of laws that address routine commercial transactions, such as the formation of the agreement, the inclusion of terms and conditions, warranties that are made (or more often not made), and many other factors.

The UCC is intended to apply only to the sale of goods, but it is such a comprehensive work that courts tend to use it more widely. While designers may well consider themselves in the service business, designers do in fact deliver a product or "good." As a result, the UCC could well be used (usually at the urging of a disgruntled client) to interpret the simple "contract" signed by the design company and client. One example of the UCC's applicability to a standard contract could be the automatic inclusion of a warranty that the product is fit for the specific and particular purpose the client described to the design company.

While the UCC is not our focus here, it highlights the importance of crafting a clear statement of rights and responsibilities between the design company and the client, and of clearly understanding the industry norm. When there is a dispute, the UCC guides a court in determining the rights and obligations of parties to an agreement. In cases where the parties have previously worked with each other, the court will look to this prior "course of dealing" to help determine what the parties knew and reasonably could have expected out of their relationship.

If there is no track record, the court will look to "the standard usage of trade." In effect, the focus shifts from the particular parties to what others in the industry do and have done in similar situations. It is

the UCC's instruction to "look to the industry" that makes Trade Customs so important.

If an industry develops, harmonizes, and widely disseminates terms and conditions governing the dealings of its participants, it is only reasonable for a court to look to these understandings for guidance in a particular dispute. It was with this understanding that the Trade Customs were drafted. They were developed for the Art Directors Club of Metropolitan Washington and the International Design by Electronics Association. Their goal is to promote harmonious relations through understood and clearly explained terms and conditions. The customs are now part of the Graphic Artists Guild's important papers.

What Do the Trade Customs Mean to Me?

Parties with knowledge of what is expected and obligated, as opposed to what is merely desired and sought, will always be better off; the Trade Customs eliminate the confusion over terms that lie at the heart of so many simple business disputes.

The bigger the bottom line, the more paper you need to cover it.

The Trade Customs define specific areas of responsibility between you and the client that are not spelled out in your contract, also known as a commercial agreement. Without the Trade Customs, designers are sometimes at the mercy of their client's ideas and wishes. They can be used in conjunction with any contract as long as it doesn't contradict that document. Therefore, elements of the Trade Customs that contradict an agreement between you and your client will no longer be enforced. For example, some companies issue purchase orders to designers that contradict certain parts of the Trade Customs. If you do not formally disagree with the client's purchase order, the client can rightfully claim that Trade Custom does not apply. This is another good reason for you to make sure your client has a copy of the Trade Customs as soon as possible. The rule of

thumb is to cover your bottom line. The bigger the bottom line, the more paper you need to cover it.

A reproduction of the Trade Customs can be found on page **75**. Here, let's look at each part of the Trade Customs to see what they mean to you, your company, and your client. Some of these terms have been covered earlier in this book. They should now be read for their part in the overall Trade Customs and for their relationships to one another. These Trade Customs are worded so that they can be easily understood. You should still be sure you know what the words mean.

The bigger the bottom line, the more paper you need to cover it.

1. Estimate: An estimate is a "best guess" as to what it will cost for you to produce a project. Estimates are usually offered when there are still some unknowns, but you need to give some idea of cost for a budget. It is important for you to make it clear that the estimate is not a fixed price, and to clearly spell out what elements are not included in the estimate. Common sense tells us there is no such thing as a "ball-park estimate." The price you give should be carefully thought out to cover the worst-case scenario, but since there usually are some unknowns, an estimate is an educated guess. I've learned that most people treat an estimate as though it's carved in granite. Don't make this same mistake. Estimates are for loose budgeting, and they can vary from reality by the extent of unknown variables. A quotation is just the opposite. Don't get the two mixed up.

2. Quotation: A quotation, or "quote," is a fixed price for producing a project. Generally, a quotation includes costs for all facets of the job. If there is any work not defined in the specifications, you should assign an hourly rate to this work and note it in the quotation as such. If any materials or out-of-pocket expenses such as travel, food, lodging, etc., are not included, these areas should also be clearly stated in the quotation.

Because the cost of labor and materials may change, quotations are subject to acceptance within thirty days. This time frame can be altered if you and the client agree to change it. Quotations do not usually include author's alterations or changes by the client because each company has a different approval process and a different way of organizing its work. Sales tax is not included in a quotation unless you and the client agree to include it.

3. Alterations: Alteration charges apply to changes the client makes after you have produced the work initially agreed upon by both parties. You should make it very clear to the client what constitutes alterations, such as how many layouts will be shown for what amount of money. The client's concept of alterations may differ from yours, so the best course is for you to write a memorandum to the client as to when alterations begin. It can be very dangerous and costly to try to explain these things later.

4. Overtime: On the surface, overtime seems very simple and straightforward. However, there are pitfalls. First, the client should be informed that their change in the previously agreed upon schedule has made overtime necessary. Second, the client should know what your company's overtime rate is, and if at all possible, how much overtime will be needed. On the other hand, if overtime is contemplated from the beginning, the client should let you know if this is part of their production requirements.

Overtime differs from one design company to another. Some feel their hourly rate does not need to increase because they work late hours on many projects anyway. Others feel that the client should pay a premium for schedule changes that cause overtime.

5. Copyright/Ownership: Your work is automatically protected under federal copyright law. Until you agree to transfer copyright ownership (as compared to merely handing over a copy of the work itself), you own all copyrights and decide what compensation you want for the reuse of the work. Designers hold the rights to their work, even if the client beats them to the copyright office and tries to copyright their work for themselves!

If the client issues a purchase order prior to the start of a project claiming it is their policy that all designs produced for their company belong to the company, you will have to relinquish your rights to the work if it did not contest these terms and conditions within the appropriate timeframe. If the client issues a purchase order after the project is completed, you can determine if you wish to comply with these terms. If you decide not to comply, the Trade Customs are on your side.

These principles also apply to designs produced electronically on a computer. Although a design is easy to reuse electronically, or even alter and then reproduce, the design company's rights remain the same. The Trade Customs were edited by the International Design by Electronics Association to include the new computer technology. Now that designers are in the "Electronic Age," there seems to be a whole new set of problems concerning copyright and ownership of artwork. The Trade Customs address these issues with some very basic common sense. Unless there is another agreement between you and your client, your company owns the reproduction rights of its work. Be advised that the area of copyright ownership is a subtle one, yet because of recent changes in the law, it promises to be a controversial area that must be addressed.

6. Experimental Work: Experimental work you do at the client's request is billable. If you develop a design for the client without authorization, the work is not billable unless you and the client agree otherwise. This should not be confused with spec work, which is totally against the Trade Customs and most design codes of ethics. Experimental work is usually exempt from sales tax, as it usually is pure labor. It's best to find out if your state feels this work is taxable.

7. Condition of Copy: If the client has stated that the final copy for a project will be submitted in a certain manner (such as on paper or disk) and you have given a quotation based on this information, you have the right to amend the quotation if the specifications change. Similarly, if the scope of work has increased because the copy has changed in volume, you should amend the quotation.

8. Production Schedules: Common sense dictates that production schedules established between you and the client should not contain any liability factors for either of the parties if the schedule changes because of uncontrollable circumstances, or "acts of God." This can be superceded by a written contract. If, on the other hand, the production schedule is delayed due to the client or their company's review process, the time needed for the design company to complete the project should be increased in direct proportion to the extra time that they have used.

9. Client's Property: You should maintain adequate insurance to cover the client's property while in your possession, unless that property is extraordinarily valuable. If the client's property is unusually valuable, it is their responsibility to notify the design company and to appropriately insure it. Your liability cannot exceed the amount recoverable terms and conditions.

10. Outright Purchase Versus Reproduction Rights: Outright purchase gives your client complete copyright ownership and reuse of your work. If this option is chosen, it should be recorded in writing and worded very carefully, with specific work listed, to avoid later confusion about the extent and amount of work your client purchased. If it's your company's policy that the work can't be altered, it should be clearly stated. This is necessary because of the widespread availability of electronic manipulation. Reproduction rights are for a specific usage, and the files are retained by you.

11. Reuse and Extended Use of Artwork, Disks, Files, or Negatives: Artwork, disks, or negatives should not be reused or adapted for other purposes without compensation or permission from the designer who created the original. Changing the artwork does not diminish the designer's ownership of it. If the client wants to reuse, change, or update the artwork, disk, or negatives, you must authorize all further uses of the work.

12. Mark-ups: All of your out-of-pocket or direct expenses are subject to a mark-up, or handling charge. Expenses subject to mark-

ups include photography, printing, illustration, advertising space, and special supplies/materials purchased for a specific project. Mark-ups are handling fees and should be discussed and agreed upon.

13. Speculation: You should not be asked to perform work on speculation. In a typical scenario, a client will ask three design firms or individuals to submit a design with a proposal. This might seem harmless on the surface, but if this becomes the rule and not the exception, two-thirds of the design companies will be doing free work. The simplest answer is to remember that speculative work is against the Trade Customs. Offering a project overview within a proposal is not considered speculative work. It is more of a sign that the design company understands the project's scope and objectives.

14. Terms: As in any business, you should ask the client for a purchase order prior to starting work. The purchase order should state the agreed-upon price, terms (such as "net thirty days"), and a production schedule.

If the client cannot issue a purchase order, you should send a memorandum or letter of agreement detailing the same information that would be contained in the purchase order. If your letter says, "If any of the information herein contained is incorrect, please notify [your name] in writing, and/or by fax within twenty-four hours," your client does not have to sign the letter. Once again, a paper trail will protect you.

If the client disputes your invoice, Trade Customs states that the dispute should be made in writing and submitted to you within fifteen days after they receive the invoice. It is not uncommon for a client to dispute an invoice when it is ninety days old and everyone's memory is a little foggy. If there is a dispute over part of an invoice, the client should send you the amount that is not in dispute within the terms of your invoice and handle the disputed portion as a separate transaction.

15. Liability: The Trade Customs of Graphic and Web Design say that you are not liable for more than the design and production fees of a project. As in the Typographers Trade Customs, proofreading

72

of text is the client's responsibility. You are only liable for the correction of errors. They should be done free of charge to the client. If you are asked to approve a printer's proof because the client isn't available, you should have the client sign a letter of agreement releasing you from any liability because of an error in proofing.

16. Indemnification: This sounds complicated, but the definition is not as intimidating as the word itself. Your client has the responsibility (as well as the legal obligation) to be sure that you are free and clear of any copyright or trademark problems, including any institute of a trademark search, for all materials furnished to you. Nothing should be produced with the new mark on it until a thorough search has been made. If the client fails to obtain correct usage rights, they, not the design company, are liable. If the client makes false statements or plagiarizes within copy submitted to you, they are responsible for any legal repercussions and accept all liability, not you. This needs to be spelled out for your own safety.

So basically, indemnification simply means that you are protected from liability if you unknowingly create a design that is already in use, copyrighted, or trademarked. The key word is unknowingly. Anyone can accidentally design something that is in use somewhere else (and this does not constitute copyright infringement).

17. Print Management/Press Inspections: If you offer to "press inspect" a project, the client is still responsible for final proofreading and signing off on the proofs with text. You are responsible for signing off on a press proof for color only. The color must be acceptable by industry standards. The printer is responsible for ensuring the remainder of the press run is consistent with the approved press proof.

The client should be allowed to attend a press inspection. They will offer a different perspective of proofing and will be present to participate in the final okay for color.

What If There Is a Dispute?

The Graphic Design and Web Trade Customs are terms and conditions of sales. They state what the design and printing industries

consider common practice. If you or your client's company's policies differ, it is best to get this out, up front.

When the contract and Trade Customs are not enough to settle a dispute, you may want to consider legal counsel. But this can often be expensive and time consuming, so do your best to reconcile your disagreements outside of court. If you have tried your best and still cannot come to an agreement, or you just want some legal advice, I suggest contacting the Volunteer Lawyers for the Arts. The VLA is dedicated to providing free arts-related legal assistance to low-income artists and nonprofit arts organizations in all creative fields. Five hundred plus attorneys in the New York area annually donate their time through VLA to artists and arts organizations unable to afford legal counsel. VLA also provides clinics, seminars, and publications designed to educate artists on legal issues that affect their careers. Other states—California, Florida, Illinois, Massachusetts, and Texas, to name a few—have similar organizations. Visit *www.starvingartistslaw.com* for more information.

Volunteer Lawyers for the Arts (VLA)
1 East Fifty-third Street
New York, NY 10022
Tel: (212) 319-ARTS (2787), ext. 1
Web site: *www.vlany.org*

The Graphic & Web Design Trade Customs can vary from one design firm to another. It is important to include what is important to your company. As I mentioned earlier, these are just terms of conditions for sales, and the client always has the right to issue their own terms. But this must be done up-front, not when the project is completed.

On the following pages are the Graphic & Web Design Trade Customs in their entirety. When reproducing them to send to a new client, you can use your company's typestyles and format. After the initial document has been sent, you can refer to the *Graphic & Web Design Trade Customs* at the bottom of estimates, proposals, and invoices to remind the client that the customs are still in effect.

THE GRAPHIC & WEB DESIGN TRADE CUSTOMS

The Graphic & Web Design Trade Customs (G&WDTC) were developed by Donald H. Sparkman, Jr. and James A. Powers, Esq., for the International Design by Electronics Association, the Graphic Artists Guild and the Art Director's Club of Metropolitan Washington. These customs have been adopted by the electronic graphic design industry and reflect the current laws and practices of professionals in all disciplines of design.

The G&WDTC are those practices that delineate the specific areas of responsibility with regard to a special trade or operation that might not be outlined in a commercial agreement. Where a commercial agreement is silent with regard to one or more practices, the G&WD Trade Customs areas are used to interpret the intent of the parties.

It should be clearly understood that the G&WD Trade Customs protect both parties in a commercial agreement. It is, therefore, the responsibility and obligation of involved parties to understand their content and meaning.

1. Estimate. A preliminary projection of cost which is not intended to be binding. Estimates are based upon prevailing wages, the anticipated hours of work, and cost of materials necessary to produce work in accordance with preliminary copy, style, and specifications. An estimate is not binding upon the designer unless a firm quotation has been issued.

2. Quotation. A quotation is a fixed price for producing a given project. A quotation is firm unless otherwise specified. Quotations are subject to acceptance within thirty days and are based on the cost of labor and materials on the date of the quote. If changes occur in the cost of materials, labor, or other costs prior to acceptance, the right is reserved to change the price quotes. Subsequent projects will be subject to price revision if required. Quotations do not include alterations or applicable sales tax unless otherwise specified.

3. Alterations. Alterations are charges incurred by a client when a change is made to: approved layout, approved manuscript, or approved electronic files produced correctly or any new work not within the original specifications.

4. Overtime. Overtime is work performed by the designer in excess of the work schedule of the project. Overtime may be charged at the designer's prevailing rates for this service.

5. Copyright/Ownership. Creative work such as sketches, illustrations, layouts, designs, icons, logos, etc., produced on paper, computer disks, or any other medium, are protected under the 1976 copyright act. Until the designer transfers ownership rights, creative work remains the property of the designer. There can be no use of the designer's work except upon compensation to be determined by the designer. Purchase orders issued after the completion of creative work, claiming the client's ownership of creative work, are not valid unless agreed upon by both parties.

6. Experimental Work. Experimental or preliminary work performed at the client's request will be charged at current rates and may not be used by the client until the designer has been reimbursed in full for the work performed. All experimental work performed by a designer without authorization of the client is not billable.

7. Condition of Copy. If original copy, disk, or manuscript, furnished by the client to the designer differs from that which has been originally described and consequently quoted, the original quotation shall be amended or a new quotation will be issued.

8. Design and Production Schedules. Production schedules will be established and adhered to by client and designer, provided that neither shall incur any liability or penalty for delays due to state of war, riot, civil disorder, fire, labor trouble, strikes, accidents, energy failure, equipment breakdown, delays of suppliers or carriers, action of government or civil authority, and acts of God or other causes beyond the control of client or designer. Where production schedules are not

adhered to by the client, final delivery date(s) will be subject to renegotiation.

9. Client's Property. The designer will maintain fire, extended coverage, vandalism, malicious mischief and sprinkler leakage insurance covering all property belonging to the client while such property is in designer's possession. The designer's liability for such property shall not exceed the amount recoverable from such insurance. Client's property of extraordinary value shall be specially protected only if the client identifies the property as requiring extraordinary coverage.

10. Outright Purchase vs. Reproduction Rights. These terms should be established at the time of purchase. Outright purchase gives the buyer physical possession of the hard copy or electronic files, while reproduction rights and related copyright interests require the return of the original to the artist. Outright purchase does not give to the buyer commercial or private reproduction rights or any other copyright interests unless so stipulated in the purchase agreement. The matter of first reproduction rights with subsequent reproduction rights subject to additional compensation should be clearly understood at the time of purchase.

11. Reuse and Extended Use of Artwork, Negatives, or Electronic Files. Artwork, negatives, or electronic files purchased for a specific use cannot be reused or adapted for other purposes than originally planned without additional compensation to the artist. If this possibility exists at the time of purchase, it should be so stated and the price adjusted accordingly. If reuse or adaptation occurs after purchase, the buyer should negotiate reasonable additional compensation with the artist. Whenever adaptation requires the services of an artist, and the creator has performed to the buyer's satisfaction, the artist should be given the opportunity to revise his own work.

12. Mark-ups. Any out-of-agency services or goods such as type fonts, commercial printing, photography (electronic live or stock),

etc., or any materials used specifically for the completion of a given project will be billed to the client with an appropriate mark-up. This mark-up is a handling fee only, and unless otherwise agreed, does not include any professional or management fees.

13. Speculation. Designs should not be asked for on speculation by a client. Design contests, except for educational or philanthropic purposes, are also considered speculation and not a trade custom.

14. Terms. By assigning an order either verbally or in writing or by purchase order, the client agrees to the designer's terms of payment and late charges on unpaid balances prescribed. Payment shall be whatever was set forth in quotation or invoice unless otherwise provided in writing. Disputes over invoices must be made by the client in writing within a period of fifteen days after the client's receipt of the invoice in question. Failure to make such claim within the stated period shall constitute acceptance and an admission that the client agrees with the invoice submitted. If only a portion of the invoice is in dispute, it is the client's responsibility to pay the portion not in dispute within the terms of the invoice.

15. Liability. A designer is only liable for the correction of errors made during the design and production processes. The ultimate proofing prior to printing or other media completion is always the client's responsibility unless the designer accepts this responsibility in written agreement. In any instance, the designer cannot be liable for more than the cost of design, production, and the electronic files of a job in dispute.

16. Indemnification. The client shall indemnify and hold harmless the designer from any and all losses, costs, expenses, and damages (including court costs and reasonable attorney fees) on account of any and all manner of claims, demands, actions, and proceedings that may be instituted against the designer on grounds alleging that the said designer unknowingly violated any copyrights or any proprietary right of any person. Any materials such as photographs, photostats, transparencies, drawings, paintings, maps, diagrams, electronic

imagery, etc., furnished by the client to the designer should be free and clear of any copyright or trademark infringements. The designer is indemnified against any liability pursuant to the client's failure to obtain correct usage rights and said materials. Any false statements knowingly or unknowingly given to the designer, by the client, to be used as factual information to promote a product or service shall remain the client's sole responsibility for substantiation. The designer is indemnified from any liability due to the client's negligence.

17. Print Media. If a designer performs a press inspection for a client, the client's responsibility for proofing remains in effect. If the client has signed a printer's blueline, the designer is not responsible for any errors reflected in the approved blueline. If the designer approves color on a press proof or any other color proof, the designer is only responsible for approving color acceptable by industry standards. The printer is responsible for ensuring that the subsequent press run matches the color within acceptable standards of the proof approved by the designer.

18. New Media. If a designer reviews a Web site for a client, the client's responsibility for proofing remains in effect. If the client has approved a site's content, the designer is not responsible for any errors reflected on the approved site. The client's Webmaster is responsible for ensuring that the colors and images remain within the acceptable standards of what has been approved by the designer.

For a *free* copy of the Graphic & Web Design Trade Customs write to:

Art Directors Club of Metropolitan Washington
Graphic & Web Design Trade Customs
1025 Connecticut Avenue, N.W., Suite 1201
Washington, DC 20036

Include $6.00 for shipping and handling

Or email: *donald@sparkmandesign.com*

CHAPTER 7

ETHICAL BUSINESS CONDUCT IN GRAPHIC AND WEB DESIGN

*An Interview
with David Cundy of
Design Trust*

Ethics are simple...yet complex. Most think of ethics in the vein of treating both clients and competitors fairly. Truth is probably the bedrock of ethical behavior. But as in every aspect of life, there are gray areas, and those areas are often exploited because they are gray.

Interview with David Cundy

David Cundy is president of Design Trust, an integrated marketing agency he founded in 1982, and Experegy, a marketing consultancy he founded in 2003. As a longtime technology leader in the design profession, David was a founding board member of the International Design by Electronics Association (IDEA), a worldwide organization dedicated to the advancement of technology in design, and the Northeast Software Association (Nsoft), a forum for software executives dedicated to fostering high technology businesses in the Northeast. David has served on the board of the American Institute of Graphic Arts (AIGA) New York Chapter, and as president of the Type Directors Club. David has taught, lectured, or critiqued design at Pratt Institute, Manhattanville College, and Yale University.

Sparkman: You've seen some dramatic changes in our profession over the last two decades. Are ethical issues different for designers today? What new ethical issues have arisen?

Cundy: Today, designers must address evolving ethical issues, requiring that they have better business heads and better protection than ever. New issues include continually evolving technology, intellectual property ownership, doing business overseas, and a changing ethical landscape—all of which we'll discuss. But at their core, ethical issues remain fundamentally the same as always. And the proven benefits of ethical business conduct, including repeat business, referrals to desirable clients, attracting and retaining talent, and maintaining personal reputation, make ethical business conduct good business.

Sparkman: So what are "ethics" as they apply to the practice of design?

Cundy: A brilliant designer once told me that ethics are a luxury for good times. I've also heard that ethics are what your competitors and clients haven't got. And while both perspectives are revealing, the fact is that ethics are critical to the orderly conduct of business and society in general, and have been the claimed differentiator of Western business. What are ethics as they apply to the practice of design? Ethics are a systematically applied set of rules of business conduct under which professionals—both designers and clients—operate. These are a) be honest and proactive in disclosure, b) play fair and do what you say you will, and c) charge what you say you will, or pay for services received as agreed, in a timely manner. Because of their legal underpinnings, ethical rules must be documented in order to be enforceable.

Sparkman: What documentation is required?

Cundy: Documentation includes proposals, contracts, written communications—such as e-mails, letters, reports, and change orders—and documentation of oral communications through phone logs and meeting notes. Proposals, for example, that clearly document objectives, audience, scope, services, deliverables, timetables, costs, and terms create the foundation for successful business relationships. Let me just say that none of these matter if good faith isn't present.

Sparkman: What is good faith?

Cundy: Shocking as it may sound, I once heard that a seasoned businessman described contracts as "made to be broken." That's not good faith, part of which is the ethical intention of a party to honor the terms of a contract, even when it isn't to that party's advantage. In order to have an ethical society, leaders must set an example—in government, corporations, consulting, and business schools. Lately, despite high-profile trials and government regulation, we have seen poor examples set in all of the above sectors. As I look ahead, I don't like where this trend seems to be leading.

Globalization has also created new ethical issues. If you work internationally, you have to deal with vastly different cultural ethical norms, some "unethical" by our historical standards. Examples include cultures where contracts are endlessly renegotiated, even after signing; where the provision of creative services in advance of hiring (speculative, or "spec" work) are expected; where marginal rates are condoned; where payment is considered optional; where kickbacks are required; and where mutual bad faith is expected, to name a few.

Sparkman: Is good faith enforceable?

Cundy: Actually, it can be—or at least it can be fostered. Any credible corporation today has established BCGs [business conduct guidelines], some of which are even published online. These are guidelines for employees and suppliers codifying required ethical behavior. We recommend following the signing of a contract with a "new client kit" containing your design firm principal's thank-you-for-your-business note and a copy of your firm's BCGs. Follow that with a phone request for the client's BCGs, and you may even be providing valuable internal policy education.

Sparkman: You mentioned spec work. Isn't spec work expected today?

Cundy: Hardly. Government anti-trust regulation supposedly established to thwart anti-competitive and price-fixing behaviors among oligopolies legalizes the provision of free services and spec work

under the assumption that firms won't be able to provide such services for long, and that Adam Smith's "Invisible Hand" of market forces will sort things out. It hasn't, and the entire design profession continues to suffer under this actually anti-competitive practice. Spec is shameful. The message you send to clients, employees, and the world at large when you do spec work is that you place zero value on your services. At least obtain an honorarium to avoid having your valuable ideas stolen outright.

Sparkman: Should designers expect clients to be ethical?

Cundy: Of course. Client-side ethics are equally important. These run the gamut from disclosure, fairness in procurement, and accountability to honoring commitments and making timely payments. I will say this: Bad behavior reinforces itself, and an unethical client only becomes more so over time, and is thus emboldened to abuse others when you inevitably resign or are fired.

In 'fairness, client-side ethical issues often arise from designers' ethical shortcomings. If you explicitly tell a client what you'll do in your proposal, if you write a contract that specifies terms, if you communicate about issues in a timely manner, and if your invoices match expectations, you'll have very few client issues.

Sparkman: Could you amplify upon contracts?

Cundy: Proposals and contracts, often the same, are the foundation of ethical enforcement. Beware of clients who won't sign contracts! No matter how unscrupulous a client, a contract bearing her or his signature will make her or him at least think twice about breach, especially if she or he is an employee. Please understand that many people are ethical and want to do the right thing. Clients are expected by their managers to have documented the exact services you will provide. A contract makes it easier for all parties to collaborate in harmony and understanding. In my experience, most client-side problems arise from items not covered in contracts. Realistically, the best a designer can do is to cover expected issues.

Sparkman: Where can a designer find a good contract?

Cundy: Since I prefer a level playing field, I would prefer to use an industry-standard contract. None has been universally adopted to date, although two models exist. Both the AIGA [American Institute of Graphic Arts] and GAG [Graphic Artists Guild] have standards around ethical and contract issues. AIGA has both a contract and a Code of Ethics, and GAG has its Graphic Artists Guild Handbook: Pricing & Ethical Guidelines, which includes contracts. My firm uses neither contract because we like our own straightforward, plain-English version, developed over many years' experience. We continue to modify it to reflect evolving business considerations, and to incorporate terms and conditions that we identify the need for. On the other hand, the huge disadvantage of a discrete contract is that it doesn't carry the weight of an industry standard.

Sparkman: How should a designer ethically structure fees?

Cundy: Historically, there have been a number of bases for fees: Fixed cost, value—a variant on fixed cost—time and expense, and retainer.

The fixed-cost fee basis, wherein a designer agrees to provide services for a fixed cost, is never recommended unless the agreement stipulates fixed scope and certain end date (what our contracts call "timeframe certain"), as well. Otherwise you may never be paid for a project that is never completed, and grossly underpaid for a project whose scope multiplies.

The time-and-expense fee basis, the historical norm in professional services, is theoretically most fair in that you charge for your time. In fact, it has many drawbacks, including work you do that has value far in excess of its "timesheet" value, such as conceptualization or consulting. Also, if you really bill on a time-and-expense basis, you will need to use a timesheet system, engage in aggressive time management, report costs and overruns to clients, and actually bill your time. And expect the client to reserve the right to review your timesheets.

Retainer billing, whereby you receive a fixed amount for defined services on a monthly basis for the duration of the contract, is a

mutually beneficial model in that it ensures cash flow and implies a discount. However, retainer billing requires that you specify your billing basis, typically time and expense and costs below retainer must be forfeited by the client, credited, or refunded.

The above scenarios point to the value-billing model, in which the assumed market value of services is the basis for fees. Coupled with a retainer, scope, and timeframe stipulations, you get paid fair value for the services you provide. Note that the value-billing model is highly risky in competitive business development in which the low bid may be zero.

The problem with the above models is that sometimes time-and-expense billing is the best model, and sometimes value billing is best. Unless you specify "the greater of value or time" in your contracts, which clients will notice, you can't have it both ways without moving into ethically inconsistent territory.

In your contracts, it's vitally important that you clearly state that your client is paying for your services, not deliverables. If you don't, you'll never be paid for work put on hold because the client will correctly claim that you haven't "delivered" the final, approved "product."

Sparkman: Are payment terms important?

Cundy: Payment terms, the dates and conditions under which the client agrees to pay you, are the financial foundation that will keep your firm solvent, maintain credit with your bankers, and enable you to pay your employees and subcontractors, so they're very important indeed. In your contract, establish terms consistent with those of your client's organization.

To ensure timely payments, specify non-refundable initial payments upon execution [signing], with balances due exactly on dates certain [legalese for specific dates], such as "final delivery" and "end date," or whichever date comes first. And after these dates, additional fees commence.

Note that no matter when you issue your invoices, clients rarely pay in under thirty days, so if you send an invoice upon completion, you'll typically be paid sixty days later at the earliest. To facilitate timely payments, invoice early and often.

Sparkman: How do you recommend dealing with late-paying clients?

Cundy: Timely payment is critical not only for the financial health of your business, but as a negotiating tool, so it's absolutely critical to punish delinquency. Assess the situation and demand to receive a late fee for overdue accounts. When it comes to payment, remember: If you respect yourself, you'll be treated with respect. Remember also—and this is key—that the definition of a client is someone who pays you in a timely manner for the services you provide, not someone you for whom you create deliverables for possible later payment.

Strangely, some clients don't seem to care if you go out of business, and if you keep providing cash "float" for them, you will. I've heard that lists of slow-pay or no-pay clients have been published to discourage designers from doing business with documented deadbeats. Further, I recommend that you report delinquents to Dun & Bradstreet (D&B), the business credit agency, when you've exhausted the collection process. Be aware: The transaction in question and your firm's name will become available to the client if they ask D&B. Believe me, most of them don't want the blemish. In the meantime, if the client disputes an invoice, stop work until the dispute is resolved through a reading of the contract.

To neutralize invoice "losers"—those who disregard invoices and question them after ninety days and after stonewalling repeated demands for payment—always e-mail them a PDF of the invoice and copy the accounts payable department on that e-mail, requiring confirmation of receipt from both. To eliminate "late debates," stipulate in your contracts that requests for clarification or disputes must be submitted in writing within fifteen days of invoice date or they will not be considered valid. To de-fang legal intimidation, specify arbitration as the required method of dispute resolution.

Sparkman: Have there been new developments in intellectual property?

Cundy: Yes, and to the designer's benefit. Today, designers' products are provided in Adobe Acrobat PDF, EPS, GIF, JPG, TIFF, and other files from programs such as Quark Xpress, Adobe InDesign, Adobe PhotoShop, Macromedia Flash, etc. The Web

work products are coded files and media. Working files and source codes are yours and should never be relinquished without agreement and payment. If you wish to permit such transactions, stipulate buy-out terms in your contracts. This is standard throughout the professional services and software industries. Web code is much more difficult to protect, and unless you are constructing your sites from databases with back-end functionality (such as e-commerce), clients can simply download your code. To protect yourself, embed copyright notice in your code, if for no other reason than to make a client think twice before appropriating.

Sparkman: How else have ethics been affected by technology?

Cundy: With the advent of the Internet and e-mail, technology has had a big impact on ethical compliance. On the positive side, e-mail enables written authorization and electronic signatures. Also on the positive side for ethical designers and clients, e-mail has made it much easier for both parties to remember what they've said. When doing business with clients who use the phone and verbal communications [meetings] for material communications, keep written, time-stamped paper or electronic phone logs and meeting notes, and send confirmatory e-mails. That way, you'll accurately document what you've heard and said, and avoid later disagreement.

Sparkman: Are there other areas in which ethics figure in the business of design?

Cundy: Yes, primarily in employee and subcontractor relations. It is critical that you engage in ethical dealings with your employees and subcontractors. For employees, ethical behavior is supported by employment agreements, defined roles and responsibilities, policies, performance evaluations, and fairness. While you must treat your employees ethically, you also have a right to require ethical behavior from them: unethical employees can become legal liabilities.

Ethical behavior with subcontractors is also a baseline defensive strategy. Like clients, employees, and alumni, these subcontractors become "experts" on your ethics and thus reputation, to which, in the end, ethics boils down.

Sparkman: So, you're saying that ethical business conduct is a "brand" concept?

Cundy: Precisely. As a designer, your reputation is a major part of your personal and business brand, especially in today's commodity-based world. If you conduct your business ethically and demand the same from those with whom you work, you will be doing everyone a favor, and be worthy of admiration. You'll also sleep better at night.

CHAPTER 8

SELLING BRAND DESIGN
FIRST

*Are They Dressed
for a Kill*

To sell Web or graphic design, you must be selling design, and design starts with a common denominator, the client's identity. We've talked about designing on a strong foundation, and whether it's the homepage or a brochure, the brand is the cornerstone.

An audit is the only way to analyze the effectiveness of your client's brand. The audit needs to be unbiased, highly objective, and an examination of function as well as form.

The Logo Is the Foundation

Branding must start with the logo (sometimes also called a "mark") as it is used every day. It is how the company is identified in the marketplace. Some logos are symbols only, such as the CBS eye. Others are simply the name of the company (or its acronym, such as IBM); these use a specific, customized typeface. And still others use both symbols and letters. Any type of logo can be successful as long as it is used consistently and effectively, which will distinguish your client from its competition.

If your client's logo is weak, there is nopoint in adding new color or using a different typeface. The foundation is weak, and your client will be throwing good money at a bad design. If your client's logo is marginal and he or she is not sure whether it is good enough, then I would say, there's your answer. If you have to ask, it isn't good enough. You should move on to the next step—redesign.

If your client is on the fence about redesigning, try this experi-

ment. Make copies of your client's logo and its competitions' logos so they are all about the same size. Spread them out on a wall or large table and step back. Your client's should jump out of the pack. If it doesn't, it needs a complete facelift.

Oh, your client doesn't have any competition? It's a unique service or product, or even a nonprofit or government agency? Well, instead of a competitors' branding, let's look at who your client feels they are in the same league with. In other words, get a handle on what is going on in similar arenas or with companies your client would like to emulate. If it recedes into the group, your client will know it's in trouble. You can skip the audit because it's time to start fresh. But hang on to this chapter, because in a couple of years they'll need an audit.

If your client still can't decide whether it's time to retire their old logo, remind them about the fact that many companies take their branding to the next level without throwing out the foundation. Betty Crocker has a new look every couple of years. MCI has changed the orange stripe running across its initials. AT&T, after its divestiture, went effortlessly away from its bell in a circle to its abstract of the globe. Federal Express became FedEx, and since that change, has redesigned its planes and trucks yet again—and I'll bet you never noticed.

If you are not sure of what your client's branding effectiveness is, then the audit is the place to start.

The Audit

An audit is an appraisal of value. Your client's company identity is only as strong as its weakest link. In other words, if the public sees one badly designed piece from your client, the branding effectiveness is rated at that level. Doing an audit of your client's brand will help you develop a strong branding program for them. Rather than a quick look at your client's existing logo, stationery, brochures, and other collateral material, the audit is an in-depth look at who they are, where they've been, and, most importantly, where they're going. You need to make your client look as professional as you can. Perception is as important as fact, and your client needs to be perceived as a top player in your field. You can do this by including your client in the audit.

Let's see where your client has been and where it's going. Go through the following questions with your client:

- **Is the logo strong when used only in black and white? A logo has to be versatile.** If your client has a corporate color, such as blue, its logo is probably reproduced in blue on most collateral materials. But there will always be times when their logo has to be used in black and white. The yellow pages, newspaper ads, fax cover sheets, forms, etc., require a black-and-white logo. And these will test the printability of your client's logo.

 If it requires a screen of black to convey a color-break, your client is in trouble. They will have little or no control over the screen values at an unfamiliar printer. If your client's logo needs screens, you can often adapt it to solids with some simple changes. For instance, you can make part of it a solid and the other part an outline. (If you are unfamiliar with these printing terms and processes, flip to chapter 14 and the glossary for more information.)

- **Is the logo a "functional" shape?** Is it a circle, triangle, or square? The reason for the circle, triangle, or square is to make the mark fit better in any layout. When the shape of the logo is extreme, it will take up more space and will force any page or ad design to work around the logo, instead of vice versa. This is not a reason to kill your client's present logo, but you should be aware of its layout restrictions. If you are redesigning their mark, this is the time to make sure you don't make this mistake.

 The AT&T globe, the Lucent Technologies circle, the MCI initials, the BMW and Mercedes circles, and the CBS eye, for example, all fit comfortably into any spot on any page. FedEx, Xerox, Ford, and Sprint are compact rectangles that can be used in many different layouts. One of the best reasons for a compact shape (other than the obvious) is vehicle signage. A long logo type is immediately restricted to a size on the side of a vehicle that will accommodate it. If your client's company needs this type of signage, you need to be aware of this factor. Crowded logos will damage the visual effect of the best designs. If it is a compact shape, make sure the logo or signature is flexible and can be

placed to the side or under the symbol.

- **Does the logo use a contemporary or classical typeface? Typefaces go in and out of style.** Your client may not be aware of these trends, but they are there and you can explain that they work on the subconscious. You can explain that when a brand has an old look to it, it's usually because the typeface or lettering used in or around it is out of style. If your client isn't sure about theirs, you can show them what's old and what's new. This is often easy and painless to remedy. IBM, Xerox, FedEx and other companies have gone through some rather radical type changes without the public becoming conscious of it.

- **Is the brand identity timeless?** A trendy brand identity should be used for a trendy service or product. Some foods, beverages, clothes, and most rock groups can benefit from a "trendy" new look. Most businesses won't. First, most companies want to look established the day they open their doors. Second, they want to look timeless like other savvy players in the field. Third, they don't want to reprint or repaint everything they own when a trend dies.

- **Are the colors contemporary?** You can explain that colors are very important. Look at flags and the passion the colors stir in most everyone on the planet. Corporate colors are part of a company's personality. Many corporations have adopted blue because it is a soothing, non-threatening, and very acceptable corporate color. It is also a color that has not been fully explored. The IBM, AT&T, and Xerox blues are so similar that you probably can't believe they are truly different and protected by zealous corporate communications specialists within each company. Many different blues have not been used and might be a way for your client's company to rise above the pack.

Corporate colors aren't just the colors used in your client's logo. You should develop a palette of ten to twenty colors to complement your client's logo color. This is only important if you design

collateral materials that need to relate to each other. And they should be reexamined every year to make sure they are still in vogue. Remember "harvest gold" and "avocado green" from the 1970s? You wouldn't want them in your palette today.

- **Are there graphics standards to go with the logo?** Graphics standards evoke fear in many. They feel standards will be expensive, restrictive, and cumbersome. This is false, and you should reiterate this. You can explain that graphics standards should be a succinct series of instructions on the proper usage of the company's logo, colors, etc. Without guidelines, individuals will use their own design skills (or lack of) to produce official collateral materials. This is especially true in large companies. It can turn into design anarchy and leave a company with either no personality, or what is worse, a look of disarray.

- **Is there an uncomplimentary nickname for the logo?** NASA called theirs "The Meatball," and I once worked with a major trade association that called their logo "The Radiator" because its initials in its logo looked like tubing. These uncomplimentary nicknames suggest that there isn't much respect for the logo's graphic integrity. Nike, on the other hand, has its "swoosh," which is descriptive and respected.

NIKE has its "swoosh" and OSHA has its "swirl."

When I designed the branding for the Occupational Health and Safety Administration (OSHA), the new mark had a graphic that made up the "O" (see below). While in a meeting with the director of public affairs and her staff, someone described the "O" as "the eyeball." I decided to nip this in the bud; in the graphics standards manual, I referred to it as the OSHA "swirl." The name stuck, and I was able to avert the establishment of a nickname that would last indefinitely.

Is anyone on an executive level in charge of branding? A high-ranking, experienced executive should be placed in charge of branding...no exceptions! Branding is much like a freight train. It takes a lot to start it moving, and it moves very slowly at first. As it gains momentum, it gains effectiveness through client or customer awareness. If its effectiveness is diluted through a lack of maintenance and people using it incorrectly, it will take a lot to get it back on track and up to speed again, like the train. Your client will understand this using that analogy. After all, it's their money, isn't it? And money talks.

Another example you could offer is how FedEx changed its name from Federal Express. They cashed in the acronym already in use and saved a substantial amount of money by changing the color of their planes. For the original Federal Express brand, the whole plane was painted purple. But under FedEx, they painted the planes white, which weighed less than the purple paint. They saved weight, and thus fuel.

Let's Evaluate the Audit

If your client answered no to at least three of these questions, you need to reexamine the branding system. Branding has always been important to savvy companies, but only in the past decade has the word taken on a life of its own. With the communications revolution through print and new media, the graphic look has risen to the top of the corporate agenda. Before, middle management was in control of the company's look. Collateral materials, other than the annual report, were seldom reviewed by the CEO and the board of directors.

With the advent of the Internet, top management has had to look first at its competition and then at its own graphic integrity. In some cases, it wasn't a pretty sight. Publications going outside of the company were often created in-house without any thought to professional design. In many cases, the original logo had been bastardized so many times that it looked as though the company had multiple identities, and none of them were any good. Many executives, for the first time, saw design as a necessity, not a decoration.

Branding through Design

A vice chairman of Chrysler Corporation once likened the appreciation of design in business to the old-school theory that anything

artistic was not quantifiable to many executives, and thus it was irrelevant to sales. Unfortunately, this mentality still exists in some boardrooms, but those companies are the exception to the rule when it comes to the major players in corporate America. Ask the leaders of Coca-Cola, FedEx, Nike, IBM, American Express, ExxonMobil, and the many other successful companies if they believe in branding through design; they would laugh at the no-brainer question.

Is Your Client His or Her Own Brand?

Many companies have an elaborate set of standards to safeguard their brand and corporate image. Even before Mobil Oil Company merged with Exxon, it had always been conscious of the impact its brand had on the consumer. The letterforms in the name Mobil were turned into a complete alphabet so that any product of the parent company would have the parent company's identity. They were so successful that for years the Mobil design standards were some of the tightest in the world.

With other companies, a personality is the brand. In many cases, the personality is larger than the trademark. People make strong connections between a brand name and a representative that they recognize from ads. Jimmy Dean is the sausage king. Dave Thomas, who named his restaurant chain after his daughter, personally appeared in most Wendy's commercials. The personality doesn't need to be the owner of the company; it can be a spokesperson, such as Charlton Heston representing the National Rifle Association. Catherine Zeta-Jones and James Earl Jones have spent years as the ubiquitous spokespeople as for T-Mobile and Verizon, respectively. And some are fictitious characters, like Tony the Tiger.

There are also companies whose brands are represented by the product. Tide laundry detergent has its box. Coca-Cola has the shape of its bottle. Porsche, although it uses a shield for its actual logo, its identified best by the shape of the car, nicknamed "the bathtub." Companies like Apple, IBM, and Sony all rely on their trademarked identity because there is no one product that defines each of them.

This should get you thinking about your company's identity as well. Should it be more than a mark? The possibilities are endless, so don't just settle on the obvious.

EVERYTHING YOU NEED TO KNOW ABOUT TRADEMARKS, LEGALLY SPEAKING

An Interview with Intellectual Property Attorney
Barry Miller

For this chapter, I interviewed Barry Miller, Esq., of Shulman, Rogers, Gandal, Pordy & Ecker, a leading law firm in the Washington, D.C. metropolitan area. Barry has over thirteen years of experience working with small firms as well as Fortune 500 companies. Barry is working with clients facing traditional copyright and trademark issues as well as new ones brought on by the Internet. Here, he answers questions that are universal to those involved in branding. These answers will be part of your support system for your client to protect his or her brand.

In selling design, protecting your client's brand is now more important than ever before. Savvy companies know that designers are honest and can't afford to get a reputation as knock-off artists. They take their work seriously and pour a lot of energy into developing a mark that is right for the client and their business. In selling brand design, you are the expert. You better have answers that will add value to your services.

If you are a trademark specialist, this section may contain information you already know. If not, the new information will help you make more informed decisions.

What Are Trademarks?
Branding has always been important and trademarks protect brands. Man has used graphic symbols since the beginning of civilization. Egyptians used symbols for their gods and pharaohs. Other symbols

followed, like the Jewish Star of David and the Christian cross and fish. In the Middle Ages, families identified themselves through heraldry. The maker of Porsche automobiles still uses a shield as its logo.

In the old West, the star signified law and order. Symbols like pawnshop balls, striped barber poles, and cigar store Indians were all used to identify their respective businesses. Eventually, pamphlets, magazines, and newspapers became the way of communicating news, which quickly hastened the development of print advertising.

The names of businesses often became beautiful calligraphic works of art. Initials functioned as monograms for companies as well as families. The industrial world was edging its way into the era of the trademark. People were beginning to understand the true power of branding.

What Are the Designer's Responsibilities?

Designers are usually charging for their design time as well as the value of the logo. They cannot guarantee that someone hasn't created the same mark for another company, only that they are not aware of it. The words "cease and desist" will send shivers down your client's spine because it means the brand is already taken and cannot be used. If you are in charge of developing the new company identity for a client, this can be embarrassing, to say the least. We have a responsibility to get it right for our clients.

That being said, it is the client's responsibility to perform a trademark search and the subsequent registration. A trademark search is when your clients (or their attorney) search for any potential conflicting names or logos and clear the mark for usage. Barry urges designers to be very clear on the issue of responsibility: "Indemnification offers protection, but you will need to reach that agreement prior to creation of the work." So I asked Barry about a particular scenario: If a graphic design firm designs a logo for a client and has no idea if there is another logo similar to it, is the design firm liable for damages if another company sues their client? He said that, in general, if there's been an infringement, only the client can be held liable. They can be required to pay damages and an injunction can be issued. But in some circumstances, the designer can also be held liable.

Trademark Searches and Registration

According to Barry, registering a trademark is the easy part. It's getting to the point where you are prepared to register a mark that gets tricky. Once you have designed a logo for your client, the first step is to search the database of the U.S. Patent and Trademark Office (USPTO). The database is available to everyone, and the search can be performed at the Patent and Trademark Office, in a library, or even on the Internet. The search is to see if any other brand already registered could pose a threat to the one we wish to register. There are companies that specialize in performing searches for law firms and companies developing products.

Since there are is no guarantee that a mark is free and clear to be registered, each mark is examined on an individual basis by the state. The search process is similar on a national level. As Barry says:

> It's the selection and adoption that is so important. You need to select a name that you can prevent others from using and be sure that it's not already in use by someone who can ultimately prevent your use. An early trademark search and application for registration is important because later, the expense to fight a lawsuit and to start all over far outweighs the cost of the search and registration. There are plenty of businesses willing to risk not searching a mark in order to save some money, but it's the classic issue of "pay me now or possibly pay a lot more later."

If your design team has a great idea, but you don't want to develop it too far before knowing whether it is cleared for registration, Barry suggests doing a "knockout search." He says, "If, for example, you want to register the name 'Pacesetter' and you find it online, there may be no reason to submit the name to an attorney for a full search." Anyone can search the Patent and Trademark Office's online database at *www.uspto.gov*. Simply click on the "Trademarks" link in the menu on the left-hand-side of the site, which takes you to the trademarks home page. There you'll find many informative links and resources, including a link to the Trademark Electronic Search System (TESS).

So you've done a knockout search. You've decided to go ahead with your idea and have developed the brand identity for your client, including logo, typefaces, etc. Your client's next move is to do an extensive, professional trademark search. Unless you or your client has experience in the intellectual property arena, Barry recommends not doing the official trademark search alone. An intellectual property professional is a must:

> If, for example, someone chooses a name for a brand that has family or sentimental meaning, they may not be objective in their analysis of search results.
>
> On the other hand, during a search, a layperson may come upon a mark that is similar to their chosen design, like a star in a circle, and think that they can't use it. They may not understand that if the mark they've found is the star Texaco uses for petroleum products and they make tennis shoes, there may not be any

If your client is unfamiliar with the process of trademark searches and registration, the first question may be, so what is all this going to cost me? Barry explains:

> The search and review by an attorney usually runs about $600. The application by the attorney, including the government fee, would cost another $600. The follow-up work by the attorney is usually done on an hourly basis and if everything runs fairly smoothly (with a few minor glitches), you will probably spend another $500. If everything is smooth as glass, the total could be as low as $1,200.
>
> Compare this to when an opposition to your mark is filed: the matter becomes a civil suit and can get expensive. Costs for oppositions that don't settle early are usually in the $30,000 range but can climb up very fast, occasionally running upwards of $100,000.

Happily, your brand identity has been cleared for registration. Here Barry outlines the steps to registering a brand:

Selection or adoption of a brand name usually comes first. If it appears to be available, the business should prepare and submit a trademark application to the U.S. Patent and Trademark Office. Six to eight months later, the business should receive the first office action. This is the PTO's initial response regarding registerability.

It's a rare event that you don't receive an office action. [Common requests in this document include] asking you to reclassify the description of the goods or services your mark represents or refusing registration because the PTO feels the mark is similar to an existing mark. Referring again to the star example, you may then need to send arguments back stating why your mark is different not likely to be confused with the Texaco star.

You can often overcome this initial refusal. Attorneys at the U.S. Patent and Trademark Office (PTO) are very aggressive with initial responses, but can be convinced of a mark's registerability. Unfortunately, the most experienced examining attorneys at the PTO are snatched up by private law firms when they gain significant experience.

If things go smoothly and you're able to overcome an office action, four to five months later, the mark will be published for opposition in the U.S. Patent and Trademark Office's Official Gazette. Publication gives interested parties the right to oppose registration if they feel their mark would be damaged by the new mark. If someone does oppose, they have thirty days to file an opposition or to get an extension. If no opposition is filed, you will receive a certificate of registration from the U.S. Patent and Trademark Office. The entire process takes fourteen to eighteen months if everything runs smoothly and much longer in some instances.

Registration is valid for ten years. After the fifth anniversary, you have to file a document with the U.S. Patent and Trademark Office stating that the mark is still in use in order to take advantage of the four remaining years of the ten-year term. The mark is renewable after ten

years and every subsequent ten-year period if it is still in use.

Trademarks can be registered on a state or federal level. The state level registrations are geographically limited to the state's boundaries. In order to qualify for federal registration, your client needs to do business across state lines. During our interview, I told Barry about the time in the late 1980s when I was designing packaging for sports accessories, such as socks, wristbands, and headbands, as well as products like tennis balls. My client would take a prototype and send it to an associate in another state who would purchase the item, thus creating an interstate sale. But was that a legitimate procedure and proof of a legitimate interstate sale? Barry explains: "You really need to use the mark in commerce between states or other commerce that is regulated by Congress. The initial shipments you described, which are generally referred to as 'sham' transactions, could put your trademark application at risk. Should some party contest your ownership of registration, and reveal how you came up with your claim of priority—that it was not a bona fide first use— your registration could be invalidated. A bona fide first shipment is something more than sending a prototype for the purpose of establishing first use. However, a first shipment that is a precursor to full-scale sales, if sent as part of a bona fide sale, might suffice." In other words, you should, as always, consult the expertise of an intellectual property professional.

We are all familiar with the ® (a registered mark), TM (a trademark) and SM (a service mark) symbols. But what do they mean and what protection do they offer? Barry explains:

> The TM and SM symbols signify that you are claiming common-law trademark rights. This will not give you priority over a prior user, though, so you might still be asked to "cease and desist." Using these notations does give an infringer notice that you are claiming trademark rights and can enhance the damages you can recover. If there is a dispute, the infringer will not be able to claim that he did not know that the term was a trademark.
>
> If a third party has priority by virtue of their prior

usage, they have common-law rights. If you later receive registration for the same mark, the third party can challenge you and force the cancellation of your registration at any time within the first five years of your registration.

After the fifth year, if you have filed the appropriate form—a Declaration of Continued Use—the mark will become incontestable unless the third party can prove fraud or that the mark has become generic.

The ® symbol indicates to consumers and competitors that the company has registered its mark with the USPTO. A company might be tempted to use the ® symbol even though its mark has not been registered. "There used to be a severe sanction, but not anymore," says Barry. "Now there's a policy that if the PTO sees the registration mark with your proposed trademark submission, it will tell you to stop. That's about all it'll do. The trademark office has jurisdiction over registration only." That does not mean, however, that using the ® symbol without proper registration does not have repercussions: "If I want to make sure no one uses a mark that I have selected but not registered and I use the R in a circle to discourage others from using it, a competitor might sue me for an unfair trade practice."

Infringement Basics

There are different ways trademark infringement can occur. Since much of it is by accident, attorneys offer the best form of protection before a mark has to be disbanded because it threatened another brand. We designers need to be aware of the basics so that if we do create a mark that threatens another existing trademark, it's perceived as totally unintentional.

Infringements may be dealt with in a different way than on a national level and in some cases, better. However, some states have their own anti-dilution protection, so a mark may receive more protection on the state level than it would on a national level. Since dilution is generally seen as an infringement on a "famous" mark, the state may not need to recognize the infringed mark as famous to

be protected. Again, it is best to consult a trademark attorney about such matters.

If a company or individual attempts to market a product or service by using a name that is a parody of an existing name, this is considered trademark parody. This is almost always a bad practice because it is usually ruled as an "infringement" on the original trademark. Specifically, the courts consider the confusion that the parody might cause for consumers as a "dilution" that threatens the original mark's strength. This is true, even if the parody product isn't related to the product with the established mark.

The very nature of a parody is often to make someone or something the butt of a joke. Thus, a trademark parody can be said to damage the integrity of the established mark. This could conceivably enrage the original owners and create the atmosphere for litigation with a vengeance. The record shows that if the mark was in poor taste, the courts, in almost all instances, ruled in favor of the original owner of the mark. This doesn't just mean that the parodist must stop using the parody mark, it can also mean an award of damages. But not every trademark parody is ruled a trademark infringement. If the parody is in good taste and the mark's original owner is comfortable with the parody using the owner's name recognition, the parody is often deemed harmless.

Trade Dress Law

Trade Dress Law is relatively new in the trademark legal arena. It protects the distinctive look of a product and its packaging. Hallmark Greeting Card Company copied the look of a Colorado-based Blue Mountain Company. The Trade Dress Law was invoked. While Hallmark did not infringe on Blue Mountain's copyright, through the doctrine of trade dress, Hallmark did not have the right to use the unique look already in place by the Blue Mountain Company.

The trade dress doctrine could conceivably be used to protect a bottle's shape, an artist's style, an automobile's distinctive design, etc. As I have said, the Internet could be the place where an infringement of the trade dress doctrine is noticed. For years, two companies could operate with the same name, same logo, and never know the other existed. Now, any aggressive company can go online

and discover rivals who may or may not pose a threat.

The importance of trademark and trade dress laws is vitally important to any business, and therefore designers. It makes intellectual property a natural partner in growing any client's business. While graphic designers and package designers work on a brand's image and level of quality, the client needs legal assurance that they are not in harm's way.

Cyberspace and Trademarks

The Internet can be a client's worst enemy. Several years ago many local companies were able to keep their logos hidden from the rest of the country, not to mention the world. Trading in a small geographical area, they weren't exposed to other companies with similar names, logos, or business functions. Since registering a trademark or servicemark costs money, the attitude was often, who cares? It worked to the extent that many companies took on a cavalier sense of ownership for their marks. And a rude awakening was about to begin.

Suddenly, companies with no trademark protection were developing Web sites to aid customers in receipt of critical information. The sites needed to register with a domain name—often the company name plus ".com"—and this was their first venture into difficulties. Sometimes another company with the same name registered the domain name first. The company then had two options. One was to come up with a different name for the domain. Of course, this was not a popular option because what business owner want his or her company's Web site URL to be anything other than the company name?

The other option was to buy the domain name from the person or company who registered it first. The Internet registrars decided to let the opposing groups fight it out amongst themselves. They would shelve the domain name until the dispute was settled and one company prevailed. This meant, in most cases, he who had the best lawyers, deepest pockets, and a registered mark would win. On a side note, this became a thriving business for some individuals who registered domains using the names of large companies and then sold the domains to those companies for huge sums. Barry explains:

For awhile, people were out there registering domain names containing other's trademarks because it was easier for companies to pay them $500 to get their name back than to sue. This was a lot cheaper than paying an attorney for five hours of work at $250 an hour. Fortunately, the Anti-Cyber Squatting Consumer Protection Act was passed, making it somewhat easier to strip these people of those names.

With the registration authority changing from Network Solutions to ICANN—the Internet Corporation for Assigned Names and Numbers—you now have twenty to thirty domain name registrars accredited by ICANN. ICANN's dispute mechanism provides some relief for those who have been cyber-squatted. The damages awarded to victims of cyber-squatting in a court action can range from $1 to $100,000.

Since the Internet is global, your brand will be seen. Even if your client is a dry cleaner with one store, he or she could get sued and lose the company name, not to mention the logo you may have designed. On a grander scale, the bigger the company is, the more of a target it is for a lawsuit.

In Conclusion

Many questions were answered and I'm sure many more will come up later. We did cover the basic trademark issues that most of us have questions about. If you read between the lines, someone can litigate a trademark for any reason, including being a nuisance.

While law can go either way for either party, common sense is often the best defense. If a brand is put in harm's way, it could be a costly mistake. In my opinion, it is a lot cheaper to use an attorney to help build your brand's foundation now that it would be to clean up the mess of a prolonged and protracted lawsuit later on.

CHAPTER 10

LOW BUDGETS/HIGH DESIGN

It's Quality, Not Quantity

As mentioned earlier, professional Web and graphic design is not fun and games to the prospective client. It's not the unnecessary embellishment of a printed piece, a package, or vanity Web site. I've noticed that companies who are the most competitive and fighting for their place in their market seem to be fully aware of the cost-and-effect relationship of their marketing dollars. They can't afford to shotgun; they must take careful aim at their target—customers.

There is good, mediocre, and bad Web and graphic design. What your client gets depends on your company's knowledge and judgment, not their budget. Budgets only restrict how much money they can spend, not how much design they can get. If they spend money wisely, they're corporate heroes. But a poor end-product will also be remembered, not how much they saved their company in design dollars.

Research and the Client Meeting

Once you have been awarded the project, you will meet with your client for a kick-off meeting. Before this meeting, brief your client on the materials and information that you will need in order to get started on the project. First, your client needs to tell you what the budget is for the project. You can't work blind and still offer effective solutions. Next, the client should bring at least a rough draft of any text you will use as part of your Web or graphic design. Final copy is preferable. Also ask them to bring all photos, logos, or other

existing artwork that has to be incorporated into the Web site or graphic design piece.

When you finally have the meeting, use this opportunity to introduce the client to the people who will be working on the project (that is, if you are not a solo operation), or at least give your client their names and contact information. They don't need layers of bureaucracy to get in the way of a time-sensitive project. But keep in mind that certain designers may be good at what they do, but not good with clients. You have to be the judge. Also, your company may have a management strategy that prohibits the designers from meeting or working with clients.

Budgets only restrict how much money your client can spend, not how much design they can get.

There are also a couple of key issues you should bring up at this initial interview. In this technological age, the first questions you should ask have to do with computers. Find out what computer platforms your client uses and what programs they are familiar and comfortable with. This is important because you are probably using a Mac, and you may run into file conversion or compatibility problems if your client only works with, or only has access to, PC computers. As for programs, the most prevalent word-processing programs are WordPerfect and Microsoft Word. QuarkXPress has been the most popular page-layout software for a few years, and at this time, it's the most prepress-friendly of any of the page-layout software programs. However, InDesign is gaining in popularity. There are some companies that have bought PageMaker and feel it's best, but not the majority. Each software program is constantly improving. There will probably be new ones before this book is printed!

Turnaround and scheduling are also important issues. Most designers and design firms are used to quick turnarounds. After I've gotten to know a client, I tell them that it's wise to try to keep schedules reasonable, so that when the real crunch comes, it's not

just another false-alarm. I once had a client who said every job was rush. My reply was, if every job was rush, then what job was really rush? That client finally saw the light and became more judicious with his deadlines. Common sense says that there must be an order to priorities.

Finally, you need to review the client's goals. You already know much of this from the RFP, but a final review is valuable. You may also help them identify any goals they were not aware of.

Getting the Most for the Least

It's time to look at how clients can get the most for their design dollar. If the project is a Web site, knowing your client's goals will help in designing the architecture (number of pages, etc.) of the Web site. A site with a few quality pages is better than lots of pages done on the cheap. A Web site is like a book. The first thing the viewer sees is the homepage (like a book's cover), and that's the first impression.

There are effective Web sites that are what I call "design-build" sites. You can make your client look good by offering a first class homepage with a minimum number of secondary pages. Because the design-build Web site is minimalist and cost-effective, you can improve on the solid foundation you've created by adding more informational pages as time and budget permit.

The most compelling image on a Web site or printed piece is the human figure or face.

With graphic design for print, quantity (the number of printed copies) will tell you many things. It will have a budget-bearing effect on the number of colors, varnishes, and other printing matters such as foil stamping, die-cutting, embossing, and the grade of paper selected. As a rule, if only small quantities are required, special effects like stamping or embossing and the best grades of papers can be used without significant cost increase within your printing budget. Large press runs make special effects expensive, and the grade of paper is a significant cost factor.

If you are doing one-color printing, the one color does not have to be black. There are dark PMS colors that look black until they are screened back. Colored papers create the appearance of a second color when combined with the right inks. You can offer a three-color effect from overprinting two colors. (For more on printing processes and terms, see chapter fourteen and the glossary.)

You can also achieve classic designs with the use of just black and white. Some of the best design I've ever seen was done in black and white. This was when the lack of color became a powerful statement of simplicity. Newspaper design has always utilized the power of black ink to make strong design statements. Have some pieces in your portfolio showing examples of this.

What if your client has no photographs available, but they can't afford stock photography or illustration either? A good Web or graphic designer can work award-winning wonders with typography alone. Charts and graphs can become illustrations. *Fortune* magazine did this in the 1950s and 1960s. The real restriction on your client's projects isn't money, it's imagination. It's your Web or graphic design company's imagination that will make the difference.

It has been said that the most compelling image you can use on a Web site or printed piece is the human figure or face. To prove this, visit a newsstand. When you are standing in front of it, turn your back on the publications. Now turn around. The publications that feature people on the covers will draw your eye to them much faster than the ones with cars, motorcycles, or boats. Designers have always known this, and they use this effectively on everything from Web sites and annual reports to point-of-sale posters.

Coping with limited budgets can make you an asset in the client's eyes. Use it to your advantage. Creativity is the most important part of budget-restricted projects. The client can cut back on many things, but not good design.

Stay on Your Toes

If you are representing Web or print designers, you must be a diplomat with them, as well as your client. If the client's budget is on the low side, you must make sure they won't get an inferior job. The designer must be made aware that each project is an investment in

solidifying an account. But if despite all of this, the client's budgets are too low, look for another client. If this project is the exception to the rule, make it known to the Web or print art director or the designer (depending on how your studio works). If you contemplate difficulties with the design staff over budget, ask management to intercede and explain the situation to the designer or art director. Remember, it's up to management to make sure your jobs run through the studio smoothly.

If you're representing yourself, you still need to be aware that you may have to invest more than just time to keep an account growing. To grow your business, sometimes you'll have to do more than you think is fair, like lowering your price to get a job or offering a freebee. But if your client asks for too many favors or requires you to often work on the cheap, cut your losses and cut the client loose.

WEB DESIGN MARKETING STRATEGIES

*An Interview with John Waters
of Whet Design, Inc.*

To sell Web page design, you must be selling design, not technology, not programming, and especially not pretty pictures. This chapter will help you understand why design is the key word, not publication, Web annual report, corporate identity, or advertising design.

The Internet is changing, even as I write this chapter. This means you have to be aware of what is new, what works, what doesn't work, and what has been discarded. The Internet is a simple concept that appears to be a miracle cure for all communications. This couldn't be further from the truth. It is a jungle, and it can be a bottomless money-pit. Your success will come from guiding your client through this jungle.

The Olden Days

Prior to the mid-twentieth century, graphic designers did not exist the way they do today. While advertising agencies and illustrators produced intricate borders, hand-lettered text, and wonderful illustrations, they were not the people who were typically designing and setting the printed page. The "graphic designers" of the time were primarily typographers (who designed "typefaces" or fonts), typesetters (who set the lines of type), and printers (who printed the type onto a paper page). Some typographers worked independently, while others worked in type foundries. Typesetters and printers worked for

typesetting companies, where practically all typesetting for publishers and advertisers was performed.

These typesetting companies transcribed and edited text, and handled the production of paper or film output. In the traditional hot-type letterpress, typesetters produced solid lines of text cast from rows of matrices. Each matrix was a block of metal—usually brass—with a letter engraved into it or stamped on it. Each line of the text was composed by means of a keyboard similar to a typewriter. The depression of a single key released the matrix of a character from the magazine that stored ninety characters. After a few rows of matrices were assembled, it was transferred mechanically to a mold-making device. An alloy was forced into the mold against the matrices and hardened almost immediately. The result was a bar with raised letters where the molten metal had filled the impressions of the letters.

After these metal bars were used to print a text, they would be dumped back into a pot to be melted down for use again. The free-standing unit used was a linotype machine and it was much faster than typesetting done by hand and required less of a staff.

The Revolution Will Be Computerized

The hot-type linotype system eventually began using a process called offset printing. Once the type was cast, it was inked and pressed onto clay-backed sheets of paper called "repros." The repros were pasted onto paperboards and these became "mechanicals." The mechanicals were photographed and became negatives used for offset printing. The negative would later be exposed to a photosensitized aluminum plate. The image of the text on this plate could be reproduced at will, much like a photograph. Headlines, however, were still set letter by letter; this was called foundry type.

But offset printing was not the biggest change typesetting would see in the twentieth century. An even bigger revolution was on its way. Hot-type linotype and foundry eventually received competition from cold type. Cold type was similar to what people do today with word-processing and page-layout programs like Word, WordPerfect, PageMaker, and Quark. But only typographers and publishing houses had the equipment to create pages of cold type that could be photographed for offset printing. The designers would

purchase typesetting from these shops until the advent of the home computer. This marked the beginning of the desktop revolution and the end of commercial typesetters.

The emergence of the computer began in the late 1980s, with Macintosh as the frontrunner in graphic design industry. Typesetters were correct in criticizing the typeset product generated by those early design computers and software. In many cases, the type was inferior in proportion, and tracking defaults were often uneven. Typesetters saw the early days of the computer as a fad that would probably go away. But much like the first airplane's short flight compared to today's supersonic flights, the technology would not only catch up but surpass. Now we designers can set type in fractions or single-point increments. And with the fonts redesigned by new masters, the art of typography is as strong as one's imagination.

But as the desktop revolution raged on, typesetters were not the only professionals reluctant to embrace it. Most of the people who owned independent, quick-print shops did not love computers. They were watching computers wipe out typesetters and later many service bureaus. The computer seemed to be the villain, and they even felt it could someday threaten their own livelihood by replacing the printed page.

And just when they thought things couldn't get worse, the Internet appeared in the mid-1990s—another communication method that didn't need paper.

The Information Superhighway

In 1995 people began to wander around on the World Wide Web. The main "surfers" were eighteen- to twenty-five-year-old males. To get online, you subscribed to a handful of companies fighting to get you to use their service plans. These are called "Internet service providers," or ISPs, and the most popular of which was America On-Line (AOL). But small ISPs like Earthlink and Netzero cropped up, offering simple dial-up service. Each offered a set number of hours of free time with additional hours at a special rate. As the popularity of the Internet grew, competition got fierce, and the amount of free time was constantly being increased to get you, a potential

customer, online. The Internet was a complicated universe with one door opening to a thousand others. The small ISPs gave you a key to open the door, but after that you had to find what you needed on your own. AOL tried to regain its supremacy in the industry by offering navigation tools to areas of interest. They offered a search engine and provided "key words" that you could place in screen "bar" taking you to desired Web sites.

Designers were quick to see the potential of Web sites and e-mail. They embraced the Internet as another way to communicate faster with clients, printers, and prepress houses. The computer wasn't going away any time soon, and for those trying to ignore the Internet and e-mail, it was a little like ignoring the phone and the fax machine. In the next several years, businesses realized they had to have a presence on the Internet. No matter what the field, competitors would use their Web site as a talking point to show they were on the leading edge of technology. But many of the Web pages created were nothing more than ads with a twist—and the twist was that you could see their ad on your computer.

Selling Web Pages

Today, everyone is online. We don't need the yellow pages if we can get on the Web. Almost all businesses have a Web site with at least their address, business hours, and contact information.

Before you can sell Web pages, you have to have your own Web site. If you are just starting your own business, be it a freelance solo venture or a small start-up, your Web site will be your showpiece until you've added clients to your portfolio. Your site is your company brochure. Go online and check out your competitions' sites. Make sure yours is as good or better. If you write copy, start an online newsletter that your clients will enjoy and want to come back to visit your site on a regular basis. You can also feature new projects like "Work of the Week." The object is to look better than the competition.

We have already established that a Web page has to be more than pretty images advertising your client's wares. A Web page can be very expensive, and like any business investment, it can be a success or a bust. So, what does a Web page need to achieve? Truthfully,

there's no blanket answer. The more you know about your client's competition, its niche audience, and which of its products or services are the most marketable, the more you will be able to make design suggestions that are relevant to their marketing needs and their budgets.

What if there is nothing tangible to sell? If your client is offering a service, such as law, accounting, or even plumbing, you could design the home page as a historical perspective on their profession. This can prove educational, and visitors will perceive your client as a champion of the field. Sometimes a Web page can be used as a public service–type informational page. If the Web page is used this way, the company is a sponsor of good news and always a winner in good taste.

Quality, Not Quantity

Remember that something very creative and well designed doesn't have to come with a big price tag. What can be done on a bare-bones budget? Establish reciprocal links; that is, links to complimenting Web sites on your client's page in exchange for those sites putting up a link to your client's site. It's a free, easy way to promote your client's page and attract visitors (and hopefully, they'll become new customers). What if the budget won't allow for all of the products in the product line to be shown or listed? You can design an elaborate opening page with teasers. Display the hottest items or the best values and make the page revolve around these items. As we saw in chapter 10, "Low Budgets/High Design," it's about quality, not quantity.

Clearly, the Web site design is a two-way street. Not only are you targeting your client's niche audience, you must also think about providing the visitor (and potential customer) with a friendly, comfortable surfing experience. Web sites, online communications programs like AOL Messenger, and Internet commerce have become important, dependable tools, but they can also be a cumbersome impediment if they are not user-friendly. Even if someone visited the site once, why would they come back? Here are some taboos that will never go away:

- **Don't create a slow-to-load but beautiful page.** People don't like to wait around. And like a print ad, people don't want to spend too much time reading.

- **Don't talk down to your reader**. Each page should reflect the level of your client's sophistication.

- **Don't overuse animation.** It may look like a neat gimmick, but in many cases, that's all it is.

- **Don't just create a colorful yellow pages ad.** The Web is not a big phonebook. There already is a phone book, and it's easier to use.

- **Don't shotgun.** There is no reason to create an expensive, global presence if it isn't necessary. Say your client has only one store in a rural area and doesn't want to provide a mail-order business. Don't create a site that appears to be the next Amazon.com. Or perhaps your client is a small, local business that makes house calls, like a plumber. You don't need to worry about reaching customers on the other side of the world.

- **Don't serve up a vanity page**. This is a pretty Web page but it lacks anything more than basic information. Restaurants often do this because they feel anything more would cost too much money. What they don't realize is that highlighting a few signature dishes with some beautiful photography could garner more business. We often forget that the Internet is like having four-color printing at our fingertips. We can show products at their best without the high costs of color-print advertising. And don't forget, there probably are other graphics for this account that you can use.

Just because your client wants a vanity page, doesn't mean it is the best exposure for the money. Be creative and proactive by coming up with other uses for the Web site that the client hasn't thought of. If you don't, some other designer will come up with a better, more effective message, and you'll lose your client. Try ideas such as a calendar of events related to your clients industry or ser-

vice. It can be anything educational.

- **Don't shoot from the hip.** That is, don't submit a proposal to design a page if you are not sure of all of the technical support you will need.

- **Don't let the site get stale.** Provide new information on a regular basis. Update the information to keep it timely. For expert advice on how to do this, flip to chapter 12, "Content Management on the Web."

One important thing to remember is that your client's Web page will be easier for your competition to access than, say, a corporate brochure. Don't be surprised when some competitor redesigns parts of your client's page (with just enough style to titillate), and presents its ideas to your client; you will have to respond. If your competitor offers ideas for a print project, you should carry your advice to the supporting elements on the client's Web site.

An Interview with John Waters

The following is an interview with John Waters, design director of Whet Design, Inc. in New York. John is an award-winning designer who has always been on the cutting edge of computer-generated design. He started with a Lightspeed design system in the early 1980s and made his mark producing award-winning annual reports and corporate branding programs for Fortune 500 companies.

In the early 1990s, while working with IBM, John entered the infant design field of the World Wide Web. Since then, he has experienced the extreme ups and the downs of the dot com world. Throughout the 1990s, his business, WatersDesign.com, grew to a staff of fifty-five designers, producers, and Web developers. His firm developed the strategy, architecture, user experience design, and database design for numerous complex corporate and e-commerce sites, as well as many smaller sites. I interviewed John in 1998 for *Selling Graphic Design* and asked him to update that interview for this edition.

Waters Design, located across the street from the World Trade

Center, was destroyed on 9/11. But John continues to design for the Web, as well as a variety of other media produced by Whet. He wrote the book, *The Real Business of Web Design*, published by Allworth Press in 2004.

Sparkman: What is the difference between selling Web site design and graphic design?

Waters: I believe there are two basic differences. One is technology, or rather, knowledge of technology. In the print world, that means knowing about different papers, inks, and presses. On the Web, it means knowing the value of different programming languages, coding practices, and operating and database systems.

The other difference—and certainly the more important—is helping clients realize that the Web is a "living" communications tool as opposed to a static document, which ultimately is what print pieces are. In the world of print, when a project is designed, it is produced and distributed and the work is done. On the Web, designing and building the site is just the beginning. Tools, processes, and practices must be put in place to manage the content and allow the site to continue to evolve.

Sparkman: In general, describe the Internet marketplace for graphic designers.

Waters: Wow! Since the rebirth of the Web following the death of the dotcoms, opportunities for designers have exploded. Today virtually every company and many individuals have or want Web sites. Many companies have fifty to one hundred different sites. Product specific sites, market specific, program specific, department sites, resource sites, brand sites, the list goes on and on. There are micro sites that may be no more than a couple of pages, and there are huge database-driven sites with thousands of dynamic pages. Then there are blogs, wikis, and networks of sites. The opportunities are truly immense.

However, the real marketplace for designers should not be seen as graphic design versus Web design. There are many more roles for designers today—information architects, interaction designers, user-

experience designers, database designers—and there is more integration of media. Most client companies now see the value of integrated design programs. Whether it is about branding or marketing or just information and advice, smart organizations are tying together multiple channels—Web sites, brochures, direct mail, advertising, phone messaging—to achieve greater results. The individual designer has a world of opportunities to choose from. And smart design firms are offering a broad range of design services as a strategic business asset.

Sparkman: Are designers really expected to know about all of these options?

Waters: The short answer is yes. Many designers and design firms may still have areas of specialization such as motion and sound, or poster design, annual reports, packaging, or direct mail. But it is rare today for a single project, even a poster design, to not be connected in some way to other forms of information on the same subject. Most of the time, that means connected through the Web. The good news is that it's easier today for designers to keep up with all of the requirements. Most of the information they need is on the Web, and the design tools for handling the information keep getting better. The introduction of Adobe's CS2 is a prime example. Designers can move easily between applications while working, then output from a single source to multiple channels–pages for print, the Web, or handheld devices.

Sparkman: Does that mean the capital investment required for providing Web design services is no different than what's required for providing graphic design services?

Waters: At a certain level this is true. The cost of computing continues to drop as power increases. Many of the Web sites you see today designed by what used to be called "traditional" design firms are designed, produced, and even hosted on the same equipment used for traditional media. These tend to be smaller promotional sites.

When you get into large dynamic sites with multiple databases and varying levels of transaction, the capital requirements go up. Additional servers, software, and third-party providers can add up

quickly, but the real cost is in the number of people required to deliver a really great site. Most of these are the different types of designers mentioned before. With smaller sites, there is often overlap in abilities. A graphic designer may also serve as the information architect. Often, different teams of people, and the management and coordination of all the people, are another expense.

Sparkman: What do you handle within your studio, and what do you send out?

Waters: Even as a small studio, we handle just about everything internally. We write, design, and produce—including coding—here in the office. We have numerous partners on the outside that we also call on, but by having information architects, user-experience designers, and programmers on staff, it allows us to hold costs down and better manage the outside sources when we do need them. We also have numerous servers on which we host development and staging sites. This allows us to test in multiple environments to assure that the sites work the way they are supposed to.

Sparkman: Can a design studio handle both print and Web design effectively under the same roof?

Waters: Yes. That's exactly what we do. The old perception that firms focused on technology or software are the best companies to build Web sites has changed. Most client companies today realize that it is not just the technology that makes their Web sites effective. It is how the technology is put to use. Client companies today also want graphic design companies that can do a lot more than produce a brochure.

I know many design firms that partner with technology firms to meet this new demand. This is certainly one way to go. But to be really effective, and to be profitable, the design firm needs to have more than a surface grasp of technology. They need to be able to talk and work knowledgeably with their partners and their clients.

Sparkman: What would you say are the most important areas of knowledge that influence Web site design, and how it is sold?

Waters: That's a long list of "need to knows." But the most important is probably information architecture. How does one structure vast amounts of information so it is easily found and available to multiple audiences? Familiarity with how different people use the Web—with developing fictional personas and scripting various scenarios on a site—is a must. Understanding how different search engines work—and how they are continuing to change—is very important to how information gets structured, labeled, and presented.

User-experience design, which is closely related to architecture, is probably the second most important. Many design companies have been building sites with nothing but Flash for the past couple of years and selling the "user experience," animated aspect. Most users find all-Flash sites terribly frustrating. And without extreme amounts of work, search engines do not even recognize Flash sites. Providing great user experience is much more than offering animation.

Understanding information structure, user experience, and the technologies to make them real are all required. But, like graphic design, understanding the business goals is where it all begins.

CONTENT MANAGEMENT ON THE WEB

An Interview with Brian Choate of
Timberlake Publishing

Web-based content management systems (CMS) have transformed the entire Web site sales, development, and post-project maintenance process. Development companies can now empower educated clients with safe Web-authoring capabilities and increased levels of Web site features. CMS provide companies with dramatically reduced development scope per project and increased opportunities to foster long-term client relationships.

An Interview with Brian Choate

Brian Choate is the president of Timberlake Publishing. He also currently serves on several boards and holds leadership positions in many community and private organizations. He is the chairperson for the Chamber of Commerce's Technology Committee. He also serves on the executive board of the Central Fairfax Chamber as the chief information officer. He has been a director of Lambda Chi Alpha fraternity and was recently invited to sit on the board for the NASCAR Speedway Children's Charities. Brian is a graduate of Gettysburg College and lives in Northern Virginia.

Timberlake's experience as a CMS provider grew out of its years as a Web development and hosting company that specialized in the development of Web sites and intranets that included high-end graphical and database functionalities. Timberlake was named the Central Fairfax "Service Business of the Year" in 2002. Timberlake's parent company was also rated as the third most successful

Interactive Development Company by the Washington Business Journal in July 2003. To date, Timberlake currently hosts and manages Web-based applications for over three hundred organizations.

Sparkman: How are content management systems transforming the Web?

Choate: Over the past five years, our organization has seen a substantial shift from clients requesting HTML sites to more recent requests to install CMS managed sites. A content management system makes it easier for non-technical clients to maintain and expand their Web site. A CMS uses server-based software, databases, and user-friendly, Web-based menus to manage and organize the Web site's content, links, and functionalities.

When a visitor makes a request to the Web site, the CMS selects the appropriate content and dynamically displays it in a page template. Five years ago, only a few privileged organizations could afford to install and maintain these expensive systems that would organize, modify, and maintain the relational site. Early on, the benefits of a CMS were tremendous and included shorter turnaround times to post content to the Web, auto-adjusting navigation links, improved content searches, and consistency of the design being preserved. Today, lower upfront and long-term costs have made CMS-managed sites very popular for the majority of sites developed.

Sparkman: How does a CMS managed site affect the initial graphic planning and development process?

Choate: Timberlake is an organization expert in application and CMS development, not graphic design. We rely heavily on the client's existing design firm or outside design studios to develop the client site's appearance. During Timberlake's transition into CMS, we recognized that there were two major design influences that should be considered early in the design process. Unlike a static HTML site, the links located in the navigation areas and the content throughout the site would be forever changing in shape and size from direct inputs by the client. In order for the new navigation bar links to be generated "on the fly" by the server, they could no

longer be Flash-enabled or static graphics. More specifically, the navigation bars had to be designed as text links in tables that could scale up or down based on the client's current requirements.

The layout conversion from Photoshop to HTML also took on new dimensions because the CMS required certain code parameters and offered new features basic HTML couldn't. Some of these new features include calendars, polls, forums, site searches, storefronts, photo galleries, and more. All of these new features required special considerations on how to locate and display the tools to be used by the client.

The last factor that contributed to very high, or low levels of success was communication between the client, designer, and CMS provider. I highly recommend that each graphic revision be CC'd to the CMS provider to review. Hearts sink and wallets are usually reopened when a finalized graphic layout that was initially approved by the CMS integrator turns out to be no longer viable because of some last-minute, client-requested modifications fulfilled by the best-intentioned designer.

Sparkman: With decentralized maintenance performed by the client, what precautions should designers take to ensure the integrity of their work once the site is live? How does the designer's role shift with the integration of a CMS?

Choate: For the majority of small- to medium-sized businesses, HTML sites required the designer or Webmaster to continue with the project from the initial development and launch stages through the ongoing site maintenance. The benefits of this included the designer's continued focus on consistency, proper "netiquette," and overall aesthetic integrity. Turning the keys of the Web site over to the site owner can be an eye-opening experience without the proper planning and instruction. In the initial site composites, determine the areas that will require modifications by the clients and the other areas that won't. Reputable CMS provide flexibility to offer high levels of access to certain areas in the layout while locking out modifications to others.

Hands down, CMS will offer fewer site errors than an HTML site. The navigation is automatically generated and adjusted and will

not let the client put him or herself in harm's way. More specifically, menus are usually generated automatically based on the database content, and links will never point to non-existing pages.

Also, it is imperative to rely heavily on style sheets to help the client maintain consistency and ensure a consistent appearance. At Timberlake, we have found that our training and orientation sessions usually focus 40 percent of the time on the actual CMS "how-tos" and 60 percent of the time on how to properly populate the site's information architecture and maintenance of the aesthetic consistency. If a conservative site's text is originally designed in charcoal gray, Verdana, normal, at size 8, hopes would be dashed to visit the site and see a mix of baby-blue, Times New Roman, italic, at size 16! The site owner may appreciate it, but the site visitors and your work portfolio won't!

Many of the designers we work with emphasize in the initial project stages a requirement for an ongoing monthly consulting meeting or conference call to review and touch-up pages modified between the scheduled calls. This is also another great avenue to foster ongoing work relationships!

Sparkman: When do you choose CMS technology over an HTML site?

Choate: There are three areas that can help determine an answer to your question. What is the lifespan of the site being developed? How many updates will be executed on the site each month? How organized is your client? If the site being developed is a temporary site for a short-term purpose or will truly be a static site with very few modifications, the benefits of a CMS may not be fully recognized or valued by the parties involved. However, as a designer, one internal consideration may be to evaluate how organized your client will be in the upcoming Web project. We have all received a phone call when the HTML project is nearly complete and the client decides to add another link to the navigational bar and change one or more of the global site attributes. Not only did the call change the scope of the project but just nullified all of the work completed. From a site setup standpoint, one of the best CMS attributes is that clients no

longer have to have the navigational structure or content finalized before cutting the site composite into HTML. Even better is the opportunity for them to insert and manipulate all of the content into a site that was delivered empty!

Sparkman: Why has the popularity of the CMS risen so quickly in the past two years? What should the designer and client look for in a quality CMS?

Choate: The primary reason CMS have risen so quickly in popularity is because an effective content management solution will generate a measurable return almost immediately by lowering operating costs and increasing profit. Many clients consider the following benefits when weighing their investment.

Graphic design compatibility is a huge factor and should be reviewed carefully with the proposed CMS product. Many CMS companies offer little design flexibility either by corporate prerogative or coding limitations. I strongly recommend that the designers meet with or thoroughly review compatibilities up front.

The designer and client should look for support, cooperation, and open lines of communication from the CMS provider. We have been working side-by-side with designers for a couple of years. Each of the projects have been highly collaborative, and it may not be a smooth integration process without the communication.

CMS will reduce content management costs by minimizing or eliminating the technical learning curve. Clients can recognize immediate savings because they become accountable for the management of content, allowing your technical staff to focus on strategic, more complex projects.

A CMS allows companies to share responsibility of content development among the individuals and the departments that are directly responsible for disseminating information. This speeds up the "time to Web." A CMS automates processes, provides the checkpoints, and expedites delivery of new and updated content to your public Web site, intranet, and extranet. Therefore, content owners can manage sites more efficiently, while site visitors remain satisfied with new information.

Intelligent workflow automation is built into the majority of CMS, enabling clients to ensure content is passing through the appropriate quality gates before being published. Internal messaging and tracking facilitates the workflow process to ensure expeditious delivery. Proper review and control takes place consistently, creating a dependable paper trail.

Staff accountability and versioning offers a huge safety net and level of confidence. A CMS improves accountability through content tracking and logging of work history. Now you know what specific content has been changed, who changed it, and when it was changed. Versioning allows you to revert to previous versions of content or review the history of specific pages as needed.

Consistency is maintained throughout the Web site so the branding and design is controlled to the level desired—style sheets, templates, etc.—regardless of who is responsible for the actual content. Consequently, visitors immediately experience a more professional presentation and are confident that content is accurate.

Content scheduling and visitor accessibility options offer time-controlled or user login requirements to view specific areas of content.

Improved searches on the site and via search engines. Since a CMS manages all the content consistently, built-in search engines make finding content on your site fast and easy. The internal organization of content allows you to manage your site so that it is search-engine friendly, providing better visibility within the major search engines.

Sparkman: How are CMS sold?

Choate: Build, buy, or lease are the three most predominant options available. With the number of CMS available in the market, rarely should the project parameters require building a CMS from scratch. We lease our CMS application to clients "out of the box" and offer levels of custom code development to tailor the tool to their exact specifications. Leasing options usually offer a higher level of customer support in the integration process, and often include enterprise-level hosting that can eliminate numerous setup and configura-

tion issues, and almost always include version and feature updates. The pace at which the technology has changed in the past three years does not look any different for the next three, so version updates are very valuable. Things to investigate in a lease model include control and ownership of the graphics, content, and code in the event that there is a need to move.

The "buy" model, often referred to as "open source," provides the developer with all of the code and responsibility to adapt it to the project, then find a home [hosting account] to make it work. Buy models usually do not include gratis version upgrades, and the upgrades that may be available still will require a server-proficient administrator to install, test, and debug. In some circumstances, the buy model may offer higher levels of control, quality, and ownership of the site. In any of these cases, read the fine print. There are often limitations on how the CMS can and cannot be used. The worst scenario would be to place the client into a costly legal situation at the end of the project because due diligence wasn't covered up-front.

Sparkman: Should graphic design companies offer their own CMS to clients?

Choate: I am asked this question about once a month. The answer really does depend on the design firm's core capabilities. My personal perspective is that this is a "right brain/left brain" technology. Specifically, programming and creative design are both highly specialized, quite different, and may be difficult to successfully marry. With the scope of today's Internet, companies can't do everything and be successful. Strategic partnerships may be the best solution because of the strong working relationship it fosters. We have found it to be very beneficial and symbiotic.

Sparkman: Is there a short- and long-term cost differential between HTML and CMS projects?

Choate: There is a CMS available to fit almost every requirement and budget. Based on conversations with friendly competitors and our own numbers, it is safe to plan on similar startup fees for a CMS site as a HTML site. Many of the steps for either type of site are still the

same. The graphic development and project management component is required in both circumstances, as is the conversion of the Adobe Photoshop layout into HTML. The offset in tasks includes the additional step requiring the HTML layout to be integrated into the CMS code set while eliminating the requirement for the developer to populate the site with the client's content. We have also found that the CMS-enabled sites have lived longer lives between major modifications than the HTML sites. This may also be a factor of greater frequencies of smaller changes instead of the HTML-based larger changes over fewer frequencies.

In the planning stages of our projects, we like to break the costs into up-front and recurring values. Specifically the one-time fees to set up the project and then the monthly recurring fees for support and hosting of the application(s). There is another value that may not have a dollar sign next to it but is very important. This is the success of the site and its ability to reach its ultimate goal or purpose. CMS enabled sites often maintain the client's interest or focus, and therefore the data is updated and maintained more frequently. This leads to higher levels of site visitor satisfaction and usually greater levels of success than sites maintained less frequently under the HTML code.

MARKETING COMPLEX
WEB SITES

An Interview with Chris Foss
of AmericanEagle.Com

When we talk about complex Web sites, we are addressing sites that are generating profits that keep companies solvent and in the black. The Internet is probably the lifeblood of these organizations. These sites are not vanity pages giving some fluff and information on the company and its employees. I once heard my partner describe the fisherman along the Anacostia river in Washington, D.C., as "fishing for groceries." In three words, he described why it wouldn't be too smart to join them if we were fishing for fun. These complex Web sites are fishing for groceries.

To market complex Web sites, you must know the basics of programming. This doesn't mean you have to be a programmer, but you need to be able to think, plan, and estimate on your feet. If you're a designer, you can discuss design parameters. If you're an account executive, you can discuss goals. But if you're either, you still need to know the concepts of complex Web site design. You have to exude confidence and know what possibilities exist, as well as the limitations due to your client's budget and/or the state of technology.

I have worked with AmericanEagle.com as a strategic partner on major projects for the government and corporate clients. They know their stuff and prove it every day.

Interview with Chris Foss of AmericanEagle.com

The following is an interview with Chris Foss, the director of the

Washington, D.C., division of AmericanEagle.com. His company is headquartered in Chicago and is involved with very large companies and organizations. I asked him to give me his views on his company's take of the Web marketplace in this Fortune 500 world.

Sparkman: Describe AmericanEagle.com. How are you different from other Web design companies?

Foss: The official one-line description is that AmericanEagle.com is a full-service Web site design, development, hosting, and marketing company headquartered in Chicago and with offices across the country.

That description is true. However, when you get down to the core of it, we are one hundred men and women whose professional careers started and "grew up" with the Internet over the past ten years and who probably understand how to convey messages through Web sites better than anyone in the world.

We are a family-owned-and-operated business that has been around since 1978. Starting with software development, we evolved into a networking company that developed its own line of computer hardware products. In 1994, one of our network clients asked us about putting together a Web site. Granted, at first, we didn't know any more about Web sites at that time than anyone else—probably less!—but once we started, we quickly realized that we were good at it. After an overlap of about three years, AmericanEagle.com completely transitioned away from the networking and hardware business and focused 100 percent on designing, building, hosting, and updating Web sites.

This is one of the key differences between AmericanEagle.com and other Web site design companies. Because the company has been around since 1978, AmericanEagle.com learned a lot of tough business lessons early. When the Internet crash happened, AmericanEagle.com was not one of the "high flying" companies that collapsed. In fact, as other companies were closing their doors, AmericanEagle.com was expanding into other cities.

Another big difference with AmericanEagle.com is the vast experience we have in building sites for companies of all sizes across all types of industries. Since 1994, we have designed more than 3,000

Web sites—everything from small "mom-and-pop" shops to Fortune 500 companies, from small nonprofit organizations to the most popular professional sports sites in the country. This cadre of experience enables AmericanEagle.com to walk into just about any sales meeting and immediately identify sites in our portfolio to which the potential client can relate.

Of course, AmericanEagle.com could not have survived without a true dedication to quality and customer service. The difference between AmericanEagle.com and those companies that do not focus on good quality and customer service is simply: We're still in business. They are not.

Sparkman: You've seen the dramatic changes in our industry. What has been the most dramatic in your business?

Foss: As you can guess from our history, we have experienced some pretty dramatic shifts as we transitioned from software development to hardware to Web sites; however, since we focused our business on Web site development, the most dramatic change for us was the decision to expand beyond the Chicago-land region. Our first office—in Washington, D.C.—was a bit like flying in the dark. We weren't sure how this experiment was going to work out, nor how to ensure success. After stumbling around a bit, we found the right path, and the office started to grow. Of course, with any technology business, you have to be able to adapt, and we continue to do so. Managing projects from several hundred miles away can be challenging! We constantly tweak our communication and management processes between Chicago and our regional offices as necessary, and the system continues to improve.

Sparkman: What kind of client best suits AmericanEagle.com? What client doesn't make a good fit?

Foss: Easy answer. The best type of client is one that lets us do our job. The worst is one that questions everything that we do. Everyone in the service industry has run into the situation where a client decides to outsource services, but then fails to actually let the contractor do the job appropriately. When you hire a builder to

build your home, you work with them to pick the floorplan, cabinets, and paint colors. You don't tell them things like how to pour the concrete!

Unfortunately, some clients cannot let go. We've actually had projects where we have created a great design, had it picked apart by the client, seen several different revisions, and then—surprise!—the client circles back to the original design and realized that we knew what we were talking about in the first place! Sorry, I had to vent for a second.

Unfortunately, this situation might actually be our fault in some cases because we allow the client to question us. I realize it sounds arrogant to say, but designers and project managers have to convey confidence in their designs and design process; otherwise, if the client begins to feel any doubt whatsoever, the project can quickly slip downhill.

Our best Web sites are, more often than not, projects where the client has been extremely "hands off."

Sparkman: Do you use contracts? If so, can you describe a typical contract?

Foss: While we still do some deals with a simple handshake, most of our projects require contracts simply because one person's assumption of a Web site design/development project doesn't always match up with another's! For example, some people unfamiliar with the Web just assume that a design project includes Flash productions, e-commerce, media streaming, and more, and they don't realize that they are requesting a much larger project. I love it when a small retailer begins describing his desired e-commerce site and wraps up with: "You know, something like how they do it on Amazon." My quick response is always: "No problem. We can do that. Of course, Amazon.com invests millions of dollars into its Web site each year, so if you could just make the check out for..."

Particularly with larger projects, a contract is essential in order to define the scope of a project right from the outset. A typical contract for AmericanEagle.com will be broken into the following sections: Introduction/overview—this is where we break out the overarching

goals of the project; Internet services—this summarizes the hosting services that we provide; design and development—the heart of the proposal, which I'll discuss more in a moment; and terms and conditions—this breaks out the timeline, ownership issues, and of course, the all-important cost!

The design and development section is by far the most important because it defines the actual work you will perform for the client. This should include the creative strategy, with issues such as how many comps you will provide, whether there will be any Flash modules or animations, and what will the client provide to you. It also includes the technology strategy, with questions such as what kinds and how many databases are involved, whether there is any third-party software to consider, and whether materials provided by the client will require backend integration. And finally, the site overview breaks down the structure and functionality of the site that you will build for that particular client.

Remember, "scope creep" is one of the biggest issues that come up in Web site development projects, so make sure you can fall back on the contract for any scope questions.

Sparkman: Do you require advances from clients? If so, do you ever have prospects decline?

Foss: Usually, AmericanEagle.com works on a fixed-price basis based on the functionality defined in the contract—that's why that contract is so important! Depending on the size of the project, we usually require payments upfront, upon completion of the project, and sometimes, additional payments based on milestones and deliverables. For example, with a small project, we require half up-front and half upon completion. With larger projects, however, we might break down the costs as a payment upfront, upon delivery of a project plan and initial designs, upon delivery of the beta site, and upon completion of the project.

Do some prospective clients decline? Of course. So we might need to be flexible. For example, working for the government requires the work be completed first. Others might want to explore a retainer type agreement where they hire you for an extended period and guarantee a

monthly contract. Still others might just have a project that warrants an alternate payment schedule. However, be wary of any prospect that starts the meeting: "So I have this great Internet idea…" Demand all the money up front!

Sparkman: How much of AmericanEagle.com's business is government, and how much is private sector? What are the main differences between the two?

Foss: AmericanEagle.com does work for the government on all levels—local, state, and federal—however, it only accounts for about 15 percent of our business.

What are the main differences between the two? That's a very good question, and I have a few different ways I'd like to answer. First, the sales process. With the private sector, you can usually walk out of a meeting and know whether or not you'll win it. With the government, all bets are off. Sometimes you can devote an incredible amount of hours responding to an RFP that has, essentially, already been awarded. Other times, you can submit a quote and have the agency completely shift their request and ask for something different. Either way, the entire sales process is typically much longer than the private sector. I've walked into meetings in the private sector—a FIRST meeting—and had the prospect ask to sign a contract right there on the spot. That will never happen with the government! The bureaucracy alone requires that they review multiple bids and adhere to a strict review process.

Second, payments. As I mentioned in an earlier question, the government requires that you work for them first…and then receive payment. This can be difficult if the project demands a large amount of your resources, so try to install payment breaks into the project.

Finally, the working relationship itself. In this area, working with the government is fantastic. As I mentioned earlier, clients that hire you because they trust you to do the job—and than actually let you do the job—get the best outcomes. Invariably, government clients fall into this category. Perhaps it's because the private sector is more bottom-line oriented and may insist on looking over your shoulder to make sure they squeeze the most work from you. Government clients let you do your job…usually.

Sparkman: How do you bill for Web design? Is it by the hour or by the project? How do you handle change orders?

Foss: For most projects, we bill by the project as mentioned in an earlier question. Changes in the scope of a project, however, often arise, and this requires strong project managers to identify and stop the dreaded scope creep. A good project manager will identify changes to the contract quickly and force the issue before it gets too late in the project.

Once AmericanEagle.com identifies an out-of-scope item, we immediately push it back to the sales representative to address with the client and usually stop the project until the issue is resolved.

Sparkman: Describe an average project from beginning to end.

Foss: Is there such a thing as an average project? If so, this is the process that we follow internally and that we guide the client through.

First is the planning stage. This actually begins during the sales process where we learn more and more about the clients and define their particular needs. With the contract approved, we get further into the details of the site during project planning sessions. This culminates into a written project plan that outlines everything from the creative strategy to technical requirements to future hosting details.

With a project plan approved, we actually start developing the site. First is the design side of things. We work to create various graphic designs based on the approved written creative strategy in the plan. Initially, we'll start with just one or two comps of the homepage and present them to the client for review and feedback. As the designs near approval, we will also create any interior pages that require specific [user interface]. For example, an e-commerce site will require a design for the product display pages, the checkout pages, and account profile pages.

Once the graphics are approved, we move to programming. Depending on the complexity of the project, we will program various modules and submit them for the client for review. Again, the programming is based on the approved project plan, so 95 percent of the functionality is already fully defined. We just program accord-

ing to the specifications.

The next step is combining the programming and the content with the designs. During the above stages, the client will provide the project manager with content to be placed throughout the site, and our HTML crews will "cut and code" the designs and the content. They will also work with the programming team to integrate the various programming modules.

With the above completed, we should have a fully functional beta site that is ready for internal AmericanEagle.com testing and then for client testing. Both the project manager and senior programmer check the beta site, fix any bugs, and present it to the client.

This is the stage where we encourage the client to go through every aspect of the site and make sure content is placed right and the functionality is correct. Essentially, we ask them to try and "break" the site. Typically, several rounds of changes occur during this stage because the client finally has something they can "touch and feel," and they require some additional tweaks. Depending on the number of changes, we will put together a final change document, or punch-list, that the client reviews and approves. Once completed, the site is ready for launch.

Sparkman: Does your company use graphic designers for the non-Web part of business, such as branding and print?

Foss: No. We focus strictly on the Web and refer clients to other companies for print design.

Sparkman: How do you maintain accounts once they are on board? Do you host Web sites?

Foss: Yes, AmericanEagle.com hosts Web sites in our own private data center. We've grown our facility from just a few racks of servers to about 3,000 Web sites.

Once we complete a project, we offer ongoing hosting and maintenance services to all of our clients. Some might only turn to us a few times a year, while others contact us a few times a day!

Sparkman: What advice do you have for designers entering the field?

Foss: I find the following to be quite helpful. One, partner with a programmer. A great design is worthless if it doesn't do anything, and a great program will fail without the user interface and necessary aesthetics to appeal to its target audience. Two, never design just for the sake of design. Art is a wonderful thing, but Web sites are there to DO something, to convey something. Don't let your design overpower the message. Take a look at WebPagesThatSuck.com and you'll find plenty of sites where the designer got carried away. Three, be confident in your designs. It's a slippery slope when clients start telling you how to design. Remind them that they hired you for a reason. And four, beware of scope creep!

Sparkman: What are your thoughts on where we're going, and do you have any predictions for the future?

Foss: One of the things that I run into a lot in this business is people telling me that creating Web sites is easy. "If I wanted to, I could have my nephew, niece, or neighbor's kid build the site for me. Anybody can do a Web site!" Well, that's true. It will continue to get easier and easier for people to go out, buy something like FrontPage, and create a Web site. But keep this in mind: Microsoft Corporation does not use Microsoft FrontPage to build Microsoft.com. There's a reason for that. There will always be clients out there that will want more than what a canned software package can provide for them.

From a graphic design point of view, the future looks great because even though more and more people can build Web sites, you still need the talent to create a design that will truly succeed on the Web.

Then again, as Yogi Berra said, "It's tough to make predictions, especially about the future."

STRATEGIC PARTNERSHIPS WORK

An Interview with Ed Grocholski
of the Lindberg Group

Since my firm has established strategic partnerships with complimentary organizations, I have seen a radical change in the way I look at my business. I've witnessed some major changes in the design industry as a whole and the morphing is good. There are very few designers that can be ivory towers and succeed on a steady diet of design. Only certain graphic design firms have reached a plateau that lets them pick their own projects and not venture into complimentary fields such as public relations, marketing, and Web design.

Separate, but Together

I have found that to reach the next level of profit, I have to blur the lines of communications again. My firm specializes in branding, brand collateral, exhibits, and Web design. We are specialists in these areas and I have no intention of asking my staff to develop writing or marketing skills unless they wish to. None of us are Web programmers, either but we've all designed Web sites.

In forming our strategic partnerships with a marketing firm and a Web specialist group, we all enjoy a synergy while maintaining our finely honed skills. We do have to meld our identities in one melting pot or identity. This can be a problem if one of the firms has an enlarged ego and must control every project. Clients can be uneasy about working with more than one company on a project and this can drive them to full service group, even though that group might

be inferior. This is why it's best to make the strategic partnership transparent.

Who's the Leader?

The easiest way to determine who the leader of the partnership should be is to use the company that introduced the client to the partnership. For instance; if the project is the branding of an organization and my firm was first contacted through an RFP (Request for Proposal) or informal invitation, we would take the lead and be the main point of contact for the client. Our marketing partner would be responsible for research, focus groups, and any outreach programs. Our Web partner would build the Web site that we would design. They would not be in contact with the client without us in the leadership role.

What happens if there is no clear leader because the partnership is responding to a RFP with no prior relationship with the client. The answer is in the project description. If it's mainly a marketing project, then that partner takes the lead. If it's Web site design, the Web firm is the leader. If it's branding, then we'll take the lead. If you have a problem with type arrangement, you may need to look for a different partner.

*Design firm budgets were always
in the thousands—with the partnership,
they're in the millions.*

With design losing a lot of its mysticism and aura after the invention of the computer, our clients have become more quantitative. They want dividends from projects, not immeasurable graphics, vanity Web sites, and public relations programs that just create a warm and fuzzy feeling about their company. You can't convince a client that branding is like a new suit and the investment will give their company a contemporary and better image. Let's face it, most clients don't wear suits anymore.

In a results driven world, we have to work harder, but the results

are greater. As a design firm, client's budgets were always in the thousands, with the partnership they're in the millions. Our emphasis is still design but we're reaching a higher level of clientele. This is part of the synergy of power groups working together. Like any partnership or marriage, there are no guarantees. If you feel you need protection, then you need a contract.

The contract should state who the companies are, what their responsibilities are, and how will each be compensated. There also needs to be confidentiality clause protecting all of the partners. If you are part of a strategic partnership, the partnership should only submit one invoice. This would come from the managing partner company.

Depending on your location and marketplace, you may find yourself partnering with ad agencies, technical illustrators, animators, publishers, or any other industry that can benefit in becoming involved with your company.

Interview with Ed Grocholski of the Lindberg Group

One of our strategic partners is the Lindberg Group, a marketing firm based in Old Town Alexandria, Virginia. Ed Gracholski, a partner in the firm, agreed to do an interview on working within a strategic partnership. The following questions and answers are presented to give you sense of how a design firm works with a marketing group.

Sparkman: Please describe the Lindberg Group and your role in the company.

Grocholski: The Lindberg Group is a marketing and communications company. We pride ourselves in providing strategic advice to clients and helping them implement plans that deliver desired results. Our objective is to help clients figure out the messages they need to be communicating regarding their product or service and then determining the best way to deliver those messages to potential customers or stakeholders.

As a partner in the Lindberg Group, my primary role is bringing in business and keeping clients happy. One way we do this is by forging

partnerships with other firms that provide services we may not offer. This is especially helpful when it comes to creative services. Many clients do not have a clear idea of all the elements that need to come together to make their project successful. If our firm can approach a prospective client with all aspects of a project covered using strategic partnerships, it increases the odds we will get the business.

Sparkman: What is the make up of your client list?

Grocholski: Our client list is composed mostly of nonprofit organizations and government agencies, though we do have commercial clients from time to time. We find that offering cost-effective services to a variety of clients keeps us busy and gives us an opportunity to experience a wide range of interesting and engaging projects. Typically our clients are looking for a complete communications campaign, from message development to creative services. Being able to provide all aspects of a campaign has helped us limit client turnover.

Sparkman: Describe your ideal project.

Grocholski: Our ideal project is any project where the client puts full faith in our firm to help them achieve their marketing and communications objectives. As someone who used to work on the "client side" myself, I understand that many companies and organizations have internal politics and other considerations that make it difficult to follow external guidance or advice without hesitation. This is especially true with very large organizations where there is a desire to involve as many internal stakeholders as possible in the decision-making process. This can be especially trying for creative directors and graphic designers who have to see their quality work become marginalized by considerations that have nothing to do with creativity.

To me, the best projects are those where we are working with a strong internal leader who is able to run organizational traps and is open to creative input from the outside and lets a campaign come together naturally and effectively.

Sparkman: Please describe how a strategic partnership works with a designer or design firm.

Grocholski: First, we have to find partners who have a similar philosophy to ours. For instance, when it comes to design we look for partners who understand how to be creative while being cognizant of a client's internal organizational considerations. We also look for partners who respond well to deadlines and who will try to work with us on tight budgets.

The process for finding these partners can be challenging. Usually we run across prospective partners as we do work with the same clients. If we like the prospective partner's work, we will meet with them and learn a little more about their approach to business. Then, if a small project comes along that might make sense for this particular design firm, we may give them a work order for a couple thousand dollars to work on it. If they deliver good work on time and on budget, we will consider them for larger projects that come along.

In terms of establishing a partnership, we prefer to work on a project-by-project basis, using work orders and simple contracts for each project. Once a good track record is established between our two firms, we will start going in together on new business proposals. The larger the project, the more formal the contracts.

Sparkman: Do you have any advice for those selling graphic and Web design?

Grocholski: I think the best advice I can give is to be flexible and also to understand how your work will ultimately be integrated into your client's overall branding or outreach. One of my biggest challenges in working with creative services professionals over the years is the perception by some within the industry that their work is "high art" and that they cannot possibly alter their work in response to clients' needs. There really isn't room in commercial graphic design for that approach. Sometimes you have to make changes in your work, even to the detriment of the creativity of the work, to meet the needs of a client. This isn't to say that some pushback isn't sometimes called for, but in the end the client is paying the bills and some flexibility is going to be expected.

On the subject of Web design, it is always helpful if you understand the technical aspects of Web programming. Over the years, I have run into graphic designers who design Web pages where the ratios are all wrong or the design is in a format that doesn't work well with the Web platform being used by the client. A certain level of expertise in programs such as Flash and Dreamweaver is very useful.

Sparkman: Do you feel that the way you do business has changed radically since the arrival of the World Wide Web?

Grocholski: Yes. I think creative services, in particular, have changed drastically. I remember working with a large Madison Avenue advertising firm in 1992 that was still using glue sticks and cut-outs on foam board for its mock-ups. By 1995 that firm would have been laughed out of any corporate pitch meeting.

The challenge today for creative services firms is time. In the days before the Web, it could take several days to simply process photos, create mock-ups and then ship them to a client. Now the technical aspects of that process are virtually instantaneous and the slowest part is the actual human creative process. This puts a great and often unrealistic expectation on designers to deliver excellent work quickly. From my personal standpoint, I find that I have to set realistic expectations for clients. I can't tell you how many times I get an e-mail with a poor quality photo attached at 10 a.m. from a client with a request that we have a great piece of creative work done by noon, simply because we now operate in "Internet Time." In many ways the Web is both a blessing and a burden.

Sparkman: Do you use contracts? If so, can you describe a typical contract?

Grocholski: Yes, I use contracts. I try to keep contracts as simple as possible, usually two or three pages in length. It is important that your contract contain a detailed scope of work, a clear fixed budget and a clause for ending the contract with proper notice.

Strategic Partnerships Agreement
A strategic partners' agreement is shown on the following pages. Beware! It has never been tested in court.

1010 South Street, Sanford, Virginia 20001
Phone 550 050 1000
Fax 550 050 0002

November 26, 2008

Jonathon Smith
President
Smith Marketing Group, LLC
1000 West Street, Suite 100
Sanford, VA 20000

Dear Jonathan:

On behalf of our partners at Design, Inc. (hereinafter referred to as "DI"), we are pleased to offer this letter of understanding to Smith Marketing Group, LLC (hereinafter referred to as "SMG"). (DI and SMG are each referred to herein as a "Party" and collectively, as the "Parties.") This letter confirms our understanding regarding the terms and conditions under which we will form a strategic partnership to maximize the value of our customers' brands in addition to our own brands (the "Partnership"). Subject to the termination provisions set forth below, this Agreement shall extend for an initial period of one year from the date of execution (the "Initial Term"); provided, however, that DI and SMG mutually may agree to extend the Agreement beyond the Initial Term, subject to such terms and conditions as the Parties mutually may agree. (The Initial Term and any subsequent terms, collectively are referred to as the "Term").

WORKING AS AN DI STRATEGIC PARTNER

DI will introduce SMG to its clients (each, an "DI Referred Party") in connection with business opportunities it feels are in keeping with its philosophy of bringing the best resources to bear in providing business solutions to our clients. In some mutually agreed upon cases, SMG may be represented as a part of the DI team (the "DI Team"). In other cases, DI and SMG may agree that it's best for SMG to represent themselves directly to the DI Referred Party. In exchange for the referral of business, SMG will compensate DI in an amount equal to 5 percent of the revenues excluding direct expenses incurred, such as the base cost of printing and other out-of-pocket expenses that SMG collects from the DIReferred that SMG collects from the DI

Referred Party the "DI Referral Fee." In accordance with applicable laws and other applicable rules, SMG shall not pay a DI Referral Fee on the referral of legal business. For purposes of computing the DI Referral Fee, revenues collected from the DI Referred Party and paid through DI to SMG will be included as revenues for purposes of computing the DI Referral Fee. SMG will pay the DI Referral Fee to DI with respect to each DI Referred Party from the revenues collected from such Party once each month with respect to revenues collected during the prior month. The obligation of SMG to pay the DI Referral Fee shall be contingent upon SMG receiving payment for services it renders to the DI Referred Party.

Where SMG operates as a part of the DI Team, SMG will invoice DI for the service(s) it provides to the DI Referred Party. Unless otherwise agreed in writing by SMG and DI, the invoiced amounts, less the DI Referral Fee, shall be paid in accordance with the normal account receivable policies of SMG (i.e., net 30). Where SMG does not act as a part of the DI Team with respect to a DI Referred Party, SMG will invoice each DI Referred Party in accordance with SMG's normal billing policies.

When the aggregate amount of the DI Referral Fees has reached $100,000, the DI Referral Fee will be increased to 10 percent with respect to future revenues of SMG that are attributable to an DI Referred Party. SMG agrees that compensation, billing, and all representations in connection with an DI Referred Party will be made in a manner that is agreeable to both DI and SMG.

WORKING AS AN SMG STRATEGIC PARTNER

SMG will introduce DI to its clients (each, an "SMG Client"), as SMG deems appropriate, in light of the needs of the Client and the capabilities of DI (each SMG Client, collectively are referred to as an "SMG Business"). In some mutually agreed upon cases, DI may be represented as a part of the SMG team (the "SMG Team"). In exchange for the referrals of business, DI will pay SMG a fee equal to 5 percent of the revenues it collects excluding direct expenses incurred, such as the base cost of printing, ad space, and other out-of-pocket expenses that are attributable to an SMG Business (the "SMG Referral Fee"). DI will pay the SMG Referral Fee to SMG with respect to each SMG Business from the revenues collected from such Party once each month with respect to revenues collected in the prior month. The obligation of DI to pay the SMG Referral Fee shall be contingent upon DI receiving payment for services it renders to the SMG Business. For purpos-

es of this agreement, revenues collected from an SMG Business and paid through SMG to DI will be included as revenues for purposes of computing the SMG Referral Fee.

When the aggregate amount of the SMG Referral Fees has reached $100,000, the SMG Referral Fee will be increased to 10% with respect to future revenues of DI that are attributable to SMG Business. When DI acts as a part of the SMG Team in connection with an SMG Client or otherwise, DI will operate at the direction of SMG. When DI has been referred directly through SMG, DI will operate under its operating philosophy; provided, however, that, at all times, DI hereby agrees that compensation, billing, and all representations will be made in a manner that is agreeable to both DI and SMG.

In the event that DI acts as a part of the SMG Team, DI will invoice SMG for the services it provides to the SMG Business. Unless otherwise agreed in writing by SMG and DI, the invoiced amounts, less the SMG Referral Fee, shall be paid in accordance with the normal account receivable policies of DI (i.e., net 30). Where DI does not act as part of the SMG Team in connection with an SMG Business, DI will invoice each SMG Business in accordance with DI's normal billing policies.

STRATEGIC PARTNER DISCOUNT FOR PARTNER BRAND

Where one party engages the services of the other in connection with the continued development of such party's brand, services provided will be estimated in advance and such amount will be subject to a discount equal to 10 percent of the estimated value of such services.

CONFIDENTIALITY

SMG and DI agree to operate under the terms of the mutual confidentiality agreement attached to this letter, as such agreement may be amended from time to time.

COVENANT NOT TO COMPETE

Both DI and SMG acknowledge that, by virtue of the partnerships contemplated herein, each Party may establish and/or continue to establish favorable relations with the other Party's customers, clients, and accounts and/or will have access to certain trade secrets and other proprietary information. Therefore, in consideration of such relations and to further protect trade secrets and other confidential information, directly or indirectly, of both DI and SMG, the Parties hereby agree that during the Term and for a period of

one (1) year from the date of termination of this Agreement, DI and SMG will not, directly or indirectly, compete without the express written consent of the other Party, and such consent shall not be withheld unreasonably;

A. engage, directly or indirectly, in any business that is in competition with the other Party in those markets in which such Party competes anywhere in the world as of the effective date of the termination of this Agreement (a "Competitive Business");

B. actively solicit clients, customers, or accounts of the other Party, on behalf of, or otherwise related to, any Competitive Businesses or any products related thereto; or

C. actively solicit, induce, or attempt to induce any person who is or shall be in the employ or service of the other Party to leave such employ or service for employment with the recruiting Party or any business with which such Party is affiliated or otherwise disrupt or interfere with the relationship of the other Party with any person who is or shall be in the employ or service of such Party.

The foregoing notwithstanding, if any court determines that the mutual covenant not to compete, or any part thereof, is unenforceable because of the duration of such provision or the geographic area or scope covered thereby, such court shall have the power to reduce the duration, area or scope of such provision to the extent necessary to make the provision enforceable and, in its reduced form, such provision shall then be enforceable and shall be enforced.

GENERAL INDEMNIFICATION BY DI

DI shall defend and indemnify SMG, its officers, directors, employees, and agents and hold each of them harmless from and against any and all claims, losses, damage, penalties, fines, forfeitures, legal fees and expenses and related costs, expenses of litigation, judgments, settlements and any other costs, fees and expenses (each, a "Liability") that were caused by or resulted from, or are otherwise arising from or related to, a breach of any of DI's duties, representations, warranties, covenants and agreements contained in this Agreement, or by the willful misfeasance, bad faith, or negligence on the part of any officer, employee, director, or agent of DI in connection with the performance of, or failure to perform as provided in, this Agreement.

GENERAL INDEMNIFICATION BY SMG

SMG shall defend and indemnify DI, its officers, directors, employees, and agents and hold each of them harmless from and against any Liability, as defined in the aforementioned paragraph above, that was caused by or resulted from, or are otherwise arising from or related to, a breach of any of SMG duties, representations, warranties, covenants and agreements contained in this Agreement, or by the willful misfeasance, bad faith, or negligence on the part of any officer, employee, director, or agent of SMG in connection with the performance of, or failure to perform as provided in, this Agreement.

VENUE

The terms outlined in this letter will be governed under the laws of the Commonwealth of Virginia. Notification may be sent to Steve Jones, President for Design, Inc. at 1010 South Street, Sanford, Virginia 20001 and Jonathon Smith, President, President, Smith Marketing Group, LLC, 1000 West Street, Suite 100, Sanford, VA 20000.

For Smith Marketing Group, LLC

Date

For Design Incorporated

Date

Strategic Partners' Contract

5

WE'RE NOT PAPERLESS YET

Paper Cuts Can Be Fatal

You may have to provide some print management, or buy printing direct. As I mentioned earlier, I prefer to bill these services directly to the client, but manage them for an hourly fee. No matter what you do, you must know about printing. Unless you are strictly into multimedia, the final phase is printing. Even if you have a print buyer within your company, you will have to discuss printing with your client.

Finding a Printer

Selecting a printer sounds simple. All you do is get out the phone book and look up a printer. There are probably plenty of them if you are in a metropolitan area. In a small town, you have fewer local choices, but in the age of the Internet, overnight delivery services, and fax machines, out-of-town printers are easily accessible.

Printers are as different as people, because they are people. But printing plants usually operate in similar ways, because their managers have come from other printing plants, bringing with them some bad habits, as well as some valuable improvements. You need to get to know the strong suits of the various printers in your area or the ones your client's company uses. Just like restaurants, some offer a great product while others offer good service. Look for the ones that offer both.

When choosing a printer, you should not only interview the printing salespeople, but also meet their customer service representative (CSR). This is the person you're going to spend the most time talking to. The

printing salespeople are constantly out making calls, so you need access to their in-house personal assistant. There is no substitute for human contact. The CSR should be able to return your phone calls within the same day. If there's an emergency, you should expect the CSR to be able to reach your printing salesperson as soon as possible. You should also expect a back-up CSR if yours is sick or on vacation.

You should not only interview printing salespeople, you should also meet their customer service representative.

I also suggest you take a tour of the plant. This is not just for PR, but also so that you can note several important things: How busy are they? Who are their customers? How advanced is their prepress area? Do they have proper facilities for press checks (meaning an area other than the press room for viewing proofs)? A printing plant's personality will show when you see it in action.

Types of Printers

In this age of tight budgets, most corporate and association printing is one or two colors. Look for a small, commercial quick-print shop that recognizes the time-driven nature of business printing, instead of a large, chain printer that usually caters to casual, walk-in customers, like Kinko's. Word-of-mouth referrals are the best. If you can find another company similar to yours in size and in your general area, their production manager has probably found a good source and will be happy to share it with you. (That is, unless you're in direct competition.)

If your clientele produces high-end, four-or-more-color publications, you will need printers who specialize in this kind of work. Here again, the referral method is best. These printers may be able to handle your two-color needs, as well. But be careful, because the reverse is not always true. Some two-color printers will say they can handle four-color projects, but this is neither cost-effective nor smart.

158

If you're new to printing, you must learn as much as you can about the state-of-the-art processes of today. Printing has been evolving almost yearly since the 1960s. Four-color process is the printing method for achieving all-color printing. While printing is CMYK (cyan, magenta, yellow, and black), computer colors are like those in television, which is RGB (red, green, and blue). When choosing colors, you'll need to know about the Pantone Matching System. With its books of color chips, it is the main color selection method of the industry.

You'll find additional need-to-know terms in the glossary. I also suggest getting a copy of International Paper's Pocket Pal. This little book will become your printing bible. It contains almost a college course in commercial printing and paper.

With a publication, catalog, or annual report that is printed in large quantities, you will probably need printers who have Web presses. These presses print off rolls of paper, as opposed to sheets, and they're very fast. Web papers are less expensive and make sense for long runs. They print on both sides at the same time. A word of warning, though: it's best if the printers you choose have backup presses. Web presses are complicated machines and can break down. If this happens and your client's job is on a tight deadline, you need to make sure the printer can run the job on another press. There are large and small Web presses. Find out which size Web press is best suited for your client's printing needs.

Press Inspections

Important projects often demand press inspections. Press inspections are critical if a printing project is very complex, your client's neck is on the line, or you or your company won't get paid if the printer screws up. Press inspections are sometimes referred to as "on-sites" because you or the client has to personally visit the printer to see proofs. When a printer knows you are coming to check your job, there is a psychological factor at work. They realize that this is an important project and needs special attention. Printers may even boast about catching problems before you arrive to impress you, to show that they are on top of the job.

If you are going to perform press inspections, you should get

yourself a loupe, which is a magnifying glass that printers use to check registration and screen densities. You should also bring any previous proofs with you if the printer doesn't already have them there.

Here you'll find a list of steps to follow during the inspection. Go through them, in order, and don't skip any of them!

1. Corrections: Make sure all corrections you asked for were made. It can be disastrous if you just assume that they were. Corrections made after these proofs are inspected and approved can be very costly. It may even involve printing everything all over again.

2. Images: Make sure you have all original color transparencies, artwork, and layouts with you. Don't trust your memory of what the images look like.

3. Colors: Look at color subjects upside down as well as right side up, so that the picture itself will not distract your eye from being objective. Check the registration. If you are using more than four colors, make sure you have your own PMS swatches of the fifth or sixth colors and check that they match the proof. The printer's PMS book may be out-of-date and doesn't have the colors you requested or the colors may not be as true as your own book.

4. Ink: If there are solid areas of color, ask the printer for a densitometer reading. This instrument, which looks like a big desk stapler, allows the pressman to check the amount of ink on the sheet.

5. Approval: Last but not least, okay a sheet for the pressman, date it, and sign it. Now do the same thing for yourself, because your copy can be crucial. I once had a designer come back from a press inspection without a duplicate of the okayed press sheet. Sure enough, the job was bad. We asked the printer if we could see the okayed press sheet. We were told it was lost. We didn't have a leg to stand on. Don't let this happen to you!

Is It Worth the Paper It's Printed On?

Appropriate choice of paper is the second most important part of a

printed piece. Design is probably first, because a good design on the cheapest paper can still be effective. Knowing what papers are best suited for what types of printing projects is the only way to get the best results. There are many choices, but knowledge of paper types will narrow those choices down. Selecting the right paper is an art form. You can limp along using the same papers over and over. No one will question you if your standby sheet is a good sheet. Many people, including award-winning designers, use the same papers over and over again from laziness or lack of knowledge. But there are many great papers out there. Don't fall into a rut; try them out.

Paper Production: What You Need to Know

Paper is manufactured in a mill and is made primarily from wood pulp. The wood is stripped of bark, ground up, and turned into usable pulp by means of heat, chemicals, or mechanical grinding. Once the pulp is in a semi-liquid form, it is bleached. This gives the finished papers their brightness. Less bleaching leaves the paper browner, as in grocery bags. After bleaching, dyes are added (to give the sheet a specific color, such as titanium oxide for opacity and brightness), as well as fillers (such as rag content from cotton fibers). These give papers their various properties.

The modern papermaking machines are very complex, usually made up of three sections. First, the pulp is fed into the wet end. Then, it is forced into the second area, called the press section. Here the water is pressed out between rolls and felts. A dandy roll is used to compress the sheet and distribute the fibers. The dandy roll may carry a design on it to give the paper a watermark. The third section is where the product is dried to the desired level in a machine composed of steam-heated cast-iron drums. Now it has changed from a watery mush to paper that is recognizable as such. After this process, the paper is "calendered," or finished. Coatings are then added, if necessary.

Here is a more detailed breakdown of paper characteristics that you should be familiar with:

The Sheet: Paper has two sides. There is a wire side, which is the side of the sheet exposed to the wire in the press section. The other

side is the felt side or top side, which was exposed to the dandy roll. The size of the sheet can vary.

Paper Finish: This is the texture, or smoothness, of a sheet of paper. The usual finishes (from rough to smooth) are antique, eggshell, vellum, machine finished, and coated. Finishes can also be embossed onto the paper through the use of rotary embossing machines. Tweed, linen, and ribbed textures are just some of the patterns used.

Paper Coatings: A coating is a chemical applied to a sheet of paper to make it glossy. The coating can be on one or both sides of the sheet. If it's on one side only, it is called C1S (C one S). A sheet that is coated on two sides is C2S (C two S).

Paper Grain: The grain is the direction of the fibers within a sheet. Folding against the grain often causes cracking. It is important to know how the grain runs in a sheet you're planning to print on and then fold. Your best source for this information is your paper merchant or your printer.

Paper Weights: The basis weight or paper weight is the weight of a ream of paper. A ream is five hundred sheets. Different types of papers come in different sizes, but the common denominator is the ream. A "basis 80" means that a ream of five hundred sheets, at 25 x 38 inches in size, weighs eighty pounds. There are exceptions to this, but for the most part, this formula will work for you. There are papers manufactured in Europe that are not standard American weight, but they offer variety and quality, and you can profit by knowing about them and their advantages.

Papers are also divided into "grades," or types, and have traditionally had different uses, which are often reflected in their names:

Coated papers: These are best suited for higher quality jobs and may be gloss coated, dull coated, machine coated, and cast coated on one or two sides. Printing ink does not soak into a coated sheet as much as it does with an uncoated paper, so coated papers make halftones and color images look richer. Coated papers are associated

with corporate capability brochures and annual reports. Since coated papers come in several grades and prices, you should not have to shy away from using them. Today, more and more coated papers are recycled, which also lowers their costs. The normal size of the sheet is 25 x 38 inches.

Uncoated papers: These can be excellent sheets for printing, and some are so smooth that it's hard to tell that they're not coated. Uncoated papers are manufactured in many textures and colors. They can simulate flannel, linen, corduroy, or other textures. The normal sheet size for these papers is also 25 x 38 inches.

Bond papers: These are used for stationery or forms; they take ink well from a pen. Part of this absorbency comes from the paper's rag content, which is usually 25 or 50 percent cotton fiber. With laser printers, the fine letterhead papers are not as readily used because they jam up in the printers or soak up the ink. The sheet size is 17 x 22 inches, and trimmed to 8.5 x 11 inches.

Book papers: These are used, just as the name implies, for books and textbooks. They come in antique (rough) or smooth finishes. They also come in many weights, so that a book can be bulked up or down if need be. The sheet size is 25 x 38 inches.

Offset papers: These are similar to the coated and uncoated sheets used in letterpress printing, except that they have sizing, a chemical added to resist the moisture that occurs in offset printing. The standard sheet size is 25 x 38 inches.

Index papers: These are stiff and take writing ink well, but are less expensive than cover grades, which are used for printing promotional brochures. Index papers are used for cards or tabs and are used in place of the more expensive cover stocks. They come in a smooth or vellum (a little rougher) finish. The sheet sizes are 22.5 x 35 inches or 25.5 x 30 inches.

Newsprint papers: These, as their name suggests, are used for newspapers. The sheets are not as white as other papers, and ink

tends to soak into them. Being relatively inexpensive, newsprint is ideal for large volumes of paper that modern newspapers need.

The mill makes the paper; the paper merchant is responsible for selling it. The relationship between the paper mill and the paper merchant has undergone some interesting changes over the years. Each merchant used to have exclusive rights to sell a certain mill's papers. So, the competition was more between mills than merchants. The mills promoted their own papers through advertising and through mill trips, which enabled them to wine and dine printers and designers. In the 1970s, however, the mills got smart and decided to make the merchants scramble. They gave more than one merchant the right to sell their papers. Now, one merchant usually represents several different mills.

Paper merchants are wholesalers, and they can help you learn more about paper if you know how to use them. They stock a certain number of the popular papers. If a particular type of paper is not on their floor, they can usually get it overnight from the paper mill. To show you their stock, merchants make up boxes containing all of their samples, and you can get one from your local paper merchants' sales-promotion person. They will call on you and bring a fresh box, which is important because certain papers are discontinued, while others add new grades or change colors. This same representative will come in from time to time and upgrade the box. But remember, out of sight, out of mind. If you don't call them every six months or so, they may forget to perform this service.

What Type of Paper Should I Use?

Paper choice can make a major difference in the appearance of your finished job. Coated papers are used for the lion's share of four-color printing. Uncoated are the next up. Bond, book, offset, label, index, and newsprint are other grades used commercially. Designers can often add flair to a four-color piece by using an uncoated sheet of paper. Even metallics can be printed on uncoated papers. Designers have long used white-coated papers, as these simulate the look of the papers used in the color printers generating full-color layouts. Computers perpetuate this trend, as it's easy to just lay out the job on the white screen, simulating a white paper. To simulate a

layout using a colored paper, the designer would have to create the texture and color with the computer. The technology limits some processes.

A dull or plain design can be perked up with an exciting color or texture. But remember one thing, coated, smooth papers make pictures look richer—be they in color or black and white—because the printing ink does not sink deep into the sheet. I once had a job on press that included a full-color image of an eagle that had originally been an engraving filled with delicate lines. I had chosen an uncoated white stock. While in make-ready (the process of running junk paper through the printer), the technician used some coated sheets as waste. To my dismay, the eagle looked much brighter and more vibrant on the coated sheet than it did on the one I had chosen. I've never forgotten this lesson.

Be Aware of What You'll Get

This is not to say that halftones and color images can't look good on an uncoated sheet. It only means that you should be aware of the likely effect. When in doubt, call your local paper merchant and ask them to look through their "sample room" for an example of print on the sheet you want to use. If they can't find one, there may be a good reason why. If you are still curious, there are electronic and conventional methods of proofing on the stock in question. Check with a service bureau on what's available to you and your client. Some projects may be so high profile that they justify a press proof.

Your printer is also a valuable consultant and trusted ally. They are experts on the printability of different papers and the various expenses of a project. I once used a ribbed (or grooved) sheet named Champion Benefit Vertical Cover. These types of sheets are usually made with the lines running horizontally, but the swatch book showed the sheet with grooves running up and down, so I assumed that the paper came that way. Plus, the name of the sheet was "Vertical," so I gave it no further thought. I asked three printers for quotes on my printing specs. I received the prices and released the artwork (on disk) to the low bidder. When the printer realized the grooves ran horizontally, I was notified that there would be an extra cost of $225. The printer said that he could not get as many covers out of a press sheet and more paper would be needed. I was

not happy. As always, the printing was billed directly to my client, but I was charging for print management. It had been my responsibility to get the quotes, and I didn't feel I could call my client and ask for more money. I contacted the merchant and lodged a complaint. Fortunately the mill didn't charge me for the difference.

Choosing Envelopes

Envelopes are used for everyday correspondence or for very important direct mail campaigns. Consider the envelope the introduction to you or your product, and treat it with appropriate care. This way, you're almost sure to make a favorable impression on the recipient. I have a theory that a good envelope will often save an entire piece from the trashcan. How many times has an envelope compelled you to open it? Publisher's Clearing House has certainly learned this secret. I've heard it said that most businesspeople never see envelopes, because a secretary opens it and then throws it into the trash before the recipient gets to see it. But this is actually more the exception than the rule. Let's face it; most people in middle management don't have secretaries.

Envelopes come in many sizes, colors, and textures. Here are just a few styles that you should be familiar with:

Baronial: These are used for formal invitations and announcements. They are usually white and are identified by their different sizes with an "A" prefix, such as A7 or A8.

Wallet Flap/Bankers Flap: These are used for heavy-duty purposes because they will hold materials too bulky for regular envelopes.

Commercial: These are made in bond or Kraft papers and are used for everyday business correspondence. The standard business envelope is the #10, which takes an 8.5 x 11 inch sheet of paper or standard company stationery. This size is also used for direct mail brochures that are folded from a sheet of paper that is 9 x 12 inches to a 4 x 9 inch (6) panel.

Gusseted/Expansion: A gusset is extra paper that folds out to accommodate the contents. These are used for bulky items.

166

Open-Side/Booklet: The flap of the envelope is on the long side. For instance, if an open-side envelope is 9 x 12 inches, it will open on the twelve-inch side.

Open-End/Catalog: This is just the opposite of open-side. This envelope is 9 x 12 inches, opening on the nine-inch side. The two types can be used interchangeably, depending on your preference.

Self-Sealing: These envelopes are used mainly for inter-office correspondence, or in situations where the materials in the envelope are not confidential.

String with Button and Clasp: These can be "sealed" and resealed over and over again. They are used for interoffice correspondence, and are not meant to be mailed.

Window: These have a glassine window so that the name and address, printed on the correspondence or a document, will show through. This avoids duplication of effort, reduces errors, and saves money.

There are wall charts available from envelope companies showing the many different styles and sizes of their envelopes. I suggest getting one of these and taping it on the back of a door that's usually open. A merchant who stocks Strathmore papers should be able to get you an Old Colony envelope wall chart. Old Colony specializes in nothing but envelopes and is the leader in the industry. If you're in an area without a local merchant, you can contact Old Colony directly:

Old Colony Envelopes
94 North Elm Street
Westfield, MA 01086
Phone: 1-800-343-1273

If you have a project requiring a special envelope, or if you wish the printing to run across the folds, you can have the envelope converted or manufactured. You should allow more time for this process

and budget a little more money. Here again, let the printer be your consultant. I have also seen envelopes made out of coated papers, as well as fine linen. But a word of caution: Some papers do not take glue well. Check with your local paper merchant on a specific sheet's ability to be converted into an envelope.

CHAPTER 16

BUYING ILLUSTRATION AND PHOTOGRAPHY

Saavy is Happy

There are common-sense rules that apply to the art of buying illustration and photography. Budget is probably the biggest constraint. After all, if you had unlimited funds you could hire LeRoy Neiman or Annie Leibovitz and win all kinds of awards. Unfortunately, it's the real world. Most of us have to beg, borrow, or steal to get funds for illustration or photography. Somehow, these elements appear to most clients to be the icing on the proverbial cake.

Start a Morgue

One of your first steps should be to start a morgue—not the kind that holds dead bodies. A morgue is a file or files containing reference materials. In this case, your morgue will contain books on current stock photography, illustrators and reps, special effects, retouchers, and old engravings.

Let's start with illustration. You will probably receive mailings from illustrators or their representatives. If you are just starting out or your company has just created your position for selling design, you may need some help in getting started. Join the local Art Directors Club. Usually those clubs are run by volunteers who are designers. There may be an Illustrator's Club in your area and this is an even better way to get sources. Also, a local chapter of the American Institute of Graphic Arts (AIGA) can be of assistance. If you're in a remote area, you can contact the national headquarters of the AIGA. Visit their Web site at *www.aiga.org*.

One of the best ways to work with illustrators is through companies that represent several different artists with different styles. You can discuss your budget, concepts, and schedule with a representative, who can recommend the best illustrator for your project. Sometimes this can be a big plus because you don't have to bring these delicate topics into your conversation with the artist you have chosen to work with.

Don't be afraid of logistics. I've worked with illustrators on the other side of the country. With e-mail and fax machines, you can receive rough layouts as quickly as if the illustrator was in the same city. In fact, often quicker than I used to receive them before fax machines and email. Once your client approves the sketch, the final illustration can be sent to you instantly as a file via e-mail.

For photography, it's best to review the portfolios of as many photographers as possible. They'll beat down your door once they know you're a buyer. But if you're in a remote area, get a copy of the *Corporate Showcase* This publication will give you mini-portfolios on photographers, as well as on illustrators and designers all over the country. If you're in a large metropolitan area, there may be local sourcebooks available.

For a listing of professional photographers, contact the American Society of Media Photographers (ASMP) in your area. If there is no local ASMP visit their Web site at *www.asmp.org*. Once the word is out that you're a buyer, you'll be on mailing lists and get tons of photographer's promos. These are excellent to carry around so you can show your client who's best at what. But do your homework. Find out what each photographer's day-rate is. This way you can work within your client's budget.

How Is Location Photography Bought?

The majority of location photographers charge by the day. This is called their *day-rate*, and usually doesn't include any expenses. All you get is the person behind the camera. Their assistant, travel, food, lodging, film, and processing are all extra. It's best to get an estimate of what costs the photographer feels will be incurred. Also, photographers limit the usage of their photos. You must negotiate if you want unlimited usage. Your client's photos may also be sold as stock by the

photographer after they use them unless you have made an agreement to the contrary. The photographer's estimate should spell out these conditions, but again, your purchase order can contradict them. If the photo subjects include people, make sure the photographer gets signed releases from everyone.

Location photographers can also charge by the photograph. If this is the case, there are probably still expenses not included in the fee. Here again, get an estimate of the expenses and a usage agreement. Remember, everything is negotiable. Don't let anyone dictate terms you feel are unfair. But remember, everything must be agreed upon, in writing, before the assignment starts, not after.

If the location photography is part of a graphic design project and a layout has been produced, the designer should, if at all possible, art direct the photography on location. This will ensure that the graphic feeling within the layout is maintained.

Is Studio Photography Different from Location?

Studio photography is similar to location. The same principles apply to estimates. Studio photography is usually billed by the image. With assignments such as catalogs, either a day-rate or a cost per picture can be used. You must again discuss your client's use of the photos with the photographer.

Stock Photography: The Good and the Bad

The good thing about using stock photography is that there are no hidden expenses from a photographer. The fee charged for the stock photos is usually negotiable, and will vary according to the type of publication, number of copies printed, whether the photo is on the cover, the size of the photo, and a number of other variables.

The downside to stock is that the photo may have been used before by someone else. Also, it may be difficult to find the exact photo of what your client wants. Stock photos can cost anywhere from a couple of hundred dollars to a thousand or more. Most stock photo companies charge a minimum of fifteen hundred dollars if a photo is lost. This is because the photo they send to you is the original, not a duplicate. If a stock-house sends you thirty slides to review and something happens to them, you're out forty-five thousand dollars.

Make sure your insurance covers your exposure.

With many stock photos available on Web sites, you can download images for layouts. These are low resolution images that are not suitable for printing in brochures, magazines, or other publications. This way the stock photography agencies protect themselves while making the photos available to designers for comps.

One of the most popular methods of collecting images is the CD-ROM. Designers can buy a CD filled with categorized subjects and use images over and over again. The disks are relatively inexpensive and easily stored. Some agencies will offer the option of keeping the images on their Web site and you can download them as needed. This easy and convenient; plus, you can't lose them.

BILLING FOR YOUR TIME

You're Worth It

C harging a client for your services goes against the grain of sales. Selling is considered overhead by most companies. But that is not always true, and in this chapter you will learn how to become a valuable consultant to your clients and a profit center for your company. If you are the company, the graphic designer and the bookkeeper all rolled into one, we'll look at billing methods.

Billing for Your Time

Let's look at what you can bill for. As I mentioned, you can become a profit center for your company if you provide services that your company can bill to your client. Most people in sales never think of these ways of being multifaceted. Your initiative will make you a far more valuable salesperson than other candidates who lack your skills and business savvy.

Consultation/Research

If you are providing consultation specific to the planning of a project, your time should be billable. This is only true if you can provide a "value added" service, not sales chit-chat. A good rule of thumb is to ask the question: *Could this process be completed just as successfully and on schedule without my input or assistance?* If the answer is *yes*, then don't count your time as billable.

If you are doing research to aid a designer, this should be billable. After all, the designer's time performing this same function

would've been billable. If your company doesn't have a formula for billing your services, you can use various methods to determine your hourly rate. We'll look at methods of doing this a little later in this chapter.

Print Management

This one area can make you an invaluable member of the professional team. If you ask to attend press inspections with a designer, you will learn what to look for and how to mark press sheets.

There are printing plants that will welcome your visit. They will answer any questions you might have without laughing at your lack of knowledge. If you can provide print management, your company should be able to bill for your time. This is a tremendous relief for the harried designer who would prefer to be designing than press inspecting or the clueless client who's unfamiliar with the printing process. It also makes you worth more than other salespeople, because you *can* provide a billable service. Most people miss opportunities by staying within the parameters of their job description. No one has ever achieved greatness only by doing the job they were expected to do.

*If you're writing
proposals, letters to clients, or press releases,
you are already writing.*

Writing and Editing

Another obvious but overlooked service that you can provide is writing or editing. This may intimidate you if you are not writing professionally. Most people don't realize that they are already providing this service internally. If you're writing proposals, letters to clients, or press releases, you are already writing. or press releases, you are already writing. If you feel that your work needs polishing, there are courses available from many colleges and universities throughout the country. Why not improve these valuable skills?

Editing is just an extension of writing and should be billable. So is

proofreading. That's part of editing and should be billable as well. Many times clients will ask for these services as part of a project's scope of work. If your company elects not to bill for these services, you will still have developed another facet of your professional value to your company and possibly a potential employer.

Deliveries

You probably take layouts, proofs, and disks to your client as well as the printer. Most salespeople charge nothing for this service, but they acknowledge that the client would've paid for a courier. You should make sure that this service is billed to the client at the same rate a courier service would.

This can add up to several hundred dollars a week that could offset your entire expense account. Smart companies bill for everything that is billable. You're not doing a visible favor for your client by not charging for legitimate services.

You may want to develop a simple form for these deliveries. My company is in the Washington D.C., metropolitan area, and the courier services have divided the area into zones. The delivery charges vary by zone and distance. This a fair way to adjust delivery charges, and once you know the costs, you can design similar rates and apply them to your form. You should fill out the form for each delivery and turn it in to bookkeeping. This is also a good way to keep track of your mileage if you're being reimbursed for it by the company. If this form is to be your mileage record as well as the company's, you may want to design it as a no-carbon-required two-part form so you can keep a copy.

The form on the next page is just one example. You can design your own to suit your needs. The simpler the better. The more complicated the form, the less likely you'll be to fill it out on a day-to-day basis.

What Is Your Time Worth?

Your company may not have a formula for billing your time. You can use the system outlined here. First, you must affix an hourly rate to your billable labor. This can be one rate for everyone in your company, or it can be an individual rate for each person. You can use the hourly rates to determine a cost by project.

I've found the most effective way to determine an hourly rate is simply to multiply your actual hourly rate by four. If you're making $50,000 a year, that hourly pay is $25. I use ratios and in this case, let's use four times your salaried hourly rate. Your billable rate is $25 x 4 = $100 per hour. This takes into consideration your benefits and overhead such as rent, phones, supplies, administrative personnel, and the like. This type of formula is used by lawyers and accountants alike. And they are in business to make money.

Design + Associates, Inc.

Delivery By Hand Form

Date: _____

Client: _____

Job #: _____

To: _____ From: _____

Delivery Charge: $_____

Mileage (To and From) Mi. _____

Signature

You can vary the ratio depending on where the company is located. Obviously the East and West Coasts are going to be higher, so you might use 4 to 4.5 for New York and 3 to 3.5 for a more rural area.

Since your billable hourly rate is based on your salary, this presupposes that the more you are paid, the more can be billed for your time. Billing by a ratio of your hourly rate should mean that if you are paid more money, you're capable of working faster than someone making less.

This ratio or formula is used by lawyers and accountants.

A Billing System

To keep track of your billable time, you need a system. Each project probably has a number already assigned to it. If not, start a numbering system of using the simplest workable way to assign client and job numbers to individual projects. The client's number could be his or her phone number. This makes it simple to contact them and guarantees that each number will be different.

Next, you should design a time sheet to keep a daily record for each job. I've tried weekly, but people have a tendency to wait until the end of the week to fill them out. At that point, they are just guessing.

The time sheet on the next page is very simple but adequate. You could make your codes letter abbreviations for services, like *CM* for Client Meeting or *R* for Research. When the time sheet is turned in, someone must enter the hours and codes into a data bank to be used to generate an invoice. There are simple programs that can be adapted to run this system. A more sophisticated approach is to network everyone into a central system so that the times and codes are immediately posted to each project electronically.

If you want to reduce the billing for hours system to its simplest form, you could average out the time used by individuals to complete a project and apply a total figure based on the size and scope of

the job. However, this only works accurately if you have a constant repetition of similar projects. For the most part, it would be nearly useless in a small or large design company. There are pitfalls to any system and the best precaution is paying attention to details.

Below, I have created a simple *daily* timesheet. You can code your billable work in anyway you wish to. I suggest that you also record unbillable work as well, as this becomes a record of the time you have worked. This is the same timesheet can be used to track designer's billable hours.

Time Sheet

Design + Associates, Inc.

Name: Jane Doe
Date: 8/7/99

Job #	Hours	Code
1000	2.5	Writing
1001	.5	Editing
1003	1.0	Client Meeting
1008	.5	Research
1015	.5	Print Management
1001	.25	Print Management
1028	.5	Editing
1014	1.0	Research
1000	.5	Writing
1003	.25	Overhead
1028	.5	Editing
Total	8.0 X $100.00 =	4,800.00

COMMONLY USED BUSINESS TERMS

Learn the Talk—Then Walk the Walk

The following terms are meant to help you understand words that may be thrown around while you are negotiating with your client, photographer, printer, or others. You may know most of these words, and this might seem silly, but this section may just reaffirm and further clarify what you thought you knew.

Your suppliers have an advantage. They are in business to survive, and the terms they use are precise. They cannot afford misunderstandings or mistakes that could kill their companies. By the same token, you must realize exactly what is being said to you, verbally or in writing. No good businessperson wants to surprise his client at the end of a project with an invoice full of unexpected charges. But it's "buyer beware," and you need to know as much as you can if you're buying illustration, photography, or printing for your client.

Knowledge Leads to Sales

The following terms are presented because they relate directly to you, the seller of graphic arts products and services. Other terms are not listed because they are obscure, or not common to the graphics industries. It is important that you have a basic understanding of business in general. If you are selling a service that affects your client's bottom line, you must know more than just the technical terms of the industry. As you know, business is profit. No profit, no client, no design company, and no job for you. With a good foundation of business terms you'll talk your clients talk.

Accounts Payable is the money owed by a company to a creditor for goods or services purchased.

Accounts Receivable is the money owed to a company for work performed and invoices issued. Your invoices are their receivables.

Aging is the money owed to a company, noted by the length of time it has been outstanding. This is measured in 30-, 60-, 90-, or 120-day increments. Aging is very important to banks when considering a loan for a company.

Alterations are changes made by the client to work completed correctly by the supplier. This is the one area clients must try to control because it's probably the greatest area of wasted money. The industry average for alteration is said to be 10 percent. Don't believe it. It's really more like 30 to 40 percent.

Arbitration is settling a dispute through an individual or a panel, rather than in a court of law. If both parties can agree on this method, they will save legal fees and court costs.

BPA, or "Blanket Purchase Agreement," is an open or standing purchase order for an amount of money you can spend with a supplier. BPAs are used for multiple projects during a given timeframe. For instance, a BPA for ninety days for $20,000 to a supplier means you can spend the $20,000 on different projects for ninety days. Every company qualifies service companies differently, so learn about your company's procedures from your accounts payable staff.

BPO, or "Blanket Purchase Order," is the same as a blanket purchase agreement. Some companies use one term, some use the other. It is an open or standing purchase order for an amount of money a supplier can spend with your company.

Brokering is when someone buys a good or service and resells it to another. A service charge is usually added to the cost, and this markup is the broker's profit.

Cash Flow is the coming and going of money that every business experiences. It is the constant cycle of invoicing, being paid, paying out cash to suppliers, and making payroll. Interruptions in cash flow will cause companies to borrow money.

Change Orders, another term for alterations, are changes made to existing work or proofs. They are billable, just like other alterations.

Comp Time is hours given as time off for hours worked as overtime. Companies paying comp time should not bill more than their normal hourly rate for overtime situations. This is a practice of accountants.

Contract is a written agreement between two parties outlining the responsibilities of each. A contract can be just a memo from one party to the next, spelling out the terms of the agreement. If the recipient does not respond, then the party sending the memo is presumed to be correct. You can create your own "paper trail" and protect yourself from liabilities that your supplier assumes you will accept. This is important, because in our society, virtually all business is conducted on the basis of contract.

Cost Per M is cost per thousand. When asking for a printing estimate or quotation over five thousand copies, it pays to ask for a price for additional thousands at the time of the initial run.

Estimate is a best-guess calculation of what a good or service will cost. An estimate is not necessarily a bottom-line cost. It is not a quotation or a formal proposal.

FOB means "Freight on Board." This term is used to specify location of delivery, such as FOB Detroit.

Indemnification is protection from legal reprisal. If you agree to someone's indemnification in a situation, you are agreeing that they are not liable in that situation.

Invoice is a bill for a specific product or service, and only one

invoice is issued. Most companies pay invoices only, never state-ments. Unpaid invoices will appear on monthly statements, and interest may be charged against the unpaid balance. If you have a dispute over an invoice, you should pay immediately any portion not in dispute. Any dispute should be called to the seller's attention, prior to the invoice becoming past due.

Letter of Intent is a letter defining the terms of an agreement. When there is no contract, this is the next best thing. And if you generate the letter, you can make sure you are fully protected. If the letter to you is not correct, always respond to a letter of intent in writing. The content of a verbal response can easily be forgotten at a later date.

Liability in business means exposure to legal action or financial responsibility. Ignorance is not protection, and every letter, memo, or other written document decreases your liability. You can transfer liability in the beginning, but when it's too late, you can be hung with it. Always create your own insurance with a paper trail.

Markup is a handling charge. Markups can be any amount added to a good or service bought by a supplier. Usually markups do not include any service by the designer.

Out-of-Pocket Expenses are costs to the designer, photographer, or printer in addition to their labor. This can be tricky, so get a writ-ten definition of what "out-of-pocket expenses" really means. For instance, you don't want to buy someone a car, so he can travel on your behalf!

Print Management is the time a designer spends working with a printer. Creating a schedule, providing specifications, checking proofs, and press inspecting are all part of print management.

Print Overrun is when a printer runs more copies than you have ordered. Check with the printer as to your liability in such an instance, because some printers will charge for the excess. Make sure you understand the printer's terms and conditions. You do have the

opportunity to dictate your own terms, specifically that you will not pay for overage, in your purchase order.

Print Underrun is a run that is short. The printer may say in their terms and conditions of sale that a percentage of underage is acceptable. Here again, you can disagree in your purchase order.

Proposal is a fixed-price bid for a good or service. Usually proposals will contain a capability statement showing the suppliers' credentials, a technical proposal stating how the supplier intends to accomplish the project goals, résumés of key individuals who will work on the project, a cost proposal, and references with phone numbers.

Registered Trademark is a logo or logotype that has been registered through the U.S. Patent and Trademark Office. An R in a circle (®) signifies that the trademark has been registered. If you are in a position within your company to recommend registering your company's logo, I strongly urge you to do so. Remember indemnification; the first company to initiate registration has the best chance of the design's survival as their own property.

RFP is a "Request for Proposal." This is usually a form inviting people to submit a proposal on a specific project.

RFQ is a "Request for Quotation," and is the same as an RFP.

Search is the work you perform prior to submitting a logo or logotype for formal registration. The Patent and Trademark Office will help you if you wish to try to do this yourself, but my advice is to let a lawyer take this step.

Spec Work is work performed in speculation of receiving a project and is done when several graphic designers are asked to submit free designs with their proposal. The American Institute of Graphic Arts and the Graphic & Web Design Trade Customs are strictly against this practice, and the majority of designers will refuse to do spec work. Companies who want multiple design choices will often offer a fee to several design firms, but design contests other than for charity are considered speculative.

Service Mark is used when the logo or logotype represents a service rather than a product. This is indicated by a small SM (SM) next to the mark.

Statement is a summary of your company's account with a supplier. A statement shows your outstanding balance, often by thirty-day aging stages. It is not an invoice, but it will list invoices already sent to you.

Terms are the number of days after which a supplier expects full payment for goods or services. Thirty days is usually the length of the term. Interest may be charged after thirty days, in the same way a credit-card company would charge your personal account.

Thirty Days Net means complete payment in thirty days. It does not mean installment payments or other extended terms.

Trademark is the term used when the logo or logotype represents a product not a service. This is shown by a small (TM) next to the mark.

Transmittal Letter or Letter of Transmittal is a note or letter stating something has been sent from one company to another. If it is a package coming to you, the transmittal letter will tell you what you should be getting, and the sender will retain a copy of the letter for their protection.

COMMONLY USED GRAPHIC ARTS AND COMPUTER TERMS

It's an Acronym World
Today

The following terms and definitions have been compiled to aid you in communicating with other graphic arts professionals. These definitions have been updated to include terms used in electronic design, prepress, and printing.

To list all of the terms used in the field of graphic arts would be counterproductive. Many are either too technical or have little meaning in your areas of responsibility. These are basic terms that are necessary for memos, proposals, RFQs, BPOs, purchase orders, and contracts.

AAs are "Author's Alterations." These are changes made to the copy by the client, and are considered billable. Unless included in the original estimate or contract, the designer will bill for this as it is additional work.

Absorption is the rate at which paper takes liquid, such as ink. It is also the rate at which light is transmitted through a translucent surface.

Accordion Fold is used to describe a brochure, pamphlet, etc., with two or more parallel folds resulting in an accordion-like format.

Additive Color is the term used when describing the combination of red, green, and blue. RGB is the acronym for these colors and generally refers to transmitted color, such as that seen on a computer monitor or television screen.

Against the Grain describes paper that is folded at a ninety-degree angle to the direction of its grain. This is usually considered the least acceptable way to fold a sheet because it often causes cracking.

Airbrush is a way of applying color with a spray. It also defines an effect simulated electronically to give something a soft edge or a gradation of tone.

Analog Color is color that is transmitted in a non-digital manner. In printing, it refers to a color proof pulled from conventional separations.

Antique Finish is a natural rough finish of certain printing papers.

Aperture is the opening of a camera lens. The "F" stop number signifies the size of the lens opening.

Art or Artwork, when discussed in terms of the prepress stages of offset printing, refers to a mechanical that will be photographed for the creation of a negative for printing. The new electronic technology refers to prepress information as files.

Ascender is the vertical line that rises above the body of a lowercase letter, such as the back of an *h*.

ASCII (Pronounced "Ask-ee") is the "American Standard Code for Information Interchange." This is a general standard for information processed as text characters, usually electronically.

Backbone is the back spine of a hardbound or perfect-bound book.

Backing Up is the printing of the reverse side of a sheet.

Bad Break in typography is any line that ends with a widow or begins with an orphan. (See also the Widow and Orphan definitions.)

Basis Weight is the weight in pounds of five hundred sheets of paper in a standard size for a printing press. Five hundred sheets of a printing paper that measures 25 x 38 inches of sixty-pound text has a basis weight of sixty pounds.

Bit, in computer terminology, is a single unit of numerical information. The word is derived from BInary digiT.

Bit Map, in computer terminology, is the complete image or page with all information portrayed by pixels.

Black Printer is the black in four-color printing. It is the *K* in CMYK (Cyan-Magenta-Yellow-Black) notations.

Blanket is the rubber-surfaced roller on an offset press that receives the ink from the printing plate and transfers it to paper.

Bleed is when an image, photograph, or area of color seems to run off the edge of a printed page.

Blind Embossing is the printing process where an image is raised on a sheet of paper through the use of dyes without color.

Blueline is a proof made with photosensitized paper from the final offset negatives that will be used to make the final printing plates. The color of the exposed area is blue.

Body Copy is the main portion of text in a printed piece. This is in contrast to headings, which are called "Heads" and "Subheads."

Bold Face is the term used to describe type heavier in weight than the normal (or "roman") state of its text face.

Bond is a grade of writing paper used for letters and forms, which generally comes in a 17 x 22-inch sheet size.

Book Paper may be coated or uncoated and usually comes in a 25 x 38-inch sheet.

Break for Color is the keying of elements and areas for their assigned colors in printing. These can be screens, solids, or process builds. These are also called color breaks.

Brochure is generally any printed promotion that is more than two

pages. A brochure can be as simple as a four-panel, 4 x 9-inch pamphlet, or an elaborate sixty-four-page, 8.5 x 11-inch, full-color corporate capabilities promotion. Generally a two-page (front and back) promotion is considered a flyer.

Bulk refers to thickness of paper. This is often used in book printing to give the desired thickness to the final printed product.

Burn is the term used when a printing negative is placed on photo-sensitized paper or a printing plate, and is exposed to light to form a proof or a printing plate.

Byte is a single unit of digital information within a computerized image.

CAD-CAM is "Computer Assisted Design" and "Computer Assisted Manufacturing."

Calendar is the process that gives smoothness and gloss to a sheet of paper at the end of the paper-making process.

Caliper is the thickness of paper, usually measured in the thousandths of an inch, called Mils.

Camera-Ready Art (CRA) means that copy is ready to be photographed to make negatives for offset printing.

Caps are capital letters. Hence, "all-caps" means all capital letters. The chapter titles in this book are set in all-caps.

Cast Coated is a paper that has been coated so that ink will stand up on the surface and offer the best representation of color. Most paper companies keep their coating processes secret.

CD-ROM stands for "Compact Disk-Read Only Memory." It's just like your stereo CD, but it has graphic images instead of just music. Read Only Memory means you can read the information on the disk, but you can't alter, delete, or add to the content of the CD.

Character is a letter or a symbol in a typeface.

CMYK is Cyan, Magenta, Yellow, and K for Black. These are the ink colors used in four-color process printing. (See also Process Colors.) They are subtractive colors, as all four combined make black.

Coated Paper is paper that has received a coating of some kind in the manufacturing stage. These papers can be made in any color and can be dull or glossy. Ink generally stands up extremely well on this type of paper, which makes these papers a favorite among graphic designers.

Collate is the arrangement of multiple sheets or pages in their correct order.

Color Balance is the correct relationship of four "process" colors.

Color Correction is any method used to correct an imbalance of color in a printing image. Formerly, dot-etching was often used to change the structure of a color subject by hand-altering the density or number of dots in a given area. Now color corrections can be made electronically on the computer.

Color Keys are clear color overlays (usually made by 3M) to proof color breaks.

Color Proofs are representations of any color images or full color images that let you see the effect of the colors that have been specified.

Color Separation is the division of each of the four process colors into their respective percentages that make up a full color image or picture.

Condensed Type is a typeface where the letters are thinner than they appear in the normal state.

Contacts are photographic prints made by negatives directly exposed to photosensitized paper.

Continuous Tone is a photograph that does not have a dot structure. This is the opposite of a halftone.

Copy is material furnished to a graphic designer or a printer and

may include illustrations as well as text.

Cromalin is a color proof using the DuPont Cromalin process.

Crop is the term used to size and shape photographs or illustrations for reproduction.

CRT is a Cathode Ray Tube on a computer monitor, which is the monochromatic (one-color) or full color video display.

Curl is the effect on paper caused by the differences of coatings from one side to the other.

Cut-Off is the print length of a sheet of paper on a web press or a paper machine.

Cyan is blue in four-color (CMYK) process printing.

Dandy Roll is a cylinder that creates a watermark in a sheet of paper during the papermaking process.

Deckle Edge is the edge of a sheet of paper that has been created to look torn or ragged. This effect is used on formal invitations and specialty printing projects.

Densitometer is an instrument that measures the density of printing ink on paper.

Descender is the part of a lower case letter a vertical line that extends below the baseline of a lowercase letter, such as the back of a *g*. This is the opposite of an ascender.

Die Cutting is a process by which a shape is cut through a piece of paper by using a die. A die resembles a sharp cookie cutter and can be used to create special folders or shapes.

Digital Color Proofs are proofs produced from electronic data. Conventional proofs need film, whereas digital proofs utilize digital information generated from a computer.

Digital Plates are generated without negatives directly from an electronic prepress system.

Digital Printing is plateless printing through electronic prepress. The process is very effective for on-demand, four-color printing.

Dimensional Stability is the ability of paper or film to maintain its size and shape during changes in the moisture content and humidity within its environment.

Display Type is type used for headlines. It is generally used for titles, and it is set larger than other text within the same area.

Dot is the smallest area of density in a halftone. If you look at any picture through a loupe or with a magnifying glass (preferably in a newspaper) you will see the dots that make up the picture.

Dot Etching is a way of altering a four-color image by using chemicals to eliminate or increase dots on the negatives or positives for any of the color in certain areas.

Dot Gain occurs when the dots in printing become larger, and cause the ink to reproduce darker or more intense than it should.

Dots Per Inch (or DPI) is the measure of how many electronic dots per inch are generated by a computer-linked printer. The more dots per inch, the sharper and crisper the image will be.

Draw Down is the process of spreading ink on a sheet of paper by hand with a spatula to test color.

Dummy is a bound replica of a planned printed piece. A dummy can be just a folded and stapled sample made up of plain paper, or it can be a complete bound proof.

Duotone is a process of giving a black-and-white photograph a two-color look. Consult your printer on the various duotone effects available. There is also a Pantone Matching System book available in art supply stores.

Duplex Stock is paper that has two different sheets laminated together so that a different color or finish is on each side.

Dye Transfer is a photographic process for intensifying color and retouching photographs through the use of dyes. This process has been replaced by electronic retouching.

Electronic Dot Generation (or EDG) is the method for creating halftones electronically.

Em space is a unit of space in a typeface equivalent to a square. Its name comes from the fact that in early fonts, the capital letter M was usually cast on a square body.

Emulsion Side is the treated side of film that collects light, causing a photographic image to appear.

En space is a unit of space equivalent to half the width of an em space.

Enamel is the term used for the coating on certain gloss papers.

EPS (Encapsulated Postscript File) is a file format for images that allows PostScript information to be transferred between computer systems. EPS files are limited in the way they can be manipulated. The image can be scaled but it can only be used in black-and-white.

Expanded Type is a typeface that is set wider than it appears in the normal state.

Felt Side is the smoother side of a sheet of paper. It is generally the top of the sheet when it's being manufactured.

Flat is composite film that is ready to be converted into an offset printing plate through exposure to light.

Flatbed Scanner is a four-color scanner that scans an image flat, in contrast to wrapping the original around a drum.

Flush Left, Ragged Right is the term for type that is not indented on the left side and not justified on the right side.

Folio is a page number. It can go on the top or bottom.

Font is a specific typeface or type style.

Fountain is the area that adds water or synthetic gum to one of the printing cylinders on a printing press.

Front-End System, in electronic prepress, is the desktop area in the production and printing process.

Galley Proof is a version of the copy after it has been designed. Galleys are usually associated with book production, where manuscripts written in word-processing programs like Word or WordPerfect are set out in page-layout programs like Quark, InDesign, or PageMaker, and then proofread for errors.

Gathering, in print binding, is the assembly of folded signatures in their correct sequence.

GCR is the "Gray Component Replacement."

Generation is each stage beyond the original in the reproduction process of an image, either text or illustrative materials.

Gigabyte (GB) is one billion bytes.

Grain is the direction of the fibers within a sheet of paper. Folding against the grain can cause cracking. Grain long or short means which way the grain is running in a sheet.

Grayscale is the range of gray measured from white to black. Color density can also be measured by a grayscale.

Gripper is the part of a printing press that holds and moves a sheet of paper.

Gumming is part of the plate-making process. Gum is applied to the areas on a printing plate that will not take ink.

Gutter is the inner margin of a bound publication.

Hairline is the thinnest rule possible that will hold up in the printing process.

Halftone is the reproduction of a continuous-tone image so that dots are formed, and the image can be printed.

Hard Copy is any visual material that is not on a computer screen. It can be a printout of a manuscript or a photocopy.

Hardware is the physical computer equipment, as opposed to software, which is information that operates the equipment.

Hickeys are spots where ink does not adhere to the paper surface during the printing process.

Highlight is the lightest area in a halftone, containing the fewest dots.

Holdout is the property within a sheet of paper that lets the ink set up and gives the richest color. Too much holdout can cause problems when one sheet's ink rubs off on another. This is called "off-setting."

HSV is "Hue, Saturation, and Value." This describes the luminance in computer graphic programs.

Hue is pure color, as opposed to a tint or a shade. Tints of color have white added to them. Shades of color have black added to them.

Imagesetter is a device used to output paper or film from electronically generated information.

Imposition is the order or position of pages on a printing form that will make up the correct signatures when trimmed.

Impression, in printing, is the term for each time the printing press comes in contact with a sheet of paper.

Insert is a sheet of paper that is blown in or bound into a publication.

Italic is type that slants right. It is the opposite of oblique.

Justify, in typography, is text that extends (or is "flush") to both the

left and right margins. This book's text is justified.

Kerning, in typography, is the space between letters in copy.

Keyboard is the unit containing keys on a computer. To "keyboard" copy is to transcribe text from a hard copy into a word-processing program.

Keyline is an outline indicating color breaks and other information for the prepress process.

Kilobyte is the term for one thousand bytes.

Kiss Impression is the lightest impression possible to leave an image in the printing process.

Kraft is paper or board made from unbleached pulp, usually tan.

Laid Paper is made with a pattern of parallel lines in the sheets, such as a ribbed effect. These papers have a specific personality and are used to achieve a specific look.

Lamination is a process in which heat is used to apply a plastic film to a printed sheet of paper. This makes the sheet more durable and colors appear more vivid.

Laser stands for "Light Amplification by Stimulated Emission of Radiation." In prepress, lasers are used to produce images from digital data.

Layout is a graphic design term used for a prototype showing color and typographical relationships. In printing, a layout is the format of the pages.

Leaders are the dots in rows, as in tabular materials. Leaders draw the eye across the page as in a table of contents or an index.

Leading in typesetting is the space between lines of text.

Line Copy is copy that does not need a screen to be reproduced. A line drawing is an illustration that is made up of black-and-white areas only.

Local Area Network (LAN) is the linking of computer equipment. In the prepress area, it is the connecting of workstations and other peripheral equipment, such as scanners and printers.

Logo or Logotype is the symbol or stylized word designed to identify an organization, product, or service. Logos are the symbols. Logotypes are the stylized words or names. A company with the name "Johnson's Wax" could use a stylized J for its logo and spell out its name in a unique typeface for its logotype.

Lowercase is the opposite of capital letters, or "Caps." The word "case" comes from the compartmented wooden boxes in which these letters were stored during the days of hot-type printing. Commoncase is type that is designed to use upper- and lowercase letters in the same sizes and weights.

M is the abbreviation for one thousand in the measurement of paper quantities or printed copies.

Magenta is red in four-color (CMYK) process printing. The color is a pinkish hue, and does not look like traditional red.

Make-ready is the process of setting up a printing press for a run. Inferior sheets are passed through the press to get the color balanced. These are called "make-ready sheets."

Matte Finish means a dull surface.

Measure is the width of a line of text in typesetting, usually calculated in picas.

Megabyte (MB) is the term for one million bytes.

Menu is the computer term for choices of functions offered on the computer monitor.

Modem (MOdulator/DEModulator) is equipment used to send information over phone lines from one electronic system to another. It converts data into high-frequency signals.

Moire (Pronounced "mwar-RAY") is an undesirable pattern created when screen angles are incorrect. The pattern often appears as a plaid.

Monitor is a computer screen.

Mouse is a device that lets the computer operator move the cursor around on the screen by sliding a handheld unit over a pad.

Mylar is a polyester film used in stripping. It has great strength and is very stable.

Negative is a piece of film with reversed images produced from a conventional camera or an imagesetter, and is used to produce a printing plate.

Newsprint is the type of paper used in the printing of newspapers. Made from ground wood pulp, it is inexpensive when compared to most grades of commercial printing papers.

Oblique is type that slants left. It is the opposite of italic.

Oblong is the term used for a booklet or publication bound on the shorter side.

OCR is "Optical Character Reader." As the name implies, OCR converts/reads written or printed text and turns it into digital information for the computer.

Off-Loading, or removal of data from a computer, is performed when more memory is needed. This is also called downloading.

Offset is the lithographic printing process whose name derives from the fact the offset printing plate never touches the paper. An intermediate roller or blanket receives the image from the plate and transfers it to the paper.

Opacity is the opposite of transparent or translucent. It is the quality of paper to hide show-through so that you don't see the images on the other side of the sheet.

Opaque is the process of covering areas on an offset negative to prevent exposure in non-print areas.

Orphan in typography is a word, or partial word, alone in the last line of a paragraph.

Overlay is usually a transparent material covering mechanical artwork used for marking corrections, color breaks, or variable print runs.

Overrun is the number of copies printed in excess of the number ordered. Underrun, or shortage of copies, is the opposite.

Overset is the amount of text in excess of the space allotted for it.

Page is one side of one half of a sheet of paper in a printed piece. If you pull the center out of a saddle-stitched magazine, you will be holding four pages.

Page Makeup is the assembly of all of the elements that represent a page. These elements can be illustrations, photographs, charts, graphs, typography, etc.

Palette is a group of colors available in a given medium.

Paste-up is the preparing of a conventional mechanical. The term comes from the era when rubber cement was used to literally glue type and other elements down on illustration board. Even with the advent of waxers, these mechanicals were still referred to as paste-ups.

PEs are "Printer's Errors," or errors on a proof that are made by the printer. They are often noted as "PEs" so that you won't be charged for them. But beware that if there are just a few PEs and many changes made by your company, it will be very hard to separate the PEs from your alterations.

Perfecting Press prints both sides of a sheet of paper with one pass through the printing press.

Photograph Art Direction is the time a designer spends supervis-

ing photography and reviewing proofs. Here again, it is better to have the photography billed directly to the client and for the designer only to bill the client for the time he or she is needed to perform art direction.

Phototypesetting is type composed through photography. This is also known as cold type, in contrast to linotype (or hot type).

Pica is a printing measurement representing approximately one-sixth of an inch. The pica measurements are used extensively in typesetting and page geometry.

Picking is the lifting of the printing paper's surface due to the tack of the ink. This occurs when the tack of the ink is stronger than the surface of the sheet.

Pin Register is the use of pegs/pins to align film, negatives, plates, and the like for perfect registration.

Plate is the name of the material carrying the image to be printed. Plates can be paper, plastic, metal, or other materials.

Point is a printer's measurement. There are twelve points in a pica, or seventy-two points in an inch. The height of type is always measured in points.

Positive is the opposite of a negative. The light and dark areas are the same as the original copy.

PostScript is a computer language connecting different programs, as well as platforms.

Press Proof is a proof pulled from running a color subject on a full-color press. This is an expensive way to proof a job, but the new electronic proofing systems are making press proofs less and less necessary.

Process Colors are the four colors used to achieve full color printing. They're cyan, magenta, yellow, and black (CMYK). Other colors are achieved by adding certain percentages of each of these four colors. When all four colors are combined at 100 percent, they result is black.

This is the opposite of RGB, which when combined at 100 percent, produces white.

Progressive Proofs are made from the process color builds and show the sequence they will run when on press.

Ragged Left, or Rag Left, is the term used to describe type that is not justified on the left side.

Ragged Right, or Rag Right, is the term used to describe type that is not justified on the right side.

Raster Image Processor (RIP) is the processor that reads and converts copy into digital data to be utilized as graphics in a computer system. The term "ripping" is used in describing this process.

Ream is five hundred sheets of paper.

Reflective Copy is any copy to be photographed that isn't transparent. Reflective copy can be scanned into a computer without being photographed.

Registration is the matching of images to make up a perfect unit. Registration marks are used to correctly place one element over another, and they are the guides for this.

RGB is "Red, Green, and Blue," the primary colors utilized by video/computer monitors. These are additive colors. When they are combined in their full values, white is the result. This is the opposite of process colors, which form black when combined in full strength.

Run-Around is a term describing type that literally runs around a picture, illustration, or other design element.

Running Head is a headline or title at the top or bottom of each page in a publication.

Saddle Stitched is the wire binding method of stitching a booklet. The booklet/publication literally straddles a wire like a saddle and is stapled to hold it together. This is the opposite of perfect bound,

where the pages are glued into the booklet and there is a spine.

Scaling is the enlargement or reduction of a graphic element to fit in a specific area.

Scanner is an electronic device that turns a graphic image into digital information to be manipulated by a computer.

Score is to make an impression in a sheet of paper so that cracking when folding is minimized.

Screen is a printing term describing the maximum number of dots in one square inch. A sixty-five-line screen is recommended for newspaper reproduction because it is coarse, and will work better with the high absorbency of newsprint. A 200-line screen should only be used with a fine printing paper. The normal screen used by most commercial printers is a 175-line screen.

SCSI (pronounced "SCU-zee") means "Small Computer System Interface." SCSI ports are connecting points on a computer for peripherals.

Self Cover means that the paper and weight used for the cover of a pamphlet/publication is the same stock as the text. The opposite is Plus Cover, which signifies that the cover stock is different from the text stock.

Serifs are thin lines, or "feet," appearing at the tops and bottoms of letters. The opposite of serif type is sans serif (or "lack of" serif). The typeface used here is serif.

Sheetwise means running one side of a sheet of paper through a press, then turning it over and running the other side.

Show-through is the opposite of opaque. This is when the images on the reverse side of a sheet can be seen through it, which is usually undesirable.

Signature is the term describing a printed sheet when it has been

folded. Signatures are normally sixteen pages, because eight pages can be printed on one side of a 25 x 38-inch sheet.

Silhouette is when a graphic element has had its background removed and appears to float on the page.

Skid is a wooden platform or palette holding paper or printed pages. Skids are used because they hold large quantities and can be easily moved by a forklift.

Small Caps are capital letters that are no higher than the main body of a lowercase letter (SMALL CAPS).

Spiral Binding can be wire or plastic, and is a spiral.

Step and Repeat is the process of duplicating pages.

Stet means disregard the changes indicated. This proofreading term is used when the proofreader decides something marked should be left in its original state.

Stripping is the positioning of offset negatives for use in creating a plate, as done on conventional prepress.

Surprint means overprint. An example is a yellow box with black type surprinting over it.

Tagged Image File Format (TIFF) is the file format for images commonly used for high-resolution files.

Text is the body copy within a document, versus the headlines or subheads.

Thermal Printers produce color proofs, using a transfer sheet and heat to transfer images onto a page.

Tints are screen percentages of a solid color. A tint is also created when white is added to a color.

Tooth is a term used to describe the rough finish of a paper.

Varnish is used to enhance a printed image. Gloss varnish will brighten an image, while a dull varnish will mute it. Varnish is also used to make dark ink less likely to show fingerprints. Special effects can be achieved when tints of ink are added to a varnish. If you are going to flood varnish a solid, however, the paper you use will lose its identity.

Washup is the cleaning of the rollers, fountains, and other parts of a printing press, in preparation for the next run. There is a charge for a washup if it's necessary between runs of the same job.

Waterless Printing uses silicone coatings on the plates instead of water. This type of offset printing is environmentally friendly, as it doesn't produce pollution.

Web Press is a printing press that prints from rolls of paper rather than from sheets. Webs are used for long runs, providing economies of time and money for catalogs and other commercial publications.

Widow in typography is a very short line, word, or partial word, in the first line at the top of a page or last word at the bottom of a page. It is considered unsightly in the publishing and design worlds. You may want to reorganize (or even rewrite) the paragraph to delete the widow.

Thanks for the help—Glen Kowalsi of Studio 405 (MacLab).

INTERNET TERMS AND DEFINITIONS

*A Little More to Add to Your Already
Overstuffed Vocabulary*

The following Internet-related terms and definitions have been compiled to aid you in communicating with clients and graphic arts professionals. These are not all of the definitions, but merely a sampling to get you started.

The terms used to describe Internet services, network technologies, and specific computer programs make little or no sense to a beginner. Internet terminology combines terms from computer networking, business, government, and commercial products. This glossary avoids terms that have been defined by commercial companies for their products.

10Base-T is a wiring pattern for an Ethernet LAN. The "T" abbreviates twisted pair, the kind of wire connecting a computer to the network.

Address is the number assigned to a computer, much like a telephone number is assigned to a home. When data travels from one computer to another, the data contains the numbers assigned to both the sender's and receiver's computer.

Advanced Networks and Services (ANS) is a major Wide Area Network in the Internet that a private company usually owns and operates.

Analog-to-Digital Converter (A-to-D converter) is a converter that turns an analog electrical signal into a sequence of numbers.

Anonymous FTP is a special "anonymous" login to obtain access to public files through the FTP service.

ANSNET is a major Wide Area Network that is part of the Internet.

Applet is a dynamic Web page written using the Java technology. An applet is a program that displays smooth animation on a browser's screen.

Archie is a search service available on the Internet that searches for all files with the same name. "Archie" is also short for "archive."

ASCII is the abbreviation for American Standard Code for Information Interchange.

Bandwidth is the capacity of a network usually measured in bits per second. Systems need a higher bandwidth for audio or video files (which can be 100MB or more) than for e-mail or other services.

Baud is the number of times per second a signal can change on a transmission line. The baud rate equals the number of bits per second that can be transferred.

Binary Digit (bit) is used to represent information, including audio, video, and text.

Bits Per Second (bps) is the measure of the rate of data transmission. The measure refers to the capacity, or "bandwidth," of a network.

Bookmark is a function of an Internet browser that records a Web site's URL so it is easy to return to it.

Broadcast is information given to a group of interconnected computers simultaneously.

Browser is a program that allows users view hypermedia documents online. Internet Explorer (from the Microsoft Corporation) is a popular browser.

Browsing is looking for information by repeatedly scanning and selecting information. An Internet browsing service offers a list of

items or a menu page of information. The user reads the information, selects an item, and then the service retrieves new information.

BTW is the abbreviation for "By the Way" commonly used in electronic communication.

Bulletin Board Service (BBS) is a service that lets an individual post a message for others to read. These are more commonly known today as "chat rooms."

Carrier is an electrical signal used by a modem to encode information for transmission across a telephone connection.

Carbon Copy (CC) is used in e-mail headers for additional recipients. When you "CC" someone on an e-mail, it means you are sending that person the e-mail as well.

Client is a program that contacts a remote server by the Internet. A separate client program is usually needed for each Internet service.

Client-server Computing are two programs communicating across a network. The requesting program is called the client; the program answering is the server.

Collapsed Backbone is a router used instead of a backbone Local Area Network and connected routers. A collapsed backbone is used because it costs less than the traditional design.

Common Gateway Interface (CGI) uses a computer program to assemble a Web page whenever the user requests the page. Pages composed using CGI technology are not stored on the server's disk before requests arrive.

Connections are two programs communicating using TCP; the TCP software on the two computers forms a connection across the Internet.

Demodulation is the extracting of information from a modulated signal arriving over a telephone line. Demodulation occurs in a modem.

Destination Address is the numerical value that specifies the computer to which the information has been sent. The destination address is the IP address of the destination computer.

Digital Technology uses numbers to represent information. A computer is digital because it represents keystrokes, pictures, text, and sounds using numbers.

Digital Library Information is information that has been stored in digital form. A digital library can include documents, images, sounds, and information gathered from ongoing events.

Domain Name is a host name that stands in for a computer's IP addresses. It is most often part of a URL or an e-mail address. This allows people to create and apply original, easy-to-remember names (such as "Yahoo.com" or "person@yahoo.com") instead of a numeric IP addresses (such as 207.147.13.2).

Domain Name System (DNS) makes the connection between a domain name and an IP address. For example, when a URL is entered into the address bar of an Internet browser, the Domain Name System searches for the IP address that corresponds to the domain name and then displays the desired site.

Dotted Decimal is used to specify an IP address. Dotted decimal represents an address as four small, decimal integers separated by periods. A computer stores each IP address in binary—dotted decimal notation is used to make addresses easier to enter or read.

E-mail Address is an address assigned to an electronic mailbox. They have the form "person@computer.com."

Ethernet is a popular Local Area Network technology invented by the Xerox Corporation. An Ethernet consists of a cable to which computers are attached.

FAQ (Frequently Asked Questions) contains questions and answers most frequently asked.

File Server Program runs on a computer providing access to files

on that computer. The term is often used to describe computers that run file server programs.

File Transfer Protocol (FTP) is the Internet service used to transfer a copy of a file from one computer to another. After contacting a remote computer, a user must enter a login name and password.

Finger is an Internet service used to find out which users are currently logged into a particular computer.

Flame is a term used in electronic communication to mean an emotional or inflammatory note, often written in response to another message. The word is sometimes used as a verb, meaning to write an inflammatory message.

Folder is a synonym for directory.

Frames are a technology that divides a Web page into different areas (i.e., windows), and allows each area to change independent of the others.

FYA is the abbreviation for "For Your Amusement" used in electronic communication.

Homepage is a page of information accessible through the World Wide Web. The page can contain a mixture of graphics and text, and can include embedded references to other pages. Usually each user and each organization has a separate homepage.

Hop Count is a measure of distance in a file-switching network. If a file must travel through N additional routers on its trip from its source to its target, the target is said to lie N hops away from the source.

Host is a synonym for user's computer. Every computer connected to the Internet is classified as a host or a router.

Host Name is the unique name by which a device, like a computer, is known on a network.

HTML is the acronym for HyperText Markup Language. This is the computer language used to specify the contents and format of a hypermedia document in the World Wide Web.

HTTP is the acronym for HyperText Transport Protocol. It is the protocol used to access a World Wide Web document. A user may encounter the term HTTP in a Uniform Resource Locator (URL).

Hub is an electronic device that connects to several computers and replaces a LAN, usually an Ethernet. Hubs are used with 10Base-T.

Hypermedia is an information storage system in which each page of information can contain embedded references to images, sounds, and other pages of information.

Hypertext is a system for storing pages of textual information that each contains embedded references to other pages of information. This lets the visitor to a site progress from page to page of information.

IMHO is the abbreviation for "In My Humble Opinion" used in electronic communication.

Instant Messaging allows users on the Internet to "chat" in real time. In most programs, a pop-up box appears with two windows. In the bottom window, a user types his or her message before clicking on a "send" button. The message then appears in the top window, where the comments of both users are displayed.

Integrated Circuit is a small, electronic device containing transistors. An integrated circuit is called a chip.

Internet is the collection of networks and routers that use the TCP/IP protocol suite and function as a single, large network.

Internetworking is a term used to refer to planning, building, testing, and using Internet systems.

IP (Internet Protocol) is a specification or the format of files that computers use when communicating across the Internet. In practice, the term usually refers to the IP software.

IP Address (also called an Internet Address) is assigned to every computer on the Internet. Software uses the address to identify the intended recipient when it sends a message.

IP Datagram is a file of data sent across the Internet. The IP file contains the address of the sender, the IP address of the destination, and the information being sent.

Internet Service Provider (ISP) is a company that offers connectivity to the Internet. An ISP can connect users either by telephone lines or cable.

Java is the technology that is used to create active Web pages. Java was developed by Sun Microsystems, Incorporated.

Kbps (Kilo Bits Per Second) is a measure of the rate of data transmission equal to 1,000BPS.

LAN is the abbreviation for Local Area Network. (See appendix B for the definition.)

LISTSERV (electronic mailing LIST SERVer) is a program maintaining lists of e-mail addresses. A user can request that LISTSERV add their e-mail address to a list or delete it.

Login is entering an account identifier and password to access to a timesharing computer.

Long-haul Network is a synonym for Wide Area Network.

Mailbox is a storage area on disk holding incoming e-mail messages until a user reads the mail.

Mbps (Millions of Bits Per Second) is a measure of the rate of data transmission equal to one million bps.

Modem (modulator-demodulator) is a device used to transmit digital data a long distance across an analog transmission path.

Modulator is the electronic device in a modem, encoding data for transmission.

Multicast is the technique used to send a file to a selected set of other computers.

Multimedia is a term describing any display text, graphics, images, and sounds.

Netiquette is a list of suggestions for how to behave when using the Internet.

Network File System (NFS) is a service that lets computers access each other's file systems. The difference between NFS and FTP is that NFS accesses pieces of a file as needed without copying the entire file.

NII is the abbreviation for National Information Infrastructure.

Open System is a non-proprietary technology or system that any manufacturer can use. An open system connects systems to other systems that normally couldn't work together.

Packet is used informally to describe a unit of data sent across a packet switching network.

Password is the secret code a user enters to gain access to a system.

Ph is the name of the client program used with the qi information service. Ph provides information about an individual.

Ping (Packet InterNet Groper) is the name of a program used with TCP/IP Internets to test. Ping sends the computer a file and waits for a reply.

Plugin is the technology in which a browser can load additional software, allowing the browser to interpret new or alternative data formats.

Point-and-click Interface is a style of interacting with a computer that uses a mouse instead of a keyboard. The user moves the mouse to position the cursor, and presses a button on the mouse to select the item under the cursor.

Point-to-point Protocol (PPP) is a protocol used to send TCP/IP traffic across a serial transmission line.

Protocol is the rules two or more computers must follow to exchange messages.

PTT is the abbreviation for Post, Telegraph, and Telephone.

Public Files are files available to any Internet user.

Public Mailing List is an electronic mailing list letting anyone add themselves, delete themselves, or send a memo.

Request for Comments (RFC) is a series of notes containing the TCP/IP protocol standards and related documents.

Qi is the name of the server accessed by the ph program.

Remote Login is a service allowing a user on one computer to connect their keyboard and display to a remote computer and run programs.

Route is the path that network traffic takes from its source to its destination.

Router is a special computer that attaches to two or more networks and routes IP datagrams from one to the other.

Search Engine is a term applied to automated search services. The term refers to computer programs that such services use to scan the Internet.

Search Key is a string of characters providing a search service. The service searches for titles or files that contain the string.

Search Tool is a program that lets a user find the location of specific information.

Serial Line IP (SLIP) is a protocol permitting a computer to use TCP/IP over a serial communication medium.

Server is a program that offers a service. Many computers on the Internet run servers to offer services.

Stack is a term that refers to all the TCP/IP software on a computer. This term is derived from the way software is organized.

Surfing the Internet is slang for using Internet services to browse information.

TCP/IP is the name of protocols that specify how computers communicate on the Internet.

Text File is any file of textual characters separated into lines. Text files on the Internet use the ASCII character encoding.

Textual Interface is a style of interacting with a computer using a keyboard. Keystrokes are entered, and the computer responds.

Token Ring is a type of Local Area Network (LAN) that the network passes from computer to computer in a complete cycle.

Traceroute is a program that lets a user find the path a file will take as it crosses the Internet to a specific destination.

Transmission Control Protocol (TCP) is one of the two major TCP/IP protocols. TCP handles the difficult task of ensuring that all data arrives at the destination in the correct order. The term often refers to software that implements the TCP standard.

Trickle is a service that provides electronic mail access to FTP. A user sends an e-mail message to a trickle server; the server reads the message, obtains a copy of the file, and transmits an e-mail reply that contains the copy.

Uniform Resource Locator (URL) is a short character string used by browsers to identify a particular page of information on the Internet.

UNIX is a computer operating system developed at AT&T Bell Laboratories.

USENET is a group of computers exchanging network news.

UUCP (Unix to Unix Copy Program) is software developed in the mid-1990s that allows one computer to copy files of another.

Video Teleconference Service allows a group of users to exchange video information over the Internet.

Virtual Network is used to refer to the appearance of a single, seamless network system.

Web Site is a set of Web pages available to browsers when a computer attached to the Internet running on a Web server.

Whiteboard Service is a service that allows a group to establish a session that permits all of them to see and modify the same display.

Wide Area Information Server (WAIS) is an Internet automated search service that locates documents with key words or phrases.

Wide Area Network (WAN) is network technology spanning large geographic distances.

Window is a rectangular area on a screen devoted to one particular application program. Windows can overlap, and can be moved on top of other windows.

World Wide Web (WWW) is an Internet service that organizes information using hypermedia.

Instant Messaging Aconyms

The rage today is text messaging. There's an acronym for different phrases that speed up typing. These are also being used in e-mail but not as often. For the abreviations see the next page.

The following abbreviations are used to condense messages.

AFAIK	as far as I know
AFAIR	as far as I remember
AFK	away from keyboard
ATM	at the moment
BAK	back at keyboard
BBL	[I'll] be back later
BRB	[I'll] be right back
BWAHAHAHA	(represents an evil laugh)
CULSR	see you later
F2F	face to face
FS	for sale
FWIW	for what it's worth
GRS, GR8T	great
IANL	I'm not a lawyer
IIRC	if I remember correctly
IMHO	in my humble opinion
IMO	in my opinion
IOW	in other words
IRL	in real life
ISO	in search of
ISTR	I seem to remember
J/C	just chilling
L8ER, L8TR	later
LOL	laugh(ing) out loud
MWHAHAHA	(also represents an evil laugh)
PMJI	pardon me for jumping in
QT	cutie
ROFL	rolling on floor laughing
S/AC	sex and age check
S/H	same here
SW : ()	say what!? (gasp)
TIA	thanks in advance
THX, TNX	thanks
TTFN, TT4N	ta-ta (goodbye) for now
Y	why
WAZ^	what's up?
WBASAYC	write back as soon as soon as you can

WORDS WORTH READING

It's Not the Date It Was Written,
It's What Was Written

American Institute of Graphic Arts. *AIGA Professional Practices in Graphic Design.* New York: Allworth Press, 1998.

Brinson, J. Dianne and Mark F. Radcliffe. *Internet Law and Business Handbook.* Menlo Park, California: Ladera Press, 2001.

Chwast, Seymour. *The Pushpin Graphic.* San Francisco: Chronicle Books, LLC, 2004.

Crawford, Tad and Eva Doman Bruck. *Business and Legal Forms for Graphic Designers,* rev. ed. New York: Allworth Press, 2003.

Editorial Committee. *Graphic Artist's Guild Handbook, Pricing & Ethical Guidelines.* New York: Graphic Artists Guild, 2001.

Fleischman, Michael. *Starting Your Career as a Freelance Illustrator or Graphic Designer.* New York: Allworth Press, 2001.

Foote, Cameron. *The Creative Business Guide to Running a Graphic Design Business.* New York: W.W. Norton & Company, 2001.

Gold, Ed. *The Business of Graphic Design,* rev. ed. New York: Watson-Guptill Publications, 1999.

Goldfarb, Roz. *Careers by Design.* New York: Allworth Press, 2002.

Heller, Steven. *Looking Closer: Critical Writings on Graphic Design.* New York: Allworth Press, 2002.

International Paper. *Pocket Pal.* Memphis, Tennessee: International Paper Company, 2000.

Jensen, Rolf. *The Dream Society.* New York: McGraw Hill, 2001.

Jobs, Steve. Interview. *Fortune,* 2000.

Pederson, Martin. *Graphis Corporate Identity.* 1989, Graphis Press Corp., Zurich (Switzerland).

Pentagram. *Pentagram; The Compendium.* London: Phaidon Press Limited, 1998.

Schwartz, Even L. *Webonomics.* New York: Broadway Books, 1997.

Supon Design Group. *Using 1, 2 & 3 Colors.* 1992, Madison Square Press.

Twins, *The Stone. Logo RIP.* Amsterdam: Bispublishers, 2003.

Waters, John. *The Real Business of Web Design.* New York: Allworth Press, 2004.

ABOUT THE AUTHOR

*A Day in the Trenches Doesn't
Make One a Soldier*

Don Sparkman is the president of his own graphic design firm, Sparkman + Associates, Inc., in Washington, D.C. He founded the company in 1973, and he has personally won numerous awards for design excellence, locally, nationally, and internationally. His firm has developed graphic communications for AT&T, Black and Decker, Cable and Wireless, Coors, Eckerd Drugs, Fortran Communications, GE, Marriott, MCI, Mobil, NASA, Ogilvy & Mather, National Institutes of Health, Rubbermaid, U.S. Postal Service, and most recently the logo and graphics standards for the Occupational Safety and Health Administration (OSHA).

In 1976, Don was selected by the President of the United States and the U.S. Bicentennial Committee as one of three designers to judge the design validity of all commemorative items developed for the nation's bicentennial. He is twice a past-president of the Art Directors Club of Metropolitan Washington (ADCMW) and past president of the International Design by Electronics Association (IDEA).

He created the *Graphic & Web Design Trade Customs* for the ADCMW and IDEA, and has been published in *Step-by-Step* magazine. He has also lectured at the Design Management Institute's National Conference in Martha's Vineyard; George Washington University's Design Center in Washington, DC.; Northern Virginia Community College; the Corcoran School of Art; the American Institute of Graphic Arts; and many other institutions.

His first book, *Selling Graphic Design,* was conceived because of Sparkman's acute awareness of the problems encountered by those selling design who have had no formal training. Don has been selling design for his firm for over thirty years, and he knows the tricks of the trade.

In order to keep providing excellent service, Don has immersed his firm in the new technologies. In 1985 he bought a Lightspeed computer design system, which was one of the pioneer systems and very powerful for its time. Now, every designer in his firm works on the latest computer design system and is online. His firm is currently creating Web sites for the U.S. Department of Agriculture, Small Business Administration, as well as private sector clients.

While the Internet is an exciting electronic universe, Sparkman still believes the computer is just another design and communication tool, and that only people are designers. Don feels that "a computer has no imagination, and if we think it will serve up ideas, we cease being designers." This philosophy has helped him keep his company on the leading edge of technology, while not forgetting why it's there.

His e-mail address is donald@sparkmandesign.com.

WHERE TO FIND IT

It's All in the Book and This Will
Take You to It

Books from Allworth Press

Allworth Press is an imprint of Allworth Communications, Inc. Selected titles are listed below.

Making It on Broadway: Actor's Tales of Climbing to the Top
by David Wiener and Jodie Langel (paperback, 6 × 9, 288 pages, $19.95)

Producing Your Own Showcase
by Paul Harris (paperback, 6 × 9, 240 pages, $18.95)

The Perfect Stage Crew: The Compleat Technical Guide for High School, College, and Community Theater
by John Kaluta (paperback, 6 × 9, 256 pages, $19.95)

Business and Legal Forms for Theater
by Charles Grippo (paperback, 8½ × 11, 192 pages, $29.95)

Career Solutions for Creative People: How to Balance Artistic Goals with Career Security
by Dr. Ronda Ormont (paperback, 6 × 9, 320 pages, $19.95)

Acting That Matters
by Barry Pineo (paperback, 6 × 9, 256 pages, $19.95)

Improv for Actors
by Dan Diggles (paperback, 6 × 9, 224 pages, $19.95)

Mastering Shakespeare: An Acting Class in Seven Scenes
by Scott Kaiser (paperback, 6 × 9, 256 pages, $19.95)

Movement for Actors
edited by Nicole Potter (paperback, 6 × 9, 288 pages, $19.95)

Promoting Your Acting Career: A Step-by-Step Guide to Opening the Right Doors, Second Edition
by Glenn Alterman (paperback, 6 × 9, 240 pages, $19.95)

An Actor's Guide—Making It in New York City
by Glenn Alterman (paperback, 6 × 9, 288 pages, $19.95)

Creating Your Own Monologue
by Glenn Alterman (paperback, 6 × 9, 208 pages, $14.95)

Please write to request our free catalog. To order by credit card, call 1-800-491-2808 or send a check or money order to Allworth Press, 10 East 23rd Street, Suite 510, New York, NY 10010. Include $5 for shipping and handling for the first book ordered and $1 for each additional book. Ten dollars plus $1 for each additional book if ordering from Canada. New York State residents must add sales tax.